READING 1800 TO THE PRESENT DAY

THE MAKING OF MODERN READING

STUART HYLTON

AMBERLEY

First published 2015

Amberley Publishing
The Hill, Stroud
Gloucestershire, GL5 4EP

www.amberley-books.com

British Library Cataloguing in Publication Data.
A catalogue record for this book is available from the British Library.

ISBN 978 1 4456 4831 6 (paperback)
ISBN 978 1 4456 4832 3 (ebook)

Typesetting and Origination by Amberley Publishing.
Printed in the UK.

Contents

Introduction

As you may have gathered from a book whose first chapter deals with the relationship between the town and the motor car, this is not a conventional local history. Most local histories take us right back to the earliest origins of a community. Either that, or they are rooted in a particular (and often atypical) period of a community's history – such as one or the other of the world wars or the Civil War. Interesting and valid as both approaches are – and I have written both – what Edward I said to the town's guild in 1301, or how the community reacted to wartime rationing does not necessarily add a lot (at least directly) to our understanding of the place in which we live and work today.

What I wanted to write was more a companion to modern Reading – how the town as we know it today came about; the institutions, the services, local landmarks, different means of transport, the economy, the shopping centre, and so on. At what point did they start to take on a recognisably modern form, aspects of which we can still recognise in the town we know? Anything preceding that is kept to a brief introductory context.

It also means focusing on matters that might not normally be given a great deal of attention in a local history. Hence we go into some detail about how the M4 motorway came to be built on the alignment it is and what became of the M31; the origins of Reading Festival (something for which the town is internationally known, and which transforms it every August Bank Holiday weekend); and modern attempts to rescue the town's waterways from a century of unsightly development and blight. All of these, I believe, add to our understanding of the twenty-first-century Reading in which we spend our time.

Reading and the Motor Car

We will start by looking at how the town's love-hate relationship with the motor car has developed over the years. Since the start of the twentieth century the motor car has been a dominating force – some would say the dominating force – in the life of Reading, sometimes seeming to offer its citizens new freedom and opportunities, but all too often threatening to choke the life out of the town.

First, a few modern facts and figures about Reading's traffic, to give some indication of the scale of the problem. Something like 330,000 car trips are made on the town centre road network each day, about half of which are through traffic, and the figure is growing. Reading's traffic growth between 2002 and 2007 was estimated at 12 per cent, with another 16 per cent forecast by 2012. Looking at a wider area, and into the future, Reading's Independent Transport Commission heard in 2008 that the Greater Reading area was generating 412,000 trips a day, and that 32,000 new homes and 30,000 new jobs would add a further 130,000 extra trips to this total by 2032.

But going back into history, possibly the first real experience many Reading people had of the motor car – certainly in any numbers – occurred in April 1900. At that time, the British public were highly sceptical about motor vehicles as a serious form of transport. It was only four years since the Locomotives on Highways Act had liberated cars to travel at more than walking pace (the speed limit was now raised to a dizzying 14 miles an hour outside towns) and the motor cars of 1900 were just as likely to be seen broken down at the roadside as going anywhere. In order to dispel this image, the Automobile Club (later known as the RAC) decided to promote a 1,000-mile reliability trial, to show that the motor car was a practical mode of transport. It was the most ambitious trial ever set for the new mode of travel and led, among other things, to Edward VII buying his first motor car and giving them the royal seal of approval. The Automobile Club was supported in the project by the newspaper magnate Alfred Harmsworth (later Lord Northcliffe). Eighty-three cars entered, though only sixty-five actually made it as far as the starting line, and just thirty-five reached the finish.

At 7 a.m. on 23 April the cavalcade set off westward out of London. Their first port of call was Reading (unsurprising, since Alfred Harmsworth lived there – at Calcot Park). The local press reported their progress through Reading in some detail:

> The trial was not largely known in Reading else doubtless there would have been greater crowds to witness the progress of the cars through the town. The first car

arrived about 9.10 a.m. and from that time there was a regular procession of cars along the London Road, through Southampton Street, Bridge Street, Castle Street onto the Bath Road to Calcot Park. On reaching Reading the cars were stopped near the cemetery (where the crowd was most dense) and officials were there to hand each competitor a time card. This was checked by another official stationed opposite the Horse and Jockey Inn on the Castle Hill, so that the rate of progress through the town would be known. According to the regulations drivers were to proceed at not more than eight miles an hour through towns and the speed in the country was not to exceed twelve miles. Apparently some of the drivers had exceeded the rates of speed, for some of them had to be detained at Castle Hill three or four minutes through having been in advance of the regulation time…

As the cars ran through the thoroughfares mentioned various criticisms were passed, the dusty condition of both vehicles and occupants being freely commented upon, it being generally considered that riding on a motor car in dry weather could hardly be very pleasant. The cars passed through the town without mishap, though with some of the later arrivals there were one or two narrow escapes in Bridge Street, where traffic was rather congested.

The official time for reaching Calcot Park was 10.55 a.m., but only about half the competitors had arrived by that time, the others coming in straggling order during the next hour or two.

Reading Mercury, 28 April 1900

The winner of the trial was the Honourable C. S. Rolls (yet to forge his famous partnership with Henry Royce). Rolls was shortly to introduce a new – and potentially dangerous – motor sport to Reading. The participants assembled at the Reading Gasworks, where Rolls (this time in the role of an aeronaut, rather than a motorist) filled a balloon with gas and took off for wherever the wind would take him. He was pursued by seven motorists in a form of hare and hounds race, the winner being the first motorist to reach the balloon after it had landed. Apparently, friendly policemen held up traffic as the motorists darted out, so that they might have as free a passage out of town as had the balloon. He eventually landed at Cumnor, near Oxford, with the first motorists only a few minutes behind.

But, prior to this, in 1903, Rolls (or, rather, his chauffeur) had been the victim of a crackdown by police against speeding motorists. A speed trap was set up on the Bath Road at Sulhamstead. In the absence of cameras and radar a measured half-mile was marked out and a policeman with binoculars and a stopwatch concealed in a ditch, to measure motorists' progress along it. The seriousness of their transgressions varied considerably. It was a fair cop for the chauffeur caught doing 50 mph in his employer's racing car, a vehicle capable in 1903 of 90 mph – virtually the world land speed record of the day. Nor can the Member of Parliament and sometime Chairman of the Automobile Association Mr C. D. Rose have had much ground for complaint after being timed at almost twice the legal limit (26 mph – though this did not stop him complaining). Rolls' chauffeur was also caught, but pity Mr Harry Hampshire from Slough, who was fined for doing just 8 mph on his motor cycle combination (to which special speed limits presumably applied).

Editorial coverage in the *Chronicle* was hostile towards this new role for the police, grumbling along the familiar lines of 'why aren't they out arresting real criminals?' The editor's wish sort of came true eventually, when the Road Traffic Act 1930 removed the need for police to waste time with speeding motorists, by abolishing speed limits altogether. This was done in a year when there were already a record 7,305 road fatalities nationally, half of them pedestrians, of whom three-quarters were killed in built-up areas. But as Lord Buckmaster, the former Lord Chancellor put it, 'The existing speed limit was so universally disobeyed that its maintenance brought the law into contempt.'

It will come as no surprise that the result of this deregulation was a further increase in speeds and in road deaths, such that the then editor of the *Chronicle* was by 1933 calling for the reintroduction of speed limits (10–15 miles an hour in villages, 20 in towns) along with a host of other measures, including severer penalties and more driving bans, tests for drivers (and retests for those involved in accidents), more footpaths, road safety surveys and safety propaganda. Reading's Chief Constable was called upon to reintroduce a local speed limit in Reading, but he recommended against it, arguing that, in town, buses and trams force other vehicles down to a certain speed, while:

> ... on the main roads continual patrol is undertaken by the motor transport department of the force. Any suggestion of speed in cases of accidents results in proceedings for careless or dangerous driving being considered. I am of the opinion that a speed limit would not be entertained by the Ministry of Transport and I believe that if one could be imposed considerable congestion would ensue.
>
> *Reading Mercury*, 5 August 1933

The deterrent effect of this police presence on the roads may be judged by the size of the motor transport department of the day (for which, see the chapter on crime and punishment and the photograph of them). For good measure, at the same meeting the Chief Constable rejected the idea of pedestrian islands to make crossing Broad Street safer, on the grounds that they would interfere with the free flow of traffic. But whatever the Chief Constable might think, at least part of this editor's wish was soon to be granted, when the Road Traffic Act 1934 reintroduced a speed limit (30 mph) in built-up areas, along with driving tests for new drivers and strengthened legislation on insurance for drivers. From 1937 it even became legal for new cars to have speedometers.

But pedestrians kept on getting knocked down:

> The suggestion that Reading might have subways to enable foot passengers to cross the roads in safety was made at the inquest on Friday last week on Daniel Bartlett ... he was knocked down by a motor car at the Cemetery Junction (referred to as a death trap).
>
> *Berkshire Chronicle*, 5 January 1934

In his annual report for 1933, the Chief Constable recorded twenty deaths involving motor vehicles and 222 non-fatal accidents for the year in Reading, and lamented the 'blame everyone else' attitude that seemed to prevail:

It must be a matter for regret that in spite of all efforts the number of fatal accidents steadily increases. Every suggestion for safety is carefully considered, yet a study of the foregoing tables [of accident statistics] shows that many of the accidents could have been avoided by a little care and consideration. Representatives of pedal cyclists and pedestrians are critical of any action which they consider affect what they claim to be their right, while certain representatives of motor car owners demand legislation to deal more stringently with cyclists and pedestrians.

Annual report of the Chief Constable of Reading for 1933

But at least the police were doing their bit to manage the traffic. By 1933 there were no fewer than eight sets of traffic light signals installed in the town (including the manual set at Cemetery Junction, operated by a police constable). With three more on the way, all the town's most important junctions would soon be covered, and the Chief Constable could report that 'the motoring public are now becoming more familiar with this method of control' – and most motorists even obeyed them. One thing that was needed was a road network fit for the growing volume of traffic, and this was one of the topics addressed by a public inquiry held in November 1933:

The first of the inquiries of the Ministry of Health under the Town and Country Planning Act has been held in this area this week. The particular inquiry related to the South Oxfordshire area adjoining the Reading Borough boundary ... It is too late to consider whether town planning is advisable or not. Public opinion has so far supported town planning ... A ring road is planned for Reading. It is necessary therefore to have a line for this road which has been agreed upon both by Reading and the outside authorities, as the ring road passes outside the Borough boundary and is intended to link up with the arterial roads ... the South Oxfordshire area adjacent to Reading will always primarily remain of a residential character and be of a woodland type ... It is improbable that there would ever be any industrial development.

Berkshire Chronicle, 17 November 1933

Joint planning with the adjoining areas of Oxfordshire had been ongoing since 1928, and one of the requirements of this new road would be a new bridge across the Thames, to the east of central Reading. Ninety years later, we are still waiting for consensus to break out on this proposal, for reasons explained elsewhere in the book. As for the road itself, it was to be not just an ordinary carriageway, but a parkway, a 300-foot linear strip of land, most of which would be given over to a park, but with a 60-foot carriageway running down the middle of it. It would go around the outer built-up area of Caversham, and link to a new Reading to Oxford road. The public were asked to believe that 'the effect of the Committee's proposals should be to leave the countryside in outward appearance very much as it is today'.

Though the committee's additional proposal, for an additional 9,856 houses in the area, does rather raise the question of how this would be achieved. Fears were expressed in some quarters of a continuous ribbon of development along the northern slopes of the Thames between Reading and Henley.

But if Caversham was to be well endowed with a new ring road, it seemed one would hardly be able to move without stepping on tarmac in south Reading. The town planning scheme for Reading, south of the Bath Road, was published early in 1934:

It is proposed when the necessity arises to have three roads circling the town. The first is an inner ring road which, in this scheme, will run over Bath Road near Honey End Lane, through Manor Farm over Basingstoke Road to Northumberland Avenue, up that road to Northcote Avenue, thence into Shinfield Road. Further proposals in regard to this road are to continue it along the present line of the drive in Whiteknights Park and through Church Road and Pitts Lane, Earley into London Road, but the eastern part of the road is a matter which we hope will be included in the town planning scheme for the Wokingham Rural District. Then to the south of this road and about a mile away it is proposed to have another ring road which, as far as it lies within the Borough, will run along Manor Farm and the housing estate. Lastly the scheme provides for the south Reading section of the outer ring road, which is intended to circle the whole of Reading, but which will be largely outside the boundaries.

Berkshire Chronicle, 5 January 1934

Councillor Bale assured the citizens of Reading that the new town planning scheme would make Reading 'a very lovely place to live in'. But never mind about parkways and ring roads! A few months later the editor of the *Chronicle* had seen the future of motoring – and it was Italian:

The frightful slaughter and injury on the roads cannot be allowed to continue without an effort to stop it, but it would be a mistake to tinker with the question of the roads… Our roads are rapidly becoming motorways, with cars running on them capable of speeds as fast as an express train. Yet the precautions against accident are totally inadequate. We allow all sorts of vehicles to be used on the roads, some without the protection of lights, and pedestrians who are not allowed to cross railways are a law unto themselves upon the roads. Unsuitably surfaced, at times badly winding and even narrow are the roads, with frequent side turnings. What the country has to do is to make real motorways. If it takes a leaf out of Italy's book it will make special roads between important points and have neither crossings nor turnings left or right. Other roads, especially main roads, it will make as far as possible into motorways with every device that human ingenuity can devise for safety … Quick and cheap transport has brought many blessings. It has come to stay. To hamper it and restrict speed unnecessarily are retrograde steps.

Berkshire Chronicle, 13 April 1934

If the transport planners were anticipating a massive growth in car ownership and traffic, they failed to relay the message to their house-building colleagues, for the latter utterly failed to cater for the car. In 1949, less than 8 per cent of British households owned a car. The previous year, the Council had conducted a survey, to see how many of their tenants

on the Whitley estate might eventually require a garage. The answer they came up with was twenty-three garages for 2,500 tenants. But by 1991 66.8 per cent of all Reading households had at least one car and 22.2 per cent had more than one.

Traffic Management

The Council of the 1950s had a very different idea of traffic management to our modern one:

> As post-war traffic grew, there were … calls for the pedestrian crossings on the Friar Street/West Street junction to be removed, because they impeded the free flow of traffic, and plans for easing the traffic problems of Broad Street included not pedestrianisation but railings to keep the walking public back out of the way of the motorist.
>
> Hylton (1997), page 10

The *Berkshire Chronicle* wanted the same principle extended a lot further in 1951:

> One of the most important matters concerning the highways is to keep the traffic moving … mobility is vital in this hurrying age … it is equally obvious that the greater the number of crossings, the greater the congestion and delay. This is particularly noticeable in Broad Street, Reading, on a busy morning. Each new advance in quickening the life of the community … brings with it a parallel restriction of right and privilege. Those who find it necessary to cross the highways of busy towns must bow to the inevitable; spare a little more time to reach safe venues, and avoid hesitancy. It is better not to join the cavalcade who always seem to be fearing that they will be late for their accident.

All sorts of novel ideas were put forward to improve road safety. At one meeting of the Council's road safety committee, the mayor, no less, suggested the introduction of one-way streets, and lay-bys in which buses could pick up and drop off passengers without holding up the other traffic. Another member of the committee even suggested putting bumps in the road to slow down traffic, but was told that the idea was impracticable. In a similar vein, American-style parking meters were proposed, until it was discovered that the Council had no legal powers to install them. One other response to the congested highway network was to introduce 'no waiting' streets, but this led to Conservatives complaining that the Council was driving cars out of the town and 'harassing the poor wretched motorist'.

As for the Chief Constable, he wanted stricter testing of learner drivers and testing of some kind for older cars, this being the pre-MOT test days when old bangers continued to be driven long after they had become horribly un-roadworthy. One notable exponent of both bad driving and un-roadworthy vehicles was the Deputy Coroner for Berkshire, who managed to knock down two cyclists, before mounting the pavement and demolishing a lamp-post. When the police established that his car had virtually no brakes, he explained that he used the gears to slow down.

In 1972 the Department of the Environment got its Traffic Advisory Unit to look at the problems of Comprehensive Traffic Management in Reading. Among their findings they concluded that the town's most serious congestion occurred at the junction of the A4 London Road and the A329 Wokingham Road, known locally as the Cemetery Junction. At that time, a gyratory system with a 'hambone' layout was in operation which, despite the 'priority from the right' rule, required the regular assistance of two policemen at peak times to keep traffic moving. The junction's capacity had been calculated at about 650 vehicles per hour, while the number trying to get through it was an estimated 920 – 40 per cent more. Not only were the police required to keep it moving, there was also a good deal of rat-running through neighbouring residential streets. More generally, police officers were a significant part of the town's traffic management, with between seven and twelve of them being required to control some of the busiest junctions at peak times, despite advances like the introduction of traffic lights.

Investment in Roads

It was in the 1930s that the seeds of an idea were sown for just such a high-speed road as the then editor of the *Berkshire Chronicle* had described, linking London and South Wales – and bypassing Reading. In this next part of the chapter we will look at this, and other recent major investment in roads that have had an effect on the motorists' ability to move around – or past – the town.

Before the Reading by-pass (or the M4, as strangers to the area prefer to call it) was built, westbound motorists out of London had little choice but to take the A4. This led them through the very centre of Reading, and at peak times such as the holiday season it could take an hour and a half to make the journey from the Wee Waif near Twyford (where the traffic queue often started) to Theale (where you left the congestion of the built-up area to try your luck with rural congestion). The unfortunate Reading residents whose houses fronted on to the A4 lived in a permanent hell of exhaust fumes and traffic noise, while those seeking to use their cars for local journeys found themselves caught up in the through-traffic chaos. The coming of the M4 – whatever its detractors may say about its present-day congestion – transformed Reading's environment and underlined the town's attractions to investors.

The negotiations over the alignment of the M4 were long and complicated and had some of the alternative routes (including some long favoured by the government) materialised, Reading would have been a very different place today. It was as long ago as 1938 that the County Surveyors' Society published plans for a national road network that included a London–South Wales motorway. It largely followed the line of the A4 and was essentially a series of by-passes around the principal towns en route. The post-war Labour government included the scheme in its ten-year programme for roads, published in 1946.

However, even if the government of the day had had the money to build it, they did not have the legal powers to do so. Not until the Special Roads Act was passed in 1949 were they legally able to exclude certain types of unsuitable traffic (such as pedestrians, cyclists and animals) from such a road. By 1956 the London–South Wales motorway had

been made one of the government's five road-building priorities, and planning could start in earnest. By this time, the by-pass approach to the road had been rejected, as being too indirect and not offering the standard of engineering by then expected of a motorway.

Motorways were typically developed in sections as a series of freestanding projects, some sections of which were more straightforward than others. In the case of the M4, the Maidenhead and Slough sections had had their routes identified before the war, and were protected in the county Development Plans of the day. By October 1960 the entire route from London to Maidenhead had been agreed.

The section between Maidenhead and Swindon, within which Reading fell, was anything but settled. The pre-war alignment had been the so-called Bath Road route, which took the road to the south of Reading, Newbury and Hungerford, through the Savernake Forest and south of Chippenham. When the Minister came to take a serious look at this alignment in the 1950s he decided there was a lot wrong with it. First it was circuitous – about five miles longer than an alternative route to the north. Ministers were very keen on short, direct motorways, partly because they cost less to build (and even in those days, a rural motorway cost between £600,000 and £700,000 a mile to build) but also because traffic making shorter journeys saved on the nation's fuel import bills. Second, the road went too far south to be of any use to the major town of Swindon. Third, there were engineering difficulties on a stretch of swampy land to the south-west of Reading. This meant that virtually the whole of that section of road would have to be on an embankment, making it harder (and more expensive) for side roads to bridge over the motorway. Fourth, the route ploughed through the attractive Savernake Forest. Fifth, it would attract local traffic that should have stayed on the A4 and sixth, it would involve a difficult climb over the Marlborough Downs.

In November 1960 Transport Minister Ernest Marples announced that he was appointing consultant engineers to carry out surveys, and their preliminary reports the following spring bore out the Minister's concerns about the Bath Road route. They also produced alternatives – a northerly route through the Vale of the White Horse, running north of Didcot and Swindon, and a (shorter) direct route across the Berkshire Downs that served both Swindon and Reading (but not Newbury, which was by then under preliminary consideration to receive large amounts of growth). However, the important thing from Reading's point of view was that both alternatives went to the north of the town. Within Berkshire itself local authority opinion was divided. Those authorities unaffected by the options were inclined to raise no objections to the Minister's preferred direct route, while others favoured the Bath Road option.

Reading was particularly appalled by the new northerly options. The Borough argued that the vast majority (a later traffic survey would put it at almost 90 per cent) of the town's locally generated traffic originated to the south of the town's main traffic pinch-points – its railway and river bridges. If that traffic wanted to use a motorway to the north of the town, it would have to reach it via those pinch-points. Congestion would soon become intolerable and sweeping changes would be needed to the town's traffic circulation. The Ministry challenged this argument. According to their calculations, no less than 32 per cent of Reading's industry (as distinct from its overall traffic generation) lay to the north of the railway line. Traffic originating from the south of that point had the option (they said) of joining the motorway by driving to interchanges to the east of Reading, at Twyford, or to

the west, at Purley. Even making the rather large assumption that the Government's figures were correct – and relevant – this seemed a very odd argument:

> To plan in such a way as to prevent one third of Reading's traffic from travelling through the town centre from north to south was more important than avoiding the costly arrangements that would be necessary to prevent two thirds from moving along the same roads in the opposite direction.
>
> Gregory, page 273

The gentleman responsible for making this extraordinary case for the government was shortly afterwards moved to the Admiralty. However, it seemed decisions were being influenced by other factors beyond Reading's control. Wherever one aligned the route to the west of Reading, it seemed to affect one or another of the scenic areas with which the region was littered – such as the Savernake Forest, the Marlborough Downs, the Berkshire Downs, the Oxfordshire beech-woods, or the Vale of the White Horse. Sure enough, well organised and articulate pressure groups sprang up to protect each of these areas and send the road elsewhere. They each combined an amenity case with more or less ingenious arguments aimed at the civil engineers – the danger to traffic from fogs in the Vale of the White Horse, from frosts and cross-winds on the Berkshire Downs, from gradients on the direct route slowing up lorries until their journey became shorter in miles but longer in duration. The cost of additional bridges to cross the Thames, or of additional ground-works (even down to the need for fencing to keep deer off the road) cancelling out any savings in mileage terms were also being prayed in aid. But perhaps the most ingenious claim of all came from Mr G. A. Jellicoe of the Royal Fine Art Commission, who said that steeper gradients on the revised direct route would cause diesel lorries to emit more toxic fumes, reducing visibility and making overtaking more dangerous. There was a marked similarity between some of these arguments and those used by some of the protestors in the long and heated debate over the coming of the Great Western Railway to Berkshire in the 1830s.

The government struggled to reconcile these competing arguments, trying to balance considerations which could be conveniently quantified with those that most certainly could not, as the pressure groups sought to cast them as soulless bean counters:

> We feel, in short, that the engineers in the Ministry of Transport should not be allowed to choose a route which, while it may offer advantages of convenience and low compensation, will annihilate for ever one of the fairest parts of the nation's heritage of beauty.
>
> Downs protestors, letter to *The Times*, 27 April 1962

Heroic attempts were made to find a compromise. A variation on the Bath Road option, backed by the Ministry of Housing and the local government, had the southern alignment past Reading turning north-west to run between Newbury and Hungerford, joining up with the Minister's favoured direct route near Swindon. This was rejected on the grounds of its length and some engineering difficulties associated with it.

The Ministry of Transport's consultants may have thought they were onto a winner with their revised direct route, launched in January 1963, which appeared to address

most of the concerns of the environmentalists, except that it aroused even more furious opposition than its predecessors. None of the original objectors were won over by it, and it raised new objections where none had existed before. One set of objections it did not even try to address were those of Reading, for not only did the road still pass to the north of the town, it came closer to it, limiting the scope for northward expansion of the urban area. If it had to go north, in the Borough Council's view it should at least go as far north as possible.

One of the few bodies who appeared to be ever-compliant to the government's will was Berkshire County Council, who again raised no objections to the revised scheme and seemed primarily concerned to get the business resolved as quickly as possible. But even their compliance must have been shaken by the publication in February 1964 of Reading's detailed transport study, which shot to pieces the Ministry's claims about the transport effects of the northern alignment of the M4 and confirmed the Borough's dire predictions of its consequences. The Council was now able to claim that such drastic changes would be needed to Reading's town centre transport arrangements that they would more than cancel out the saving from building a shorter motorway. Among other things the Borough Council sought, in compensation for a northern alignment, a link road, running from Calcot to the west of Reading, passing round south Reading to the Twyford/Sonning area in the east – about ten miles' worth of road at £425,000 a mile. The Minister retaliated by claiming that Reading was trying to use the motorway scheme as an excuse to solve its local traffic problems.

But other new arguments began to emerge in 1964 and 1965 as to why a different solution to the problem might be needed. The new route needed to give better access to the northern part of Newbury, where the South East England study (published in February 1964) had now envisaged large-scale growth of a city eventually housing up to 250,000 people. A route going south of Reading also meant that traffic from the north and west, bound for the extreme south-east of England including the new Channel Tunnel terminal (the principle of the tunnel having been agreed by Britain and France, also in February 1964), could avoid London. New figures had also shown an unexpectedly large increase in road traffic between 1960 and 1964, so much so that the existing Slough and Maidenhead by-passes, built years before to sub-motorway standards, would soon be overloaded. The Reading section of the M4 was supposed to feed into these by-passes and a second motorway link between London and Reading would soon be needed. The likely route for this would be to the south of the existing by-passes. In retrospect, one might argue about the relative importance of these individual considerations to the final decision but, together, they were a considerable impetus for change.

On 9 August 1965 the Ministry of Transport issued a press release, announcing a Special Road Scheme for the Maidenhead to Swindon section of the motorway. This now took the road south of Reading before swinging north-westward to pass north of Newbury. The new route involved building some five miles more of motorway than the Direct Route, although a car travelling along it from Maidenhead to Bristol would, thanks to the magic of highway engineering, travel only three miles further.

As well as these practical considerations, the new Minister of Transport (there had been a change of government in 1964) was keen to show that he had also listened to the

environmental arguments. Part of the new route passed through land already disfigured by gravel working and hence involved little loss to amenity (could this have been the same land south of Reading, previously ruled out as 'waterlogged and presenting engineering difficulties' under an earlier option?). New information revealed hitherto unexpected and esoteric problems with the other options; for example, research had revealed that a motorway which combined the maximum permitted uphill gradient with a left-hand curve had an accident risk four times that of other stretches of motorway – and guess what characterised at least one of the opposing schemes?

But no matter – most of the major players, including Berkshire and Wiltshire County Councils and Reading Borough Council had withdrawn their objections to this revised scheme. Even its biggest detractors, while not delirious with joy at the scheme, conceded that it had made the best of a bad job. As one junior minister pointed out, at least nobody could complain about undue haste in choosing a road line that had been under discussion since 1950.

So it was that a junior government minister by the name of Michael Heseltine was despatched to Holyport just before Christmas 1971, to open the final stretch of the M4, between there and Chippenham. His speech made much of the fact that motorists could now travel from London to Bristol in around two hours. Heseltine, who lived in Wales, had had a preview of the road, being allowed to drive down it before its official opening. He mentioned the fact in his speech:

> … For the first time I have driven almost entirely by motorway from Hyde Park Corner to the city of Cardiff. I was carrying a message from the Lord Mayor of one capital to the Lord Mayor of another. It seemed to me there could be no more fitting gesture to stress the potential of this magnificent road, this new Welsh Way, this vital part of our nation's system of communications.
>
> *Reading Chronicle,* 23 December 1971

Welsh Way? What was the man talking about? This was the Reading by-pass! Fortunately, the Chairman of Berkshire County Council, Alderman Richard Seymour, had a firmer grasp on the real priorities, saying, 'We can only hope that it will result in the alleviation of the appalling traffic conditions which have existed on the A4 for so many years.'

Around six million cubic yards of gravel had gone into constructing this last section of the motorway, most of it extracted from 370 acres of land between Theale and Holyport. One lasting souvenir of all this extraction is the lake at Dinton Pastures. Within the Reading area, the coming of the motorway age affected people in different ways. The fact that there were initially no motorway services between west London and the Severn Bridge meant that businesses near the motorway were doing a roaring trade. The petrol station at Three Mile Cross was doing two or three times its normal business and the Tower Café at Theale maintained its level of sales, despite much of the traffic having switched from the A4 to the motorway.

Within Reading itself the effects were dramatic. A 25 per cent reduction in east–west traffic had been forecast, but traffic surveys showed the true figure was more like 60 per cent (and even this figure was inflated by the pre-Christmas traffic rush). But north–south traffic

through the town got much worse, as the residents of Caversham and South Oxfordshire flocked to use the motorway. As predicted, queues built up at the pinch points and, according to the Councillor for Whitley, the M4 was a disaster for his constituents, as the Basingstoke Road approach to the motorway ground to a halt. But the real beneficiaries of the motorway were the long-suffering people who lived along the A4. For the first time in years they could enjoy a decent night's sleep, even with the windows open. Some of them found it hard to adjust to the silence. But to the south of the town, a whole new group of residents began to find out what it was like to have up to 4,000 cars an hour thundering past their homes, day and night.

The Inner Distribution Road

It is impossible to introduce a new road on this scale into an existing town without upsetting the environment. However, at Reading every effort has been made to minimise this disturbance.

Reading County Borough, 1969

The 1953 Development Plan documented the trouble the town was having in coping with the age of the motor car and took some early faltering steps towards a ring road:

Almost all the traffic which travels to the town centre as well as most through traffic desirous of travelling along Oxford Road passes into King Street/Broad Street with the usual congestion and inconvenience which generally accompany these conditions, such as difficulty of parking, loading and unloading, interface with pedestrians in shopping areas and with public service transport; such an indiscriminate mixture of through and local traffic causes delay and often danger.

In the present economic conditions, large-scale redevelopment of the central area, or other obsolescent areas, is not contemplated, but provision has been made in the plan for a new road… to be constructed from Queens Road through Gun Street to relieve the traffic flow in King Street and Broad Street by making use of the reasonably wide Queens Road, which is at present relatively little used. The new road could ultimately form part of an inner ring road around the town centre, which for its completion would require new roads at the eastern and western ends of the town centre to provide for the north/south traffic, viz. west of St Marys Butts between Castle Street, Oxford Road and Caversham Road, and East of the Market Place between Reading bridge, the Forbury, Kings Road and London Street.

The same traffic study that argued the Borough's case for the M4 motorway going to the south of Reading also came up with the idea of an Inner Distribution Road (IDR), to relieve the worst effects of the traffic on the existing town centre road network. As its name implies, there was also supposed to be an outer distribution road, which never got built. So, as a 1969 report explained, the IDR was, in the short-term:

... both a town centre by-pass and the town centre distribution road. With the longer-term development of a comprehensive scheme of urban road development the IDR will revert to its long-term function of town centre distributor only ...

Eventually the road will serve a town centre of nearer to 250,000 people than Reading's own 126,000, for which the existing streets have already proved inadequate.

So, if the IDR sometimes seems overwhelmed by the volume of traffic, bear in mind that it is being asked to do a bigger job than that for which it was originally designed. As a result, a lot of through traffic gets drawn through the centre of Reading, which does not have direct through routes but which takes traffic through complex junctions with local traffic merging or leaving the route. This was still true according to the Reading Independent Transport Commission in 2008, who found that over half the traffic coming through the town centre started and finished its journey outside the Borough, and that the same was true of no less than 98 per cent of HGV traffic.

The initial version of the IDR was a relatively modest affair, involving the extension of the existing Queens Road. A more ambitious scheme was published in 1966, for a fully grade-separated dual carriageway, drawn tightly around the central business district. Early versions of this would have involved extensive environmental damage, the western part running a dual carriageway along Gun Street and Minster Street and taking out most of the eastern end of Castle Street, while the eastern section cut a swathe through the Forbury Gardens.

There were protests, and the western end of the scheme was altered, loosening its grip on the central business district, saving some of Castle Street, avoiding some of the worst effects on London Street and enabling the Council to create a 21-acre Comprehensive Development Area in the run-down area around Hosier Street. This Development Area would become the site of the future Civic Centre, the law courts, the Hexagon, and a development that started life as the Reading Commercial Centre, became known as the Butts Centre and is today the Broad Street Mall. The redevelopment of this area was enshrined in a revision to the Town Map in 1965. This part of the IDR, which today we tend to regard as something of a dismal canyon to drive through, was praised as 'particularly well designed' by the Ministry of Transport at the time, and was completed in 1969. The contractor responsible was predictably optimistic:

> Commenting on the first two stages, he said that he had heard them described as 'a scar through the landscape'. But as time went on and landscaping continued he hoped that the road would prove to be an attractive part of Reading as well as helping with the movement of traffic.
>
> *Reading Chronicle*, 5 February 1971

The environmental impact of the proposed eastern part of the IDR was much harder to live with. It was to go from the Queens Road, over the Kennet and the Kings Road, and through the archway under the new Prudential building to the east of Market Place. It would then pass through the middle of the Forbury Gardens, to join the Forbury near the gardens. Pedestrians would have a bridge between St Laurence's churchyard and what was

left of the Gardens, and the Maiwand Lion would be relocated onto that bridge. There would be a vast roundabout at the junction of Vastern Road and Forbury Road. Phase four would pass to the south of (in front of) the railway station.

In 1973, just before the Borough Council lost its highway powers to the County Council in the local government reorganisation of 1974, they abandoned phase three. It was subsequently deleted from the County Council's highways programme. The dual carriageway ended for years in the notorious ski-jump near Mill Lane, and traffic coming southwards down Caversham Road had to be diverted along Mill Lane to reach Queens Road. The town's inadequate highway infrastructure became one of the arguments advanced by the council to try and stem the flood of office development.

It took until 1977 for the County Council to replace the original IDR proposals with a more modest (and less damaging) substitute, known as the Queens Road Alternative. This took a wider sweep around the town centre and made more use of existing road alignments. However, even this was too ambitious for the cash-strapped highway authority of the late 1970s. It got dropped from the programme and, by 1980, all the County Council proposed for central Reading were some small schemes on the town centre approaches and some central area junction improvements.

These were clearly an inadequate response to the 1983 traffic forecasts, which showed that existing and committed development alone would lead to an increase in demand of at least 50 per cent by the turn of the century. The County was forced that year to adopt a two-stage strategy for Reading – completing the IDR and carrying out a study of major radial routes, with a view to upgrading them. The first stage, the Queens Road Alternative, was to be completed in four stages by 1989. But even this new strategy could not hope to cope with unrestrained traffic growth. By the mid-1990s, some of the IDR junctions would already be getting overloaded again. The rest of the growth would have to rely upon increased use of public transport, traffic management and measures to spread peak-hour flows.

More recently, an idea was put forward to squeeze 15 per cent extra capacity out of the IDR by making it one way, anti-clockwise, around the town centre (anti-clockwise would mean that the bus doors opened facing into the town centre, rather than out of it). The public were generally unimpressed with the idea, fearing longer journeys (meaning more noise and pollution), the development of rat-runs and damage to businesses.

The Cross Town Route

The Cross Town Route (CTR) was devised as a complement to the IDR. Its aim was to reduce pressure on sections of the IDR and on the London Road/Kings Road and Oxford Road radial routes coming off it. It was also claimed that the CTR would make a Third Thames Bridge – were one ever built – cost-effective, by providing it with links into the town centre. It would also increase traffic on the A329 (M), making the most of its capacity, but would also mean more traffic on the already heavily used Vastern Road and Caversham Road. It would have run from an extension of the A329 (M) at Suttons Park, north of the railway, through Kings Meadow and along Kings Meadow Road, to join the IDR at Vastern

Road/Reading Bridge. This eastern part would then link, via the existing Vastern Road, Caversham Road and Richfield Avenue, to connect to the western part of the route. This latter could be a new link, north of the railway, from Richfield Avenue to Scours Lane, or could make use of the existing road network, via Cow Lane Bridges (once widened) and Portman Road.

The Cross Town Route was timetabled to start in 1988, but was bitterly opposed, among others by the Reading Riverside Group. They objected to its environmental impact on the riverside, especially at the mouth of the Kennet, where it affected the setting of a Brunel railway bridge and the historic listed horseshoe bridge. It also took away recreational space used by the densely built-up Newtown area, would add to pollution and noise and would harm wildlife. Some on the Borough Council did not see it that way – for them it was an opportunity to 'tidy up' this unruly piece of nature around the Kennet mouth. As the Performance Review Sub-Committee put it in 1975, 'It is not known whether any car parking is to be provided in the vicinity, but the possibility should be investigated in detail.'

From a government point of view, the scheme was expensive (costing £13 million in the 1980s) and failed to meet their cost-benefit guidelines. There were also fears that it, and a third Reading Bridge, would together attract more traffic into the town centre. It was eventually dropped in 1991, but reappeared in the form of a proposal for a public transport only route in 2006. The road scheme, by now costed at £22.9 million, was linked to a £3 million 370-space park and ride site at Broken Brow, near the Wokingham Waterside Centre.

The A33 Relief Road

As we have seen, areas of south Reading bore the brunt of increased traffic, as motorists were drawn southwards through the town to join the M4. The A33 Basingstoke Road was probably the worst affected of all. An opportunity to ease this congestion presented itself when the developers of what would become the Green Park business park, to the west of Basingstoke Road, offered to build a dual carriageway between M4 junction 11 and Rose Kiln Lane to serve their development. As we will see elsewhere, the relocated Reading Football Club also contributed to the cost. The northern section of the new road, linking Rose Kiln Lane and the Inner Distribution Road, via the former Coley railway goods yard, was publicly funded, and was originally designed as a single carriageway. The new road reduced traffic in the residential areas to the east of Basingstoke Road by an estimated 60 per cent.

One consequence of providing additional capacity on the routes down to the motorway was that M4 junction 11 became severely overloaded, and work started in 2008 on a £65 million junction improvement. They turned the existing bridges over to exclusive use by pedestrians, cyclists and buses, and built a new four-lane junction around them. The scheme was opened in the spring of 2010.

And Another Road

There is another road which, though not physically in Reading, is very much a part of the daily life of many Reading people. I refer of course to the M31 motorway. In case you are puzzled, you may know it better as the A329 (M), the only part of said motorway to be completed. The original idea was to provide a motorway link between the A4, east of Reading, and the M3, somewhere near junction 3. Then someone noticed that, if the road were extended to join the M25 somewhere near its junction with the A3, eastbound traffic on the M4 bound for the south-east could save about ten miles and avoid the most heavily congested part of the M25. This helps to account for the very high-specification junction between the M4 and the A329 (M), which was originally designed to be a junction between two full-blown motorways.

The A329 (M) formed part of a grand strategy for parts of Reading's traffic. One part of this was the Cross Town Route, discussed earlier in this chapter. Another involved attaching a third River Thames crossing to the northern end of the road. Reading and the Berkshire authorities have consistently supported this. According to one estimate this would remove 55,000 car trips a day from the streets of central Reading. The Oxfordshire authorities have equally consistently opposed it, on the grounds that it would be one step nearer to turning the A329 (M) into an outer substitute for the M25. In their view, traffic moving between the north-west and the south-east would be encouraged to use this route to by-pass the busiest part of the M25. Greatly increased volumes of traffic would be discharged off the bridge and onto the wholly inadequate rural roads of southern Oxfordshire. As long as one local authority controls one bank of the Thames, and the other is under a different authority, the stalemate seems doomed to continue.

The A329 (M) opened in three phases, between 1973 and 1975, and links the A4 at Reading with the southern and western industrial areas of Bracknell. The opening of the second phase was delayed by the collapse of the Loddon Viaduct on 24 October 1972, in which three people were killed and ten injured. The northernmost part of the road was downgraded from motorway status to an A road in the 1990s, to enable the County Council to run a park and ride bus service down the hard shoulder.

Have We Progressed? Dirty Driving and Safety Fast?

The earlier comments about the dusty state of the cars in the 1900 rally remind us that the early roads in Berkshire, as elsewhere, tended to consist simply of rolled stones, which were slippery and prone to breaking up in winter and extremely dusty in dry weather. In the early days of motoring Berkshire County Council was only responsible for major roads and bridges. In 1904 they introduced an improved system of road maintenance, under which there were permanent road gangs assigned to each 4-mile stretch of county road. Even so, the County Council did not get its first tar sprayer until 1909. Only once roads were tarred could such basic traffic management measures as painting a white line down the middle of the carriageway be employed. Not that they did much good, if this plaintive comment from the County Surveyor in 1937 is anything to go by:

Only a small percentage of motorists really observe them [white lines]. I am of the opinion that it would tend to greater safety if it were possible to compel motorists to keep in the nearside lane except when overtaking.

Quoted in *Berkshire County Council*, page 12

Berkshire's first white lines appeared as long ago as 1922, but they really came into their own during the Second World War, when they were invaluable in showing blacked-out motorists which side of the road to drive on. Even so, some wartime Reading motorists mistook the nearside kerb for the central white line, and ended up driving along the pavement (at least until they encountered unexpected trees, lamp posts or pillar boxes where the open road should have been).

The numbers of vehicles on the road increased by 35 per cent between 1930 and 1936, and drivers were not even required to take a test until 1935. Small wonder the national death-rate from road accidents in that year was almost four times the present level (6,502, compared with 1,713 in 2013 – and this despite the vast increase in the volume of traffic since 1935). But are our journeys around Reading any quicker now than they used to be? The following gives one cause to wonder:

In 1889, when the speed limit for steam vehicles was 4 mph, the average speed of all vehicles was around 10 mph. In 1998, with a speed limit of 30 mph in urban areas the average speed of all vehicles in peak hours was still around 10 mph!

Ibid. – page 13

Will the same be true in another century's time?

Office Town

The transformation of Reading into an office town began in the war years and before. The town had a population of 100,000 in 1938 but by its wartime peak in 1942, this had risen to almost 140,000. Reading became so crowded that it was one of the first places (in October 1941) to become a 'closed town', where a Lodging Restriction Order meant one needed a permit from the Billeting Officer to move there. Some of the newcomers were ordinary civilian evacuees, but a considerable number were civil servants, brought to Reading to staff the regional and other offices of government departments that had been decanted to the town for the duration of hostilities. As Burton explained:

> Before the war, Reading was primarily a commercial centre, but with a growing industrial interest. During the war the number employed in industry increased, while in the retail trades and those employments connected with goods and materials in short supply, the numbers declined.
>
> Of all these changes ... the most significant was the rapid increase in the number employed in national and local government service. The evacuation of Civil Servants from London to Reading began just before the outbreak of war, but the designation of Reading as a regional capital meant that the increase of Government offices in the town would be more systematic and more permanent. The opening up of official schemes of control and restriction, from food rationing to building licences, meant that the number of persons in both local and regional government was greater than it had been before the war. The peak was reached in 1947 ... By 1950, national and local government service closely rivalled the distributive trades for pride of place as a major employer in Reading, while the proportion employed in industries declined to below the 1938 level.
>
> Burton, page 20

Even so, it was not originally planned for Reading to become a major centre for offices and high-tech industries after the Second World War. Between 1948 and 1953 the Board of Trade confirmed three times that the town suffered from an acute labour shortage of both men and women workers, which reinforced the council's view that future industrialisation should be limited to meeting the expansion needs of existing employers. In September 1951 only 498 people were unemployed – 0.7 per cent of the insured population – and there were unfilled vacancies for 1,083 males and 383 females.

The 1957 Town Map confirmed that there should be low growth in Reading, with the bulk of expansion locally being concentrated in the new town of Bracknell. Accordingly, it allocated just 115 acres of new land in Reading for industry, 310 acres for housing (directed mainly at meeting the housing needs of the existing population, with its waiting list of 3,750 households) and no specific provision at all for office development, as the Town Map said:

> It is the intention of the Council that the principal business and shopping areas for the town as a whole shall remain substantially as they now exist, with some extension towards their outer fringes. The principal addition of this nature is the allocation of an area north of London Road and west of Princes Street for a future Civic Centre.

The bizarre idea of a new civic centre some three-quarters of a mile outside the town centre was soon dropped. However, the seeds of Reading as an office centre had definitely been sown; Reading had already had a nucleus of clerical staff before the war, being an easily commutable dormitory of London. As early as 1921 2,854 of Reading's labour force had listed their occupation as clerks or draughtsmen (though they were still at that stage outnumbered by the more than 3,000 who were domestic servants). The designation of Reading as a university town in 1926 and the university's subsequent growth also created a new source of white-collar employment and, as we saw, the wartime influx of civil servants added to their numbers. Post-war government contracts for military hardware, awarded to Thames Valley firms, laid the foundations for a high-tech industrial sector in the area.

The authorities did not foresee the dramatic decline in manufacturing and the corresponding growth of the service sector. In 1960 the government was surprised to discover that the Outer Metropolitan Area, in which Reading sat, was the fastest-growing area in the British Isles, far outstripping all official forecasts.

No major office development was approved in post-war Reading until 1954, when building licences were abolished and a period of relative laissez-faire for development followed. Most of the first schemes in Reading were replacements for existing office buildings (taking advantage of the 10 per cent additional floor space allowance that the redevelopment rules of the day permitted). These included the General Accident building on London Road and the Norwich Union building on Station Road. The General Accident building happened by stages. In December 1956 General Accident got permission to use the existing (formerly residential) building on the site for offices. This was granted purely 'on condition that no alteration is made in the external appearance of such premises, the reason for such condition being the need to preserve the amenities of the locality'.

The Town Planning and Buildings Committee declined to comment on General Accident's well-known wider aspiration, to completely redevelop the site with a new office block. Did they really think that this consent for change of use would not create a precedent? The full redevelopment got approval in November 1957. One exception to the replacement plus 10 per cent formula was the Bristol & West development, built on one of Reading's few bombsites, opposite the Town Hall, where there was no existing floor space left to replace. The architecture of these first buildings tended to be a fairly bland neo-Georgian, the first really modern façade being the Bernard Sunley building on the north side of Friar Street, dating from 1959.

Concern was growing in some quarters about the town's growth in office employment even before the real boom got under way. In January 1961 the Town Clerk reported receiving a letter from the clerk of Berkshire County Council:

> ... expressing concern about the amount of office development being permitted in Reading and the effect such development must have must have on the supply of suitable labour in the surrounding areas, and suggesting the need for co-relation between the two authorities in the sphere of industrial and commercial development generally.

This may seem a bit rich, coming from the people that would later promote one of the town's biggest speculative office schemes, on the former Shire Hall site. It certainly got a dusty response from the borough council:

> The Corporation were not prepared at this stage to commit themselves to any policy of limiting office development in the Borough of a type and on sites deemed suitable by the corporation.

They did, however, set up an advisory group at the same meeting:

> ... To have regard to the current state of development within the Borough and to the problems which now require consideration.

This group advised using the five-yearly review of the Development Plan to see whether some of the areas currently deemed suitable for business development could be reduced.

The first really large scheme to be approved was the 1961 ten-storey Reading Bridge House (since refurbished and still standing over fifty years later). It stood on the south bank of the Thames, next to the bridge, on the site of an engineering works that had long been considered to be a blight on a sensitive Thames-side location. It was expected to be let a floor at a time, but almost immediately half the building was taken by an insurance company. Such companies, either moving central London activity out of the city (where office floor space was in desperately short supply) to the provinces, or setting up local branches, were one of the three main occupiers of new office floor space. The others were arms of central or local government and the growing numbers of computer companies.

In 1963 Reading Bridge House's ten storeys were dwarfed by the Western Towers development – 15,850 square metres of offices, including a sixteen-storey tower block opposite the railway station that, for a time, became the headquarters of British Railways' Western Region. It included a pedestrian route between the station and Friar Street which, thanks to under-investment, became in Punter's words 'one of the most miserable alleyways in Reading'. The shops were never successful; the Friar Street frontage was cramped and floor space in the Butts Centre (when it became available) offered retailers a more attractive option.

An incoming Labour government in 1964 decided to apply a brake to the booming office development market by requiring all schemes of more than 240 square metres in the South East to obtain an Office Development Permit (ODP). This caused a good many

schemes to founder. Interestingly, some of the first schemes to secure ODPs had public sector involvement, either as prospective tenants or with interests as co-developer. They include the aforementioned British Railways headquarters, a building on Queens Road which the Department of Health and Social Security wished to occupy, and Fountain House, the office building on top of what we now call the Broad Street Mall, where the Borough Council had a development interest as freeholder of the land. The ODP threshold was raised to 943 square metres (10,000 square feet) in July 1967 (prompting a number of schemes just below the threshold) and between 1972 and mid-1973, the *Estates Times* was packed with advertisements, seeking occupiers for office buildings of up to 200,000 square feet who might be able to secure the developer an ODP. ODPs were done away with altogether in July 1979.

One public body that did not get an Office Development Permit was the county council, for their new Shire Hall. They started work on it before they realised that they needed one, and the government's refusal to grant one was suggested by Punter to have been motivated by political spite. Their refusal may have been as well for the town, for the *Architects' Journal* did not speak highly of their competition-winning design, saying that it was:

> ... incongruous in its surroundings and may well destroy the mood of repose and tranquillity that is one of the pleasant attributes of Forbury Gardens and Abbey Ruins... the visual impact of the main block is fundamentally disturbing.
>
> *Architects' Journal*, Volume 136 pp 209–216

Alpha House (1964) on Kings Road had the benefit of a frontage to the Kennet and Avon Canal, and might have been expected to enhance the setting of that waterway. An early artist's impression at least showed a canal-side café, which failed to materialise in the final scheme after the council lost public access rights to the canal-side on appeal. Somehow this development, which is today unlettable and must rank among the town's greatest eyesores, won a Civic Trust Award in 1967. Almost as unfortunate was the oversized Kennet House, which blights a sensitive junction between the river and its canalised short-cut.

In 1971 Nugent House was built on the other side of the southern approach to Reading Bridge. The occupant of this development was to be the Thames Conservancy, but it could hardly be described as an asset to the waterways. By allowing the full standard of on-site parking, the scale of the development (and thus its impact on the river) was greatly increased. On the Thames-side elevations, the retention of the company's engineering sheds meant that the development failed to achieve one of the water authority's principal objectives, of protecting and enhancing the amenity of the river.

Another horror from that period was the planned redevelopment of Market Place, which thankfully was only ever partly realised. The Planning Committee started out with the best of intentions on 19 July 1963:

> The Market Place is a clearly defined and important part of the town centre and we have reason to believe that considerable redevelopment is likely to take place there within the reasonably near future. The importance of the area is such that we believe it to be essential that the Council should prepare a plan for the area as a whole ...

We are very concerned to secure a balanced and pleasing treatment of the elevation of buildings abutting the Market Place as a whole, without precluding the expression of individualism in any particular redevelopment.

They even appointed a leading firm of architects to carry it out. As the chosen consultants were quick to point out, someone (no names) had already made a pretty good job of ruining the Market Place before they came along:

> In recent years the Market Place has felt the negative side of twentieth century developments. Its harmony has been disrupted by continuous heavy traffic passing through it, and its scale lost in the inevitable clutter of badly-designed lighting standards, street furniture and road signs. Pavements are narrow and overcrowded and Sir John Soane's elegant obelisk is lost in a mass of parked cars, lamp posts, the ventilating shaft and somewhat monumental entrance to the public lavatories. It is a familiar pattern of disruption of a scale essentially related to pedestrians and required to cope only with horse drawn traffic.
>
> Robert Matthew, Johnson-Marshall & Partners, page 6

It sounded unpromising, though the (hopefully imminent) completion of the Inner Distribution Road at least held up the possibility of pedestrianising the area. But if things were bad, there was always scope for making them worse:

> It is virtually certain that the Market Place will be entirely redeveloped over the next thirty years. Applications for part re-building have already been committed, and reconstruction of the area adjoining the Distribution Road [to the rear of the eastern side of the Market Place] is likely over the next ten years. The pattern of land ownership is changing from many small properties to a grouping in fewer hands. In this lies a danger that the essential scale of the Market Place may be lost; the present mass of small frontages, built independently and at different times, relate to but do not dominate the central space. Larger and longer buildings could easily destroy this relationship.
>
> Ibid., page 8

Their analysis of the problem was not so bad. The Victorian buildings on the eastern side probably were doomed for redevelopment, given the lack of respect for Victorian architecture in those days (the consultants called the Victorian buildings 'charming but obsolete'), and given the redevelopment that was planned behind them. The consultants' opposition to long new buildings with a horizontal emphasis was also correct for this location. It was the brutalism of their own proposals that was the main problem. Their solution to the threat of longer frontages with a uniform character was to impose their own longer frontages with a uniform – albeit vertical – character:

> It is recommended that a restrained treatment with regularly projecting vertical ribs be used for the façade over the arcades. This would provide a framework that would

relate blocks in different ownerships and situated on different sides of the Market Place ... We consider that this treatment, with its emphasis on the vertical elements in the facades would preserve the present vertical character around the Market Place and will harmonise with the existing buildings during the phased reconstruction.

Ibid., page 11

The result is the partially realised scheme of (now in places crumbling) grey aggregate verticals that can be seen in the Market Place in 2015. It was never remotely a thing of beauty, and to say that it has not aged well would be an understatement. To quote Punter again, 'The failure to conserve the varied façades of the Market Place seems like a crime against the town's heritage.'

A decade later the southern façade of the Market Place was attractively conserved. The architects who oversaw this were the same practice that was responsible for the disastrous earlier redevelopment scheme, illustrating how far public taste had changed in that time.

Another development of the period that will not be fondly remembered is the former Prudential building (1962) at the back of Market Place. The building of this coincided with the departure of Suttons Seeds from the town, with the Prudential Insurance Company taking up part of Suttons' landholding. It also entailed the demolition of a seventeenth-century house at No. 22 Forbury. The six-storey building that replaced it (now gone) will best be remembered for the large hole in its middle, through which the Inner Distribution Road was going to run before ploughing through the Forbury Gardens. Happily, the environmental damage involved was too much even for the Council of the day to bear and, as we saw, this phase of the road scheme was scrapped in 1973.

The county council's Central Berkshire Structure Plan was approved by the Secretary of State in April 1980. It sought to limit office growth in Reading to 140,000 square metres by 1986. This was relatively modest compared to market demand, but still represented around a 50 per cent increase in town centre office floor space, and was supposed to be accompanied by balancing housing growth and major investment in transport, including the completion of a revised version of the Inner Distribution Road, a third Thames bridge and improvements to the town's radial routes.

Almost straight away, the county council's Property Officer, now freed from ODP constraints, shot the policy in the foot, by getting his council to grant itself permission for 32,834 square metres of office floor space on the former Shire Hall site, prior to marketing it to private developers. This left the borough council with little or no discretion for dealing with other office proposals in the short to medium term. They decided to deal with the problem by a piece of statistical sleight of hand; they treated the Shire Hall consent as pre-existing the structure plan accounting period (which arguably it did, apart from not having an ODP) and so did not count against the Structure Plan's 140,000 square metres allocation. Similarly, another 29,245 square metres of schemes were also treated as pre-structure plan commitments and discounted.

Another feature of this period was a spate of major office appeals – twenty of them between January 1980 and June 1984, of which twelve were allowed, providing a further 45,000 square metres of floor space. The reasons for this were thought to include the abolition of Office Development Permits in 1979 and the spectacular growth in office rents in 1979

and 1980. All in all, the rate of office growth was running at about twice that provided for in the policy, raising questions about what was supposed to be a policy of relative restraint.

The architects for the purchaser of the Shire Hall site once again produced an unsympathetic design for this sensitive site, next to the historic remains of Reading Abbey. The county council's Environment Committee could not bring themselves to approve it, and delegated responsibility for deciding the detailed application to the borough council. This proved to be a fortunate move, for it prompted a radical redesign. A smaller neo-classical building was proposed for the sensitive Abbey frontage, while the more massive and modernistic 'jolly green giant' building was concentrated towards the Kings Road frontage. The result was a radical improvement in the overall scheme.

The borough council was itself not always a purely disinterested planning authority. We saw how they were involved as co-developer in the Fountain House office development above the Broad Street Mall (1969), and there are at least two other examples of where their interests were potentially divided. As we see elsewhere in the book, the council had for years hoped to demolish and redevelop the Victorian town hall, but overwhelming public opinion prevented them from doing so. Faced with the cost of renovating it, the council saw an opportunity for funding it when the site on Valpy Street immediately behind the town hall came up for redevelopment. The planning brief for the site was most generous in its allocation of floor space, which in turn generated a substantial 'planning gain' contribution towards the refurbishment of the town hall and the adjoining remaining part of the medieval Abbey Hospitium. The town was faced with the potential for an over-development, but the architects produced a sensitive scheme (Minerva House) that sat well with its venerable neighbours and was pre-let at a record rental.

The council had for years harboured an ambition to attract a modern hotel to the town. They owned a site next door to the Broad Street Mall, one that would be ideal for supporting the business of the Hexagon, as well as generating a ground rent for the council, but a substantial office development (which became Royal Berkshire House) needed to be added to the mix to make the hotel deal viable. The planners had relatively little input to the planning permission the council granted itself, a scheme which nobody has so far accused of being sensitive. Cynics called developments such as these 'planning by rateable value', and it is certainly true that the rateable value of Reading's office floor space doubled between 1963 and 1968.

Sometimes the making of a scheme could be the tenant. The Metal Box building, between the Forbury and the railway (approved in 1972, demolished in 2015), was one of the first big business relocations out of London, and the fact that it was commissioned by the eventual occupier, rather than being a speculative scheme, made the world of difference to the architecture. While not to everybody's taste, many felt that it set a standard that few other office buildings in Reading even approached.

The Foster Wheeler building (1973), next to the station, was a scheme in which the eventual occupier was at least closely involved in the development process. The architect had originally wanted a taller, more slender building to sit next to the Western Tower, but negotiations with the planners resulted in a shorter, more squat development, though at least the town was spared the brutalism of more raw concrete, in favour of dark smoked glass. The provision of a 1,000-space multi-storey car park as part of the package was a major attraction for the council, who saw it as a major boost to trade on Friar Street.

Like many towns that saw rapid office growth in the immediate post-war years, Reading has been criticised for the quality of some (indeed, quite a lot) of its early office architecture. This can be laid at a number of doors. The planning department for a long time lacked any architectural expertise. Even had it possessed such expertise, the planning legislation offered very little power to control any but the very worst excesses. The views of successive governments were summed up in Government Circular 22/80, which said that in matters of architectural design, 'Democracy as a system of government … falls short of a far less controlled system of individual, corporate or institutional patronage or initiative.'

Mediocrity cannot be legislated against; all it can do is prevent outrages. As one planning inspector dealing with a Reading office appeal put it, a design has to be very poor to be rejected on aesthetic grounds outside of sensitive areas. In economic terms, the growth of Reading as an office centre has, in many respects, served the town well. The local economy has proved more resistant than most to the fluctuations of the economic cycle, with low unemployment and high average incomes. On the negative side, the high wage economy has contributed to the high cost of housing that has made it difficult for those on more modest incomes to live in the area.

By the end of the century the local labour force was very strongly non-manual; the 1991 census lists 55.7 per cent of the town's labour force as professional, managerial, technical or skilled non-manual, and 43.9 per cent of the workforce were employed in banking, finance or other services.

There was also a spatial dimension to office and industrial development in Reading. Offices tended to be concentrated in the town centre, where access by public transport for the office staff was at its best. Traditional industry often tended to need access for heavy vehicles, and could involve processes that were not necessarily good neighbours, on account of noise, smoke and fumes or vibration. These activities were directed more to the peripheral industrial areas. But the post-war growth of so-called 'high tech' industries has blurred the boundaries. Many of these modern businesses carry out a mixture of office work, research and development and manufacturing in an office-type environment. Government legislation responded to these changes. They introduced something called the Use Classes Order 1987, which grouped together activities which do not require planning permission to change from one to another in a single Use Class. Under this, Use Class B1 encompasses:

- Offices (except those financial and professional services that need a shop-type frontage to deal with the public);
- Research and development; and
- Light industry (involving activities which could be carried on in a residential area without causing a nuisance).

This helps to explain why in Reading in recent years one may see buildings much more like offices springing up in areas that would once have been covered in industrial sheds. That said, the town centre remains the main location for pure office development. As of March 2014, over 60,000 square metres of prime office floor space was being delivered within 500 metres of Reading station; the upgrading of the station was having a powerful effect upon the office market, as was the fact that total office occupation costs in west London were 60 per cent higher than in Reading, which looks like becoming an ever-more important office town in the future.

Fun, Fun, Fun

It was remarked in 1810 that partly 'owing to the bigotry of the Methodists' and partly to 'the immoderate thirst for gain that pervades every class of shopkeepers', dramatic performances 'in this enlightened town are not only received with disgust, and treated with neglect, but the people are instructed from the pulpit to consider them as dangerous to religion'.

Childs (1910) page 75, quoting from John Man, 1815

Today, the average residents of Reading – like anywhere else – are liable to stay at home and look first for their entertainment to the idiots' lantern, but what did they do before television was invented?

Reading's first recorded venture into theatrical entertainment seems to have been in October 1786, when a Mrs White, proprietor of the Maidenhead Theatre, set up a venue at the Marquis of Granby public house on the London Road. It appears to have done good business for about a month, until thieves stole most of the costumes. It was a loss from which the company never recovered.

Two years later, Reading got its first purpose-built theatre, when Henry Thornton opened the latest in his chain of theatres on Friar Street. He was a moderately successful actor (said to be able to 'bustle through a part with considerable ease, though unacquainted with the author's words') who turned impresario. One of his first productions was the *Beggar's Opera*, whose barbed satire appears to have pleased the audience, but which excited the outrage of local moralists, who complained that it was 'corruptive of the innocence and integrity of youth'. Later productions earned the dubious privilege of criticism from the pulpit of St Giles' church, referred to in the quotation above, where the Revd William Bromley Cadogan condemned 'those ministers of impiety and licentiousness, Strolling Players'. The company, and the theatre, are long since gone.

But one reminder of Reading's early theatrical history survives to this day. The imposing building at the north end of London Street is today known as the Great Expectations Hotel, but it started life in 1843 as a Literary, Scientific and Mechanics' Institute. Ten years later it was converted into the Theatre Royal, by the addition of a proscenium arch. Charles Dickens came to the theatre on 19 December 1854 and read extracts from his novel *A Christmas Carol*. He was apparently overcome by the warm reception he received from the working people of Reading, including many employees of Huntley & Palmer. A member of the audience describes the scene:

Dickens was exquisitely dressed, wearing a blue frock coat and a velvet vest. There he stood, with a large ivory paper knife in one hand and his book in the other. I recollect that we had great difficulty with the light; Dickens suggested that the light should be adjusted so that he could see...

<div style="text-align: right">Quoted in Phillips (1978), page 25</div>

Dickens returned in November 1858 and again delighted his audience with extracts from *Dombey and Son* and *The Pickwick Papers*. Despite these successes, the theatre had a relatively short life – by the 1860s they were forced to sell the building to the Primitive Methodists, who used it as a chapel. This use was also eventually abandoned, and the Everyman Theatre Company tried to resurrect it as a theatre. They soon got into financial difficulties and in 1957 the council took it over. The Reading Newspaper Company bought it in 1960 and today it is used as a hotel and bar.

Another conversion gave Reading one of its finest theatres. Frank Matcham was the doyen of theatre architects and in 1894 he was engaged to turn a Victorian Gothic chapel in Friar Street into a modern theatre. He produced an 1,800-seater that offered every luxury and the most modern facilities, and they called it the New Royal County Theatre (a previous Royal County Theatre had been destroyed by fire after being struck by lightning in August 1894). It opened on 16 September 1895, and Friar Street was choked with people trying to get tickets. The New Royal County had a different theatre company performing each week, giving the audience a variety of shows – classics, comedies, romances, drama and (particularly as the First World War began) patriotic pieces. By the 1930s the Royal County Theatre (it was no longer called New) had diversified into opera, but was also being used for showing the new craze, moving pictures, under the name County Cinema. In October 1936 the proprietor of the Royal County, Richard Langley, began an attempt to revive local interest in theatrical drama in the face of cinema competition.

His efforts were doomed. At about 2.00 a.m. on the morning of 7 January 1937 a patrolling policeman found the Royal County Theatre well ablaze. Attempts to stem the blaze were unavailing and, by the morning, only the outer walls of the theatre remained. Damage was estimated at £30,000 and, even with the insurance, a new theatre was not considered a viable proposition. The site was sold for an extension to Bull's department store.

The Palace Theatre opened on Cheapside in 1907, aiming to cater for those who preferred variety to straightforward drama or romantic comedies. Its promoters included a director of Simonds' brewery and a local coal merchant. Another eminent theatre architect was employed – W. G. R. Sprague – who had been responsible for a number of major West End theatres. It was elegant but restrained in design, and (mindful of the number of theatre fires occurring around the country) incorporated all the latest safety features. *Stage*, the variety industry's newspaper, called it a 'music hall that would do credit to the West End of London'. The programme for the opening night gives a flavour of what it offered. It included the Martelloni troupe of lady acrobats, Siems the Card King, the Jerome sisters dancing trio, the Herald Comedy Four, Miss Daisy Morrell, comedienne and a bioscope cinema show featuring HM the King on board HMS *Dreadnought*. The press reviewed it favourably, saying that so long as the management continued to provide programmes so free from vulgarity they could depend upon the support of the public. The Bioscope remained

part of the programme for years, until it became clear that the new moving pictures were in fact a rival to live entertainment, whereupon they were relegated down the programme and sometimes dropped altogether.

Over the years the Palace played host to most of the great names of variety and music hall, including George Robey, Harry Tate, Marie Lloyd, Harry Houdini, Gracie Fields, Tommy Handley, Jack Buchanan, Jack Warner, Frankie Howerd, Max Miller, Tommy Trinder and Ted Ray, among many others. During his appearance in 1913, Houdini tried to perform a stunt which involved him being thrown, chained and straitjacketed, off Caversham Bridge into the Thames. He was prevented from doing so by the police. On another occasion, an alligator forming part of an animal act at the theatre performed a rather more successful piece of escapology, and was found doing some window shopping in the town centre. By the late 1930s the Palace was Reading's only commercial theatre and enjoyed some good times, putting on concerts that included leading dance bands such as Jack Payne and Joe Loss, as well as more classical fare from the likes of Richard Tauber and Dame Myra Hess.

It was in the 1950s that hard times set in for the Palace. By then, not only did the moving pictures now offer colour and sound, but an increasing number of potential customers had the rival attraction of the television to keep them indoors. The management desperately sought a new market, not always with the most edifying results. One production, the *Would You Believe It!* show, included such attractions as the world's fattest family, the tallest woman in the world and the human ostrich, whose speciality involved swallowing lighted electric bulbs. Lester's Midgets featured twenty of the living doll people, including the smallest man alive. There were also nudie shows, such as *We Couldn't Wear Less!* and *Nothing on Tonight*. But nothing could stop the rot; not even formerly sure-fire hits, such as traditional pantomimes and variety favourites like Max Miller and Leslie Hutchinson (who topped the bill at their fiftieth birthday gala show), could guarantee a full house. The *Berkshire Chronicle* lamented its decline:

> Does Reading want a professional theatre? Are the public interested? The answer seems to be, not interested enough … Companies complain that they lose heart when they come to Reading. Support here is lower than nearly everywhere else in the country.
>
> Quoted in Phillips (1978), page 40

By 1959 the Touring Theatre Company were appearing at the Palace, getting excellent reviews but playing to nearly empty houses. Their season was cut short and the theatre opened only occasionally during the rest of the year. One of the last people to appear there was an eighteen-year-old rock and roller, who had sprung to fame on ITV's *Oh Boy!* show. Cliff Richard (for it was he) was apparently rendered inaudible by the screams of his largely female audience. After the show, about three hundred of them rushed to the stage door with the apparent aim of securing autographs, fragments of clothing (or, for all we know, body parts) as souvenirs. When Cliff wisely failed to make an appearance, some of them consoled themselves by trying to turn over a nearby parked car.

On Boxing Day 1959, the very last production – the pantomime *Babes in the Wood* – opened for a short run. It closed on 9 January 1960; the Palace was demolished in 1961

and was replaced by an anonymous office block. Veterans of the variety stage remembered it warmly. Max Wall said, 'I never saw a better place than the Palace at Reading.'

The Old Town Hall and the Hexagon

Elsewhere in the book we see how Reading Town Hall was developed over a period of more than a hundred years. Almost immediately it was completed, the council realised it was inadequate to meet its growing office needs, and the search was on for new premises. It still took until 1976 for staff to move out into the new Civic Offices, and 1985 for the library to relocate, leaving only the concert hall and museum in use. Reading was, for at least part of the post-war period, in the grip of a relentless and (to our eyes) often insensitive drive for modernity; at one stage, it was said, listed buildings were being demolished in Reading at the rate of one a week.

Reading Civic Society was formed in 1962 to resist this tendency, and one of the causes they championed was the Town Hall complex. In the early 1970s this was being threatened with demolition and redevelopment as ... different accounts have it destined to be a cultural centre, private offices or even a roundabout for the Inner Distribution Road. The Civic Society was instrumental in getting the complex emergency listed, but not until 1986 was its future secured and refurbishment started.

By the 1960s, Reading was in a bad way for theatres and meeting halls. Despite its inadequate facilities for audiences and performers alike, Reading Town Hall was about the only space in the town large enough to house professional concerts or major local musical societies, and was always heavily booked. Reading Council of the Arts was set up in 1967 to coordinate and stimulate cultural activities in the town. They discussed a possible theatre on the university campus, also open to local residents, but nothing came of it.

Meanwhile, Reading Borough Council was considering providing a new assembly hall, next to the new Civic Centre, to replace the old Town Hall. There was much debate about what was needed – everybody wanted something different – but in 1973 the council announced plans to build a multi-purpose assembly hall that could seat 1,500, but also adapt to the needs of smaller audiences. Plans for the £2,000,000 Hexagon were published in April 1974. Its sophisticated design could become a concert hall, a proscenium arch theatre or a dance or exhibition space, each with the appropriate acoustics. It opened in November 1977, amid fears that it would be too expensive for local societies to hire, but bookings by local societies soon stretched well into 1979, alongside many professional events. According to an *Architects' Journal* study in 1979, dramatic performances came pretty low on the venue's list of priorities, despite a quarter of all events being of that type.

Cinema

The age of cinema came to Reading in 1909. It started with the short-lived Reading Picture Palace in Cross Street Hall and was followed in quick succession by Bio-Picture Land in Kings Road, the Vaudeville Electric Theatre in Broad Street and West's Picture Palace in

West Street. The Vaudeville was the most fashionable of these, occupying the site on the north side of Broad Street near the junction with Union Street (Smelly Alley) – the site occupied (in 2015) by Boots. It was run by W. H. White, an experienced cinema operator from London, and was state of the art for its day, featuring a sloping floor for better viewing, 450 tip-up seats and a fireproof projection room (important with the highly flammable film-stock of the day).

The early programmes tended to be a series of short features, lasting about an hour and a half in total, and White was soon claiming that the Vaudeville was 'the World's Most Successful Animated Picture House'. Within three years it had been enlarged to seat 1,100. One of its particular successes was a documentary film of Shackleton's Antarctic expedition, which was shown at a time when its real-life leading man arrived at Reading Town Hall to give a lecture.

The Vaudeville advertised its admission charges as 3*d* and 6*d* (1 or 2 new pence). Some of its more rough and ready competition, like Bio-Picture Land, would let children in for a penny, for which they could watch the programme seated on a coconut matting floor. Those requiring the luxury of a seat at the cinema (carefully partitioned off from the so-called 'penny plungers') would be charged 2*d*. This cinema was renamed the Standard Electric Cinema, but was taken over for war purposes in 1914. West's Picture Palace and another cinema, the Paragon at Kings Road, also fell victim to the war. West's had boasted itself to be 'the acme of perfection and the beacon light of the world's progress in kinematographic enterprise. Accompanied by a magnificent orchestra and full mechanical effects', the latter including the sound effect of breaking glass to coincide with it happening on the screen. Admission charges of up to a shilling were charged for these additional features. As for the films themselves, in just one week in February 1910 at West's, according to the *Reading Mercury's* trailer:

> The pictorial representations included *The House of Cards*, a strong drama of the Wild West, and *Truth Will Out*, a domestic drama. Laughable series are *Incorrigable Mary*, *Who's Got My Hat?*, *Choosing a Husband*, etc.

Other cinemas came and went. The Grand in Broad Street lasted from 1911 to 1922 and the Empire in Elm Park Road was in business from 1912 to the late 1920s. In Caversham, the Caversham Electric opened in 1911. Renamed the Glendale and substantially rebuilt in 1946, it survived longer than most, finally closing in June 1977 and becoming a church. The Central in Friar Street was another of Reading's grander establishments. Opened in 1921, it had seating for 1,400, an eight-piece orchestra and a large café. At the same time, the Vaudeville was undergoing a further upgrade and expansion, to become known as 'Reading's Temple of Colour and Harmony'. Its orchestra was led by a celebrated violinist from the Royal Opera, Covent Garden, and their renown meant that the Vaudeville was one of the last cinemas to embrace sound.

The first sound feature at the Central, *Weary River*, was not an unbridled success, the heroine's voice being almost incomprehensible. The newly opened Pavilion Cinema on Oxford Road (later the Gaumont) was able to capitalise on this. It promised 'a new era in entertainment' in a cinema that had been 'specially constructed to suit the delicate

requirements of talking pictures'. The Pavilion had no orchestra, but instead offered Norman Tilley at the organ.

A flurry of new cinema building followed the talkies: the Granby, London Road (1935), the Savoy, Basingstoke Road (1936), the Rex, Oxford Road (1937), and the Regal, Caversham (1938). The Savoy also boasted of its state of the art projection and sound equipment, promising 'perfect sound and a perfect picture'. They also offered the luxury of trays of tea and coffee served to you in your seat. The last new town centre cinema of the period was the Odeon, on Cheapside, which opened in 1937.

Just as the 1930s saw a flurry of building, so the post-war years saw a succession of closures, as television kept the public at home. The Vaudeville went in 1957, followed by the Rex and the Regal (1958) and the Savoy in 1961. The Gaumont (which had been the Pavilion) closed in 1979, and the Granby (latterly known as the ABC London Road) in 1982. The last of the old-school cinemas to go were the Odeon and the Central (renamed the ABC Friar Street), finished off by the new ten-screen multiplex in the Oracle development, which opened in 1999.

One obstacle all the cinemas faced was the ban on Sunday opening. Various attempts were made over the years to get the restriction lifted, but this attempt in 1937 got short shrift from both the council and the local press, as this editorial from the *Reading Standard* 8 January 1937 shows:

> The renewed attempt to secure the Sunday opening of cinemas in Reading has been no more successful than previous efforts in that direction. It was generally known that for months past the advocates of the proposal had been anxious to reopen the question and in due course they bought it under the consideration of the Theatres Licensing Committee, who came to the conclusion that the Town Council should not make application for powers to enable cinema entertainments to be given in the town on this particular day ... The case for Sunday cinemas in Reading cannot be regarded as a strong one. The town is not a holiday resort frequented by visitors who demand entertainment every day of the week, and arguments that may have some force when applied to the larger centres of population fail to convince when brought to bear upon conditions in our own quiet community. Reading is well supplied with up-to-date picture houses and the facilities they provide on six days of the week satisfy the requirements of the cinema-going public.
>
> The decision of the Council is all the more sound because it was not reached on the narrower Sabbatarian lines. Opinions differ widely on the vexed question of Sunday observance and there is little likelihood of securing unanimity on a matter which is essentially one for the individual conscience. It is easier, however, to reach agreement in efforts to minimise Sunday labour.

It took a world war to get Sunday opening of Reading's cinemas, from February 1940. In this case, it was supposed to be for the benefit of troops billeted locally, whose duties would not permit cinema-going on any other day. Even then, the Churches tried (without success) to get attendance limited to people in uniform and those accompanying them. In the event, very few of those seen going into the cinema that first Sunday were members of the armed forces.

Reading (or, at least, Reading Rotary Club) was warned about the coming of television as long ago as 1936, when Dr N. L. Yates-Fish told them:

Television is one of those mysteries about which most people say 'it will come someday' without ever trying to imagine the thousands of barriers which impede progress towards the ultimate perfection of televised transmission ... television did not mean, as so many 'dear old maiden ladies' thought, that they could be suddenly thrown on a screen miles away in the most embarrassing moments ... Without a transmitting apparatus nothing could be sent out on television.

The speaker prophesied that in a year's time it would be possible to buy a television receiver for about twice the cost of an ordinary (radio) set of the best make. The objects would be shown on a small screen, about ten inches by seven inches. The range of the station would be limited to about 28 miles. Consequently, it would be necessary to have a station in the centre of each populated area. There was little hope of Reading getting one for a long time.

Berkshire Chronicle, 17 January 1936

The television age was not so far off as he thought for Reading. The war was a delaying factor but Reading's first television licences (all forty-six of them!) were issued in 1946. The great boost to television sales came with the coronation of Queen Elizabeth, by which time Reading could boast over 7,000 set owners.

Reading Festival

Every August Bank Holiday weekend Reading is transformed into a strange and colourful place, for what Bayreuth is to Wagner, Reading is to Status Quo and their ilk. The event for which Reading is perhaps best known nationally and internationally is its rock music festival. It is claimed to be the oldest popular music festival still in existence, and in 2013 played host to an (official) audience of 90,000.

It started life in 1961, as a predominantly jazz festival held at the Richmond athletic ground. Its promoters were Harold and Barbara Pendleton, part-owners of the Marquee Club in Soho. The jazzman Chris Barber (also a part-owner of the Marquee) was one of the headline acts during the Richmond years; on a subsidiary stage somewhere, some outfit called the Rolling Stones were apparently playing as a supporting act. The festival had a fairly nomadic existence in its early years, moving to Windsor Race Course (1966), Kempton Park (1968) and Plumpton (1969), before settling at a site at Richfield Avenue, Reading, in 1971. Its first visit was not welcomed with joy by every Reading resident, led by this editorial on 7 May 1971 in the *Chronicle*:

The principal factor that gives rise to apprehension is the lack of control over numbers. It is not possible to forecast with any degree of certainty how many are likely to turn up for such an event, but given fine weather, pop groups and intensive advertising, the numbers could become overwhelming. It would not be easy, of course, to impose an

enforceable limit, but unless the organisations give an undertaking that every means will be adopted to keep attendance to a figure which the authorities, and the Police in particular, consider reasonable, the Corporation should seriously consider the prudence of allowing such an event to go ahead.

But the *Chronicle's* views were a model of restraint compared with this father of teenage girls who filled the letters column the following week with a long diatribe, from which the following extract is taken:

I must say to the Mayor, Aldermen and Councillors, Why? Why? Did you sanction such an event which, as past functions of this kind have shown, will attract some 50,000 or more young persons to this town, 10 per cent of whom will be layabouts, anarchists, sexual perverts and other trouble-makers, who will only have come here to create havoc and corrupt our own young children, because, let's face it, they will, despite even the strictest parental control. Many homes will have domestic upheavals; it is hard enough now when parents say No, you cannot go there or you cannot do that.

The site on which this event is scheduled to take place is in itself most unsuitable. From the point of view of control it is wide open, there are no suitable toilet facilities (unless the river is envisaged as an open sewer), there is no water supply, no suitable sleeping accommodation...

I suggest that our Council think again and think very hard indeed before it is too late to retract the permission they have granted for our town to be defiled without even considering the wishes of the electorate who they say they serve. They may find to their cost that this was a very unwise decision. Elections come and go, so can councillors, and the electorate are very sensitive, especially when it is likely to affect their own personal well-being and pockets.

Reading Chronicle, 14 May 1971

The first festival was very different to its modern counterparts. Tickets were just £2 for the entire weekend and the only enclosure of the site was a 3-foot fence, policed by 200 guards to keep out trespassers. Many of the fans complained about high prices on the site, the lack of good food, shelter and drinking water and a poor sound system. One thing that has not changed over the years was that the festival weekend was preceded by heavy rain, which turned the site into a morass of mud and puddles. Carters the camping store did a roaring trade in polythene sheets at 60p a time (those that were not shoplifted). The police were out in numbers, some 550 of them to deal with a crowd estimated at anything between 20,000 and 50,000, depending upon what point the estimator was trying to make. Over-zealous policing was something else for the fans to complain about.

But one group who rapidly came to love the festival were the local shopkeepers. The proprietor of the Take 'n' Bake reported doing marvellous trade, and 'Mrs S. Parsons who, with her husband, manages a confectionary shop, said "The fans were absolutely marvellous, despite their appearance. We took a lot of money."'

Even so, few would have bet after year one on the festival becoming the venerable institution that it has. A history of the festival would require more space than we have available, so we will have to make do with a few key events and recollections. It is not always easy to gather recollections of the festival. Perhaps not surprisingly, a number of the performers could not remember a thing. Arthur Brown (as in The Crazy World of Arthur Brown) speaks for many of them: 'I don't really have any memories of either of the Reading festivals. Must have been doing too much stuff.'

He should at least have remembered the festival where he set himself on fire, while being lowered onstage by a crane. Sometimes there were memories, but of a more prosaic nature. This from Elkie Brooks, 'I don't think I will forget the experience of performing at Reading (especially the toilets).'

Members of Supertramp will remember the 1975 festival because of tingling lips. Torrential rain shorted out their electrical equipment, leaving them with microphones that gave them electric shocks each time they sang into them.

Reading fans have developed their own way of expressing their views on acts that did not please. Large cider bottles filled with urine were their missile of choice to throw at the artists, and a number of them have been driven off-stage by 'bottling'. But one band had their revenge. Several acts used pyrotechnics to add to the impact of their act, but none with greater effect than Big Country in 1983. These were set up by a supposed pyrotechnics expert, but when he let them off, according to one band member, 'He nearly took out the front ten rows of the audience... For the next few weeks the people of Reading were walking around with no ******* eyebrows.' The flames also had spotlight operators leaping in terror from the lighting truss, and the band needed treatment for minor burns.

The year 1983 was billed as 'the last Reading festival'. There had been a change in political control of the council and the new ruling group were committed to ending the festival. In addition, there were development proposals affecting part of the festival site. The organisers tried to set up an alternative festival – Reading Rocks On – but they failed to get a licence for the event in Northamptonshire. The gap in the festival calendar was one of the factors that promoted the rise of Glastonbury.

There would be no Reading festival until 1986, by which time the control of the council had changed again, in its favour. The planning problem was addressed by moving the festival site a few hundred yards along the road. After a few hiccups getting it restarted, it has continued to flourish ever since. By 1999 the Reading site had become too small for the demand, leading to the launch of a second leg to the festival, at Leeds. The Reading event has also sprouted its own local fringe festival, started in 2005. By then, tickets for the event were selling out in two hours.

Some fascinating facts about the festival:
- It requires over eight miles of fencing, 110 portakabins and 2,300 toilets;
- Festival goers consume 50,000 burgers and 2 million pints of lager over the weekend;
- The University of Reading calculated in 2009 that the festival was worth £16 million to the local economy.

Some Other Venues

A review of Reading's theatrical offerings, past and present, would not be complete without mention of the Progress Theatre. This voluntary theatre group was formed by a group of young Reading people in 1946 and for several years they put on productions in the Palmer Hall, West Street. They were then presented with an opportunity to lease the Mildmay Hall in The Mount from the Co-operative Society, which they converted into a working theatre and in which they put on their first production in October 1951. Their fundraising efforts (including an eighty-nine-hour reading of the complete works of Shakespeare) enabled them to buy the freehold in 1964 and by 1968 to upgrade the building with a new foyer and other facilities. It is small (ninety-six seats) but state of the art, and the company has a reputation for high quality performances. They also specialise in open-air productions (more Shakespeare, this time in Caversham Court Gardens) and also in the Abbey ruins, until they were closed. One of its other activities has for some years been a student group for 14–18 year olds, whose number have included Sir Kenneth Branagh (who made his first stage appearance here) and Marianne Faithfull.

There was an unemployment office on South Street until 1989, when it closed down and the council bought it for use as an arts centre. It is able to accommodate events too small to make sensible use of the Hexagon. It stages a combination of local acts, well-known people trying out new material (Michael McIntyre, Lenny Henry and Alexei Sayle are among those who have used it in this way) and artists who are on their way up. A little-known Jack Dee made an early appearance there and Eddie Izzard played to a South Street audience of about thirty. The next time he came to Reading, he sold out the Hexagon.

Last but not least among venues, the Rivermead sports and leisure centre, opened on Richfield Avenue in 1988, can also house events. It has three halls, the largest of which can provide event seating for up to 2,000 people.

Fun on the Firm

Finally, some acknowledgement needs to be made of the role of employers in providing their workforces with fun. Many local employers provided a variety of activities, both in Reading and away from it. In the case of someone like Huntley & Palmer, these could be on a very large scale indeed. For their June 1914 works outing, for example, they laid on ten special trains bound for Margate and Ramsgate, and all the local primary schools were closed, to allow the children to accompany their parents.

Sickness and Health

In this chapter we look at how healthcare in Reading has grown, from a voluntary initiative involving one or two people, to a massive state-owned and -run industry, and Reading's biggest employer, looking after the health of 250,000 people.

Before the Hospital

In the late eighteenth century, medical bills were one of the terrors, not just of the poor but also of a growing number of otherwise solvent people. Many who normally earned a living wage could be driven into pauperism by the cost of their treatment. In 1796 a local vicar, the Revd Edward Barry, floated the idea of a public subscription to pay for free medical treatment and spare the industrious poor of Reading from the indignity of appealing for parish relief. His appeal raised £7 15s 6d (£7.77) and enabled nine people to receive treatment, but it was a one-off and it took another five years for a more permanent arrangement to be established.

This later initiative was the work of a Dr Thomas, who had recently set up a practice in Friar Street. He ran a free surgery for one hour each day for the benefit of the poor and in August 1802 he suggested through the *Reading Mercury* that the town should establish a dispensary to 'enable the industrious poor of the Town and neighbourhood' to get free medical advice and treatment. He secured the support of the bishop and other prominent citizens, including Dr Valpy, the headmaster of Reading School, and within three months £300 had been subscribed. They contemplated the idea of setting up an infirmary or hospital, but dismissed it as unrealistically ambitious. Instead, a dispensary was set up to offer free advice and treatment. It was not open to all; patients had to be 'worthy objects of charity' and be recommended by a subscriber (subscribers were allowed tickets of recommendation in proportion to the amount they subscribed). Those already in receipt of parish relief (who got separate treatment) and domestic servants were also excluded from admission.

The Dispensary opened on 22 November 1802, for one hour on three days of the week, augmented by home visits where necessary. Complex cases were sent to the hospitals in Bath or Oxford, but patients whose prospects were poor would not be kept on the books for more than four months. Those who were cured were required to send a letter of thanks to the subscriber who had sponsored them, and offer up prayers. In the first year 296 patients were treated. By 1803 they were able to appoint a resident dispenser at a cost of 10s 6d (52p) a week and the following year the Dispensary got a home of its own – a house in Chain Street, behind St Mary's church.

The population of Reading rose rapidly in the first quarter of the nineteenth century, and with it the demand for – and cost of – free medical care. By 1823 some 554 patients were seen, at a cost of £415. The Dispenser was by then called the Resident Assistant, and his salary had risen to £90 a year, plus free accommodation and other perks. Ten of Reading's eighteen medical practitioners held honorary positions with the Dispensary, five of whom were also Poor Law medical officers, serving the parishes.

The publication of the *Lancet* from October 1823 coincided with the formation of a Reading Medical and Chirurgical [surgical] Society and with moves to establish a medical library in the town. The library was opened in 1827, based in new Dispensary premises in Chain Street. By 1830 patient numbers were up to 706, with a further forty coming to be vaccinated against smallpox. Changes to the Poor Law system of medical relief in 1835 left a large group of people suddenly without access to affordable treatment, and the charitable sector faced the challenge of meeting this new area of need; by 1840 their number of patients would nearly double.

Over the three years it took to build what would become the Royal Berkshire Hospital, (whose origins are discussed later) the Dispensary also nearly doubled its volume of in-patients. In particular, the eight beds in the Dispensary House treated six patients in 1836, twenty-eight in 1837 and thirty-three in 1838. Part of this increase was due to the advance of the Great Western Railway towards Reading, which was proving to be a prolific source of casualties. In a new development, the Wokingham Guardians started paying the Dispensary (£17 11s (£17.55p) in 1838) for treating railway casualties occurring in their area.

It had originally been the intention that, once the hospital had opened, the Dispensary would transfer its funds to it and cease to have a separate existence. However, when the governors of the Dispensary attempted the merger, they discovered that they had no legal powers to do so, and that the basis on which the hospital had been founded made it impossible for the two ever to unite. The work of the Dispensary would continue.

Smallpox was England's fifth largest cause of death in 1837, despite being eminently preventable. The Vaccination Extension Act was a pioneering piece of legislation, giving everyone, regardless of their means, an entitlement to free vaccination. In Reading's case, vaccinations had been available free at the Dispensary before the Act. The vaccinations were voluntary and the cost was to be met, not from the government purse but from the local poor rate. The Reading medical officers reported in May 1841 that there had been a disappointingly low take-up, of just 193 vaccinations since September 1840. It seemed that some feared (wrongly) that vaccination would actually make them infectious, while others disliked the poor rate associations of the service, implying as it did (in some people's eyes) that the recipients were paupers and had thrown themselves on the mercy of the parish.

Regulations passed in 1842 aimed to improve the quality of Poor Law medical care. Among other things, they recommended that local Poor Law unions subscribe to their local hospital. The Royal Berks approached the Reading Guardians for a subscription but they declined, saying that their medical officers were contracted to attend all unwell paupers in the union, whether through accident or sickness, and that these contracts would 'preclude the Guardians from contributing to the funds of the hospital'. They did not subscribe until 1867. The recommendation was generally not taken up immediately. Wallingford was the only Poor Law Union that did pay the Royal Berks a subscription in 1842.

One specialised area of care was for people with mental illness. Since 1835, the Poor Law guardians had been responsible for pauper mental cases in their area. Most of the harmless ones (classed as 'feeble minded' or 'idiots') could be looked after in the workhouses. More serious or violent cases required specialist accommodation, which neither the Royal Berks nor the Dispensary could provide. The Poor Law Lunatic Returns for August 1844 showed that the Reading Union had nine lunatics in Warburton's Asylum in London (at 9*s* (45p) each per week), eleven non-violent cases living in the workhouse and two farmed out within the community (at 2/3½ *d* (11p) each per week). This represented a considerable drain on the poor rate. The Lunacy Act 1845 required every county and borough to provide an asylum for pauper lunatics, and the Berkshire and Oxfordshire authorities combined to provide a 300-place asylum at Littlemore, near Oxford. This was augmented in 1863 by the opening of the asylum for the criminally insane at Broadmoor, near Crowthorne.

The opening of the Royal Berks would mean that much of the funding that had hitherto gone to the Dispensary went instead to the hospital. A number of the Dispensary staff also resigned their positions and went to work in the hospital. By 1843 the Dispensary, which was still treating almost as many patients as in 1839 (despite having closed its two small in-patient wards when the hospital opened), was operating at a loss and attempts at fund-raising had had only limited success. To make matters worse, the Dispensary buildings were now unfit and needed rebuilding. A new appeal was launched for the estimated £1,000 rebuilding cost and this one was backed by the *Berkshire Chronicle*. This time it was successful, and even raised subscriptions that secured the finances of the Dispensary in the longer term.

The latter part of the nineteenth and early twentieth centuries saw a range of other facilities opened. The council set up a small fever hospital in Bridge Street, with an 1893 corrugated iron extension for the isolation of smallpox victims. These were both superseded by the forty-bed Park Fever Hospital, opened in Prospect Park by Reading Council in 1906. Large firms like Huntley & Palmers, and organisations like the Mechanics' Institute, started providing free medical advice to employers and members respectively, and nine Reading Friendly Societies amalgamated in 1879 to form a Medical Association that gave its members access to a doctor. In 1870 the Dispensary itself set up a Provident scheme, whereby people (not receiving parochial relief but unable to afford private doctors' bills) could pay two pence a week to ensure the family had medical attention when needed. By 1900, they had over 18,000 subscribers. An 1882 guide to Reading explained it thus:

> Within the last few years a radical change has been made in the method of conducting the Institution. Up to that time its benefits were only to be obtained by the poor through subscribers' tickets, and this naturally had a tendency to pauperise the recipients. The board of management, after very careful consideration of the matter decided to make a Provident Branch, still reserving to the very necessitous the opportunity of entering by Governors' Nominations ...
>
> ... It has been found necessary, however, to guard the funds of the institution by the exclusion of a class whose income is sufficient to meet their ordinary medical expenses, but who are not above availing themselves of the institution funds.
>
> Beecroft, page 25

The National Insurance Act 1911 was an early attempt by the government to legislate for free health care. Under it, workers earning less than a given sum (initially £160 a year) would qualify for medical care, paid for by a mixture of government, employer and employee contributions. Wives, children and dependants did not qualify and it did not cover in-patient or dental treatment. The medical profession vehemently opposed this Act, and part of their response in Reading involved the formation of a Public Medical Service. This took over the Dispensary's Chain Street premises and provided a revised scheme for those Provident members who were not covered by the Insurance Act. This arrangement continued until the establishment of the National Health Service in 1948.

The Royal Berkshire Hospital

For almost a century prior to 1840 there had been pressure to set up a county hospital in Reading, but lack of funds, fears that the provision of a hospital would encourage delicate and sick people to live in the town and the vested interests of local doctors, protecting their private practices, had always ensured that the idea went no further. The idea had resurfaced in 1830 and was given impetus by the demonstration in Reading of a new technique for removing bladder stones by an eminent London surgeon in 1834. The patient was able to walk home afterwards, making it an early example of day-bed surgery, suitable for the relief of the suffering poor. It demonstrated that the Dispensary would be suitable for performing such surgery, and the acceptance of this by the Dispensary Committee was the first step towards establishing a county hospital. A new Committee was set up in January 1836 'to consider the best means of extending the benefits and usefulness of the [Dispensary] charity', following the changes to the Poor Law. The Committee reported back to the Governors on 23 February 1836 that:

> From the review of this prosperous state of the finances, the liberal offer of subscriptions, and the general expression of public feeling, the Committee think the time is fully come (which from the commencement of the Institution has been anticipated by its founders) to propose the erection of a Hospital for the benefit of the poor and afflicted of this large Town and opulent and Royal County.
>
> Railton (1994), page 76

The Dispensary put £1,000 of its own money towards the project and this was matched by a similar donation from a local grandee, Richard Benyon de Beauvoir of Englefield House. Four members of the Benyon family would hold the post of President of the Hospital over the years. A committee of the local great and the good was formed to oversee the development and the king and queen were approached about becoming the patron and patroness. William IV and Queen Adelaide agreed, even promising a subscription of fifty guineas a year from the Privy Purse, and from 6 June 1836 the project came to be known as the Royal Berkshire Hospital.

One of the people responsible for securing royal patronage (and indeed for getting the whole project off the ground) was a retired bank clerk named Edward Oliver. He had supported the idea of a hospital since it was raised in 1830 and had walked the length and

breadth of Berkshire to lobby support for it, from anybody with money or influence. He twice secured an audience with the king to promote the cause. He actually ended his days in the hospital, after being run down by a horse-drawn Huntley & Palmer delivery wagon at the age of seventy-two.

The promoters had great difficulty finding a suitable site for the hospital. One of their favoured options was four acres of land at what was then the eastern end of the town, owned by Lord Sidmouth, the former Prime Minister and a Reading man. He initially refused to negotiate its sale, saying the idea was very objectionable to himself and Lady Sidmouth. No other site appeared to be both suitable and available. But in August 1836 Sidmouth relented, to the extent not just of making the land available, but also of donating it to the hospital at no charge.

An architectural competition was launched. The specification was for a building, faced in Bath stone, capable of accommodating sixty beds and with potential for expansion to 100. The cost was not to exceed £6,000. The winning entry, from a field of fifty-five, was by local architect Henry Briant. Regardless of the competition budget criterion, the lowest tender for the work came in at £9,377, but work nonetheless began in April 1837. (King William had died suddenly in June and Queen Victoria later became the royal patron in his place).

The day of the grand opening of the Royal Berkshire Hospital came in May 1839. There were processions, a church service and a five-hour banquet for 300 guests at the Town Hall (most of them paying 5*s* (25p), excluding wine), with 'an abundance of poultry, hams, shellfish, lamb &c. &c., and jellies and confectionary of every description'. Toasts were drunk to the Queen, the Queen Dowager, the Duchess of Kent, almost every other member of the royal family, the army, the navy and the High Sheriff of Berkshire, to name but a few. Strangely enough, the editorial in the *Berkshire Chronicle* used the occasion as an excuse to lobby for more holidays for the people of Reading:

> This event, so long anticipated by the public, and in which so much interest was naturally felt by the liberal subscribers to the institution, took place on Monday last, May 27 …
>
> Great numbers of our country neighbours arrived before ten o' clock, determined to participate in the festivities of a day sacred to charity and benevolence, and one feeling of pleasure seemed to pervade all classes.
>
> The trading inhabitants of the Borough generally closed their shops, and thus gave themselves, their dependents and family an opportunity of witnessing an occurrence which, while it is calculated to gratify the best feelings of our nature, is one which in the nature of things again gladden the hearts and delight the eyes of this generation … It is singular how few are the external sources of amusement possessed by the large and wealthy borough of Reading…
>
> We say advisedly that the opening of the Royal Berkshire Hospital exhibited an intense and hearty appreciation of an English holiday that ought to be rewarded and cherished by the creation and perpetuity of some annual festival, worthy of the good town of Reading, and its sober and moral population.
>
> *Berkshire Chronicle,* 1 June 1839

As with the Dispensary, there were similar strict rules for admissions to the hospital, which was done on the basis of recommendations by hospital subscribers. They would not take anyone already receiving poor relief, anyone able to pay for their treatment or a living-in servant. A list of specific ailments was also excluded, such as consumption, primary venereal disease, confirmed epilepsy, smallpox and 'the itch'. Nor would they treat the incurable, those 'apprehended to be in a dying state', the mentally ill and children under seven. (Exceptions were made in accident and emergency cases). Admission could be somewhat hit or miss. Some would-be patients could not find a subscriber to sponsor them. Others could find a sponsor, but found the rather grand appearance of the hospital too intimidating, and chose not to take their place up. On discharge, patients were required to give thanks to God and to their sponsor, a rule which was not to change (despite protests) until 1947.

It was estimated that it would cost around £2,000 a year to run the hospital, all of which would have to be raised from voluntary donations, there being no government or local grants at that time. This was to prove an ongoing problem, as the hospital used up all the scope for expansion built into the original design within two years, and almost doubled in size in its first eleven years. Every additional ten beds required a further £300 annual income and two public appeals had to be launched to prevent ward closures and redundancies.

The first patient at the hospital was fifteen-year-old George Earley, predictably a worker on the Great Western Railway construction. He had suffered a compound fracture of the arm, which required it to be amputated at the shoulder. Few operations were carried out at this time, due to the strong likelihood of death, but George survived his, which was carried out without anaesthetic or sterilisation of either instruments or staff. Ten of the first forty-six surgical cases dealt with by the hospital were workers on the railway.

As well as sending them a steady stream of injured construction workers, the completed railway soon provided the hospital with one of its severest tests. Heavy rain caused a landslip in Sonning cutting on Christmas Eve 1841, and a train consisting of third-class carriages (or, more accurately, open trucks) and goods wagons ran into it. The third-class carriages were crushed between the locomotive and the laden goods wagons behind them. Eight passengers were killed and nineteen injured, twelve of them severely. The injured were rushed to the Royal Berks and the treatment they received earned the hospital much praise. The *Berkshire Chronicle* spoke of:

> The first rate medical aid and surgical skill, the most tender and careful nursing, joined to the greatest cleanliness and the most benefiting diet, not to speak of the great spiritual aid and comfort administered by the very able and zealous chaplain.
>
> Quoted in Railton and Barr (1989), page 57

The hospital's growing reputation attracted the attention of the better-off, and they soon received an application from someone wishing to be admitted as a private patient. He was told:

> It was contrary to the rules of the Hospital to admit respectable persons as private patients.
>
> Ibid.

It would be 1851 before the hospital relented and admitted its first private patient.

In the early days of the hospital, the nurses had a relatively limited role. They cleaned the wards, fed the patients and generally kept an eye on them. Their only medical role was to make sure the patients took the medicines prescribed for them. They were totally unqualified, often illiterate and were paid just 5s (25p) a week, plus board and lodging. Good candidates were hard to find, and even some of those taken on proved to be incapable or overly fond of drink – one turned out to be almost totally blind. Not until 1866 did they decide that in future only trained nurses should be employed.

Reference is made elsewhere in the book to the tensions between the hospital and the Poor Law Unions over responsibilities and payments. These became most poignant in the case of patients who died in hospital. Eliza Franklin was a small child, admitted to the hospital in April 1847 with severe burns from which she later died. Her father could not afford the cost of her burial and appealed for help to the Reading and Bradfield Unions. Both turned him down. The hospital secretary then wrote to the Reading Union saying that, if they did not collect the child for burial, the body would be taken to the Relieving Officer's house and left there. The hospital eventually relented and buried the child for decency's sake, but the row about the expense rumbled on for months afterwards.

Patient numbers grew steadily year on year and in 1861 it was decided that more beds were needed. It was decided to expand the hospital to 100 beds, which would be enough for many years to come. 'Many years' turned out to be four, for in 1865 plans were announced to extend the hospital further, to 120 beds. Another twenty beds were added in 1872 and by 1880 all the additional patient capacity made it necessary to provide more accommodation for staff.

The hospital also ran an out-patients' department, open three days a week. Each session could attract up to 100 patients and the chaos was not popular with the medical staff. Many of the poorer out- and in-patients alike found it difficult to afford the expensive surgical appliances, artificial limbs, spectacles or false teeth that their treatment demanded. A 35s (£1.75) artificial arm or leg irons at £5 were out of the reach of a family whose main breadwinner was earning 11s (55p) a week. Since 1841 a convalescent fund existed that would subsidise such items on a case by case basis. The fund might also provide temporary support for a patient when they returned home, or pay for a visit to a health resort, where it was felt it would aid their recovery. The hospital would later even subsidise visits to local convalescent homes in Tilehurst, and to one for tuberculosis patients at Peppard.

Some patients suffered agonies getting to or from hospital in unsuitable cabs or wagons, and in 1882 a decision was made that the hospital should have its own ambulance. A supposedly state-of-the-art 60 guinea (£63) model was chosen, a lean-to shed provided for it and arrangements made to hire a horse to pull it. Details of its rules of operation were sent to all medical men, Boards of Guardians, police stations and railway station masters within 15 miles of the hospital. A second ambulance was bought in 1896, following complaints that the first one was 'draughty'.

The population of Reading had increased threefold between the hospital's opening and 1887, and its running costs had increased proportionately, to £6,000 a year. Fund-raising was a perennial problem. In 1888/9 some 150 patients were turned away for lack of a bed; the hospital was almost permanently overcrowded, but lack of funds prevented further expansion at that time. During the influenza epidemic of 1889/90, admissions were reduced to

emergencies only. The hospital was not helped by the need to keep up with medical advances. In 1882, less than a hundred operations were being carried out each year, but the installation of a new operating theatre in that year meant that the number had risen by 1894 to 322. The theatre had to be substantially rebuilt and updated by 1896, and in 1899 one of the new X-ray machines was installed. Added to all of this, a 1900 survey revealed that the hospital buildings themselves, some now more than sixty years old, needed some £20,000 spending on them.

All sorts of new approaches to fundraising were tried. Huntley & Palmer were persuaded to endow a new ward in commemoration of Queen Victoria's Diamond Jubilee and the idea of endowing individual beds in somebody's name was introduced (£1,000 for a bed, £500 for a baby's cot). A Mrs Lloyd sponsored the fitting out of a room for the use of patients of 'gentle birth' who could not afford treatment at home, and even the children of the town's elementary schools funded a cot between them. Even so, by 1898 the annual deficit was running at around £1,500. Efforts were made to try and find out why, and one of the things that they discovered was that patients were staying in hospital far longer at the Royal Berks than at other comparable hospitals. Other hospitals were treating three patients for every two at the Royal Berks. Efforts were thereafter devoted to shortening patients' stays.

The hospital had had infectious wards since 1870, but these were only for cases arising among people who were already hospital patients. People already infected could not be admitted. As children's wards were created, it led to an increase in the number of children's diseases arising in them. This created a good deal of disruption, stopping new admissions and fumigating wards and bedding. A proper facility for infectious diseases was needed. As we saw earlier, the town council had provided a small wooden building in Bridge Street, which took a few scarlet fever cases, and a corrugated iron hut was built alongside it in 1893 for smallpox cases, but these were hardly an adequate response to the problem. A 10-acre site next to Prospect Park was finally obtained by the town council in 1905, and they built a proper fever hospital for forty public and four private patients, which opened in May 1906. Residents of Reading had use of it for free, while others paid a guinea (£1.05) a week.

Efforts to restrict the numbers of out-patients coming for treatment were unsuccessful, and in-patients could wait for up to fifteen weeks to get a bed. In 1907 yet a further expansion of the hospital was undertaken. New wards were added, including one for noisy patients, along with a new operating theatre and X-ray facility, and a second phase added in 1909. By 1912, the hospital had a capacity of 188 beds.

As we saw, the National Insurance Act 1911 enabled workers earning less than £160 a year to obtain insurance against sickness and unemployment. They would be enrolled with a panel of doctors and could get free medical treatment. Where did this leave them in relation to treatment at the hospital? It was decided that insured workers would be referred back to their panel of doctors in the first instance, to see if they could be treated by them. Their families would not be covered by the National Insurance Act and would continue to look to the hospital.

The First World War lost the hospital many staff to the war effort, and ad hoc arrangements had to be made, including bringing some staff back out of retirement. Medical staff were generally in short supply and some Belgian refugee medical staff were recruited, despite their qualifications not meeting the hospital's normal requirements. Many of the medicines commonly in use were of German manufacture, and the use of these had to be strictly rationed. The hospital made fifty beds available to the War Office, at a price of

3/4*s* (17p) per day per bed, and local firms offered vehicles for transporting the wounded. The first batch of fifty patients arrived in November 1914. A partial blackout against air raids was imposed in February 1915 and insurance taken out against aircraft damage.

All sorts of voluntary initiatives were taken to help the war wounded. Among these, the Chamber of Commerce set up the Reading War Hospital Supplies Depot, making and supplying surgical necessities. The hospital had, by 1915, been rearranged to squeeze in a total of 240 beds, putting great strain on the staff. This was not helped by the loss of staff from the introduction of conscription in 1916, nor by the huge influx of casualties from the disastrous Battle of the Somme the same year. By the spring of 1917, the hospital had further increased its capacity to 264 beds, of which 156 were military.

Until 1918, the hospital had not treated cases of venereal disease, referring these patients to the London Lock Hospitals. But a dramatic wartime increase in cases forced the Royal Berks to set up its own clinic and in-patients facility, paid for by the local authorities of Hampshire, Wiltshire and Berkshire.

Unsurprisingly, the financial position of the hospital was getting critical towards the end of the war, with a deficit heading towards £15,000 by the end of 1917. There were fears of having to close part of the hospital, but a string of public appeals raised £15,496 by the end of 1917. By this time, over 2,000 wounded were being treated in Reading's various war hospitals (the Reading War Hospital actually consisted of the No. 1 War Hospital at Battle, five section hospitals and thirty-six auxiliary hospitals).

After the war, increased costs meant that those who could afford it were now required to pay towards their stay in hospital (2*s* (10p) a day for an adult in-patient and 1*s* (5p) for a child under ten) since, 'The improved status of the industrial and labour classes make it inappropriate that they should have unrestricted access to charitable relief.' (Railton and Barr (1989), page 189).

The post-war years saw many advances in medicine introduced, including a blood transfusion service. This differed from the modern service in a number of respects. Only donors with the universal type of blood were used. They were paid a retainer of £1 a year, re-examined (for syphilis) every six months, and paid four guineas (£4.20) for every 500 cc's of their blood the hospital used (private patients paid five guineas (£5.25). Few donors actually took the payment. Blood was not stored but was taken direct from donor to patient. They started with just six donors but got up to forty-seven by 1937. The threat of war thereafter increased the number to 107.

The Local Government Act 1929 ended the old Poor Law system, and the various roles of the Guardians made way for the local authorities. The needy would be supported by the Public Assistance Committees; the sick by the Public Health Committees and those in the workhouse infirmaries suddenly found themselves in rate-funded municipal hospitals.

Reading Borough Council, already responsible for the Park Hospital, Whitley Smallpox Hospital and Dellwood Maternity Home, plus assorted clinics and other medical facilities, now took over Battle Hospital. The Royal Berks and Battle hospitals had been working ever more closely together since the First World War. The hospital's finances were once again in dire straits and a series of fundraising activities were launched (including a chance to see the wedding cake of the future King George VI and Queen Elizabeth, by which means Huntley & Palmer raised £156 from over 6,000 paying visitors).

In 1938, as the Second World War approached, the Royal Berks began putting air raid precautions in place, including making two wards gas-proof and erecting 100,000 sandbags around the building. They were also told to prepare to accept up to 180 patients, to be evacuated from London in the event of an emergency. Many of its existing patients were returned home, but the Munich crisis came to nothing and the regular patients could soon return to continue their treatment. When the request was repeated in September 1939, this time for room for 400 evacuees, it was for real. In addition, the hospital was told to keep 100 beds empty, for military and air raid casualties. Over and above all of this, the hospital also had to care for a civilian population that would be swollen by evacuation by almost 50 per cent within eighteen months, and the growing numbers of victims of motoring accidents caused by the blackout. The waiting list for beds soon grew to over 500.

The hospital's centenary celebrations, planned for 11 October 1939, were abandoned. Instead, the word 'Berkshire' was removed from the front of the hospital, so as not to give any invading forces a clue as to where they were. On the positive side, the war coordinated the work of the Battle and Royal Berkshire hospitals as never before, with the Royal Berks and its more advanced facilities concentrating on the more acute cases. But equally acute were the staff shortages caused by conscription.

The need for wartime casualty capacity at the Royal Berks became clear on 10 February 1943, when Reading suffered its most serious air raid of the war. A total of eighty-six casualties were brought to the Royal Berks, thirty-one of them needing operations and six requiring urgent blood transfusions. The hospital's three surgeons were all operating until 1.30 a.m. and casualties were being treated until 3 a.m., but the hospital was broadly back to normal by the following day.

The publication of the Beveridge Report in December 1942 set the scene for the post-war health service. The 1911 National Insurance Act was to be replaced by a National Health Service, free to all, regardless of means. The following March, the government commissioned a national *Domesday Book of the Hospital Services.* As with many other parts of the existing health provision across the country, it was not flattering about the Royal Berks:

> The buildings are antiquated and inadequate (with the exception of the new Nuffield Block and the Pathological Department). The number of beds is too small and in consequence the waiting lists are too long. There are some good men on the medical staff, but they are too few and the appointments to the staff are not made in such a way as always to secure the best man for the post.
>
> Quoted in Railton and Barr (1989), page 250

It was similarly scathing about Battle Hospital, saying it was 'not up to the standards of modern hospitals' and was dependent on the Royal Berks for specialist services. The Regional and District Hospitals Council responded in 1945 with proposals for a revolution in health provision in the Greater Reading area and beyond. For the Royal Berks alone it proposed doubling the number of acute beds, from 524 to 1,052, providing 800 surgical beds and seventy-five obstetrics. The medical staff would need to increase from thirty-nine (many of them part-timers) to seventy-nine.

Come peacetime and the appointed day for the new National Health Service was set for 5 July 1948. The hospital began clearing away the traces of the war, re-adjusting to

peacetime operation and preparing for nationalisation. Some of the most urgent new building was delayed, starting with the lack of a building licence until March 1947, with the result that it was not ready before the appointed day. A report in 1947 bore out the earlier one about the shortfall in medical provision and recommended a 1,052-bed hospital be built to serve the Reading area. The problem was that the Royal Berks on its present site could only be expanded to an estimated 700 beds, and there were problems anticipated with the enlargement of the Battle site. But then news came of the university's proposed move to Whiteknights, freeing up several acres next to the Royal Berks and making its expansion to the required size a realistic possibility. The Town Planning Committee duly zoned the former university land east of Redlands Road for hospital use, and the Chief Medical Planning Officer recommended its purchase in June 1948.

Until the hospital became part of the NHS it was partly dependent upon voluntary contributions for its continued operation. But, as the appointed day got nearer, those contributions began to dry up, falling from £19,000 in 1945 to £12,500 in 1947. At the same time, the war years had seen the average cost per in-patient stay more than double, from under £10 in 1939 to £21 15s (£21.75) in 1947. Out-patient attendance costs had risen from 2/8d per patient to 4/7d (13p to 23p) in the same period. The hospital faced a deficit of £41,000 in 1947, with no capital resources it could use to balance the books. It had to be bailed out by the Ministry of Health, at the cost of tighter government control over its financial affairs.

Under the NHS, steps were taken to remove the last vestiges of the Poor Law association from Battle Hospital. The last old people were rehoused from it in 1953, and the last acute beds were removed. But instead of removing the acute beds to the Royal Berks, they were relocated to Prospect Park, giving Reading not one but three centres of acute clinical activity. More generally, there was not yet consensus about the town's District General Hospital(s). The Hospital Management Committee still wanted a single 1,400-bed hospital on the Royal Berks site, but a 1962 Government report proposed two District General Hospitals in the Reading area, for reasons which were, and still are, not entirely clear. The dispute over this led to a so-called compromise proposal, in which the Royal Berks became the town's only District General Hospital, but was limited in size to 1,000 beds by 1975, with an additional 500 beds provided at Battle.

There followed a bewildering process of planning, review, cutback and starting again, which went round and round until 1995, when the government finally approved a scheme to rationalise all the town's hospital facilities onto the Royal Berkshire Hospital site. This led into an eight-year project, culminating in the Queen opening the new facilities at the Royal Berks in February 2006. Today, the Royal Berkshire NHS Foundation Trust (as it is now called) serves some 250,000 people in the Greater Reading area. It is thought to be Reading's largest employer with almost 5,000 staff and an annual budget of £290 million.

Crime and Punishment

Police

Today we tend to take the ability to walk the streets safely for granted. For most of us, the police only come to the forefront of our minds when one of their brightly-coloured cars makes its noisy way past, en route to an emergency, or on those hopefully rare occasions when one is the victim of or witness to crime. But you needed to be either brave or criminal to venture out at night in pre-Victorian Reading. In the days before the town had a police force, night-watchmen employed by the Commissioners of Paving were responsible for keeping the peace in the hours of darkness. But neither the Commissioners nor their employees were trustworthy – they were more concerned with protecting their own interests and saving their own skins.

> Violence of all kinds could be met in the ill-lit streets – much of it concerned with robbery. Highwaymen posted themselves outside the town and drunks and beggars set about each other within it. The watchmen were officially supposed to call the hours, describe the weather and apprehend the felons. In practice they were often drunk and invariably took themselves and their lanthorns as far as possible from the trouble spots.
>
> Wykes, page 3

One of the first actions of the newly reformed Reading Corporation, following the restructuring of local government in 1834, was to put a more effective system of policing in place. The world's first professional police force, the Metropolitan, had been formed in London in 1829, and Reading was one of the earliest towns to follow suit, in 1836. Many similar towns did not take the initiative until well into the 1850s. Its force initially consisted of thirty constables, two sergeants and two inspectors, representing one constable for every 600 or so inhabitants. Many of the new force were ex-military men, though they also included labourers, grooms, gamekeepers and gardeners. Their duties were:

> Keeping the King's Peace in all matters and especially in ridding the Town of Beggars, Unseemly Drunkards, and others who by noyse or action offend the Burgesses of the Town.
>
> Watch Committee minutes, 7 January 1836

The constables were equipped with uniforms, lanterns, rattles for sounding the alarm and short staffs for use as weapons. They were essentially beat police, patrolling a set route, mostly in the hours of darkness. They had to report in at regular intervals and could be disciplined for being late in doing so. This hardly created much incentive for them to use their initiative, for example by pursuing criminals as they fled the scene of their crimes. They were also supposed to regulate the operation of public houses, though this inevitably created other temptations, to which some them yielded.

The pay for a constable – 2*s* (10p) a day – was relatively good for the time, but the selection process was some way from being perfect in the early days. Minutes of the Watch Committee are replete with cases of constables being disciplined or sacked for:

> Drunkenness, insubordination, neglect of duty, gossiping with females, failing to account for money handed to them for various purposes, sitting or lying down and sleeping while on duty, "forming improper and indecent intimacy with females" and accepting gin from compassionate householders on cold nights.
>
> Wykes, page 4

What passed for a police station was to be found at what was then known as 6 Friar Street, near St Laurence's church, the former headquarters of the night-watchmen. They used as their lock-up the roofless nave of Greyfriars church at the end of Friar Street, which had been divided up into dehumanising cells, lacking daylight, fresh air, furnishing (other than straw), or any sanitary or washing facilities. Prisoners survived on a diet of bread and water.

Other punishments were equally brutal – public hanging was still carried out and minor miscreants could find themselves placed in the stocks and bombarded with rotten vegetable matter – or worse. Landowners would protect their property by the use of mantraps and spring guns. The hue and cry, whereby local residents were summoned to pursue a criminal from the scene of the crime, and could arrest them, using anything up to lethal force if necessary, had only been abolished in 1827. Failure to engage in the hue and cry could leave citizens living near the crime scene liable for the victim's losses. The name 'Hue and Cry' was continued in the early title of the *Police Gazette*, at least into the 1850s – Fagin could be discovered reading it at one point in Dickens' *Oliver Twist* (1837–39). People used to advertise in it for the recovery of lost goods and the apprehension of villains.

The new force appointed a Metropolitan Police sergeant, one Henry Houlton, as their Chief Constable in 1839. He and his colleagues found no shortage of illegal activity going on in the town, but gathering the evidence to prosecute the guilty parties was more problematic. The approach of a uniformed constable gave the villains early warning, but putting his men into plain clothes was felt to smack of espionage and to be 'un-British'. The first record of plain clothes activity appears in 1857, when the watch committee approved the purchase of a plain suit (price £2 9*s*, or £2.45) for Detective Constable Hernaman.

Conditions for both the police and their arrests were gradually improved. A new police station and Coroners' Court was opened at High Bridge House, London Street, in 1862 (and furnished by Heelas & Wellsteeds). By that time, the use of the degrading lock-ups at Greyfriars church had ceased, and prisoners at least had cells with light and air, beds and

blankets, and access to a water closet (if not the refinements of the furnishing department at Heelas). A police doctor had also been appointed in 1840.

By 1899 the force's numbers had grown to sixty-two, but the town's population had also increased, to 60,510, giving a ratio of around one officer per thousand – this compared with the 1 to 600 that the force had started out with in 1836. But the town did not suffer from any of the severe law and order problems encountered in the big cities. They also had new technology to assist them – the chief constable's house got a telephone in 1897, fingerprinting came in during 1901, photographing prisoners began in 1906, and in 1904 they got their first typewriter! Also, the formation of the Corporation Fire Brigade as an independent department of the Corporation in 1893 removed the last of the police's fire-fighting duties. Prior to this, since 1844 the town's fire appliances had been placed under the management of the Superintendent of Police and, until 1862, had been manned by police officers.

It was in 1862 that a big fire in the Market Place saw the police's attentions being divided between fighting the blaze and dealing with looters, who were trying to rob a nearby silversmith and were using the fire as a distraction. Fourteen police officers were injured that day, variously by flames and looters, but that did not stop one disgruntled property owner from accusing the Chief Constable of:

> ...concerning himself with the lives of his constables more than with the property of his masters, the gentlemen of this town.
>
> Wykes, page 13

Thereafter, it was decided that a permanent staff of engineers would maintain the equipment and lead the fire-fighting effort, supported by volunteers from the Berkshire Volunteer Rifles, a militia based at Brock Barracks on the Oxford Road. They remained under the overall control of the Superintendent of Police until 1893. (The fire service is discussed further in the chapter on the governance of Reading)

On the subject of emergency services, the watch committee was also responsible for the purchase of the Corporation's first motor ambulance (an army surplus Ford) in 1918. But the police also inherited new responsibilities, such as traffic control. Bicycles and trams were soon joined by the earliest motor cars (initially lumped together with steam rollers and traction engines as 'locomotives'), and traffic management became a growing part of the police workload.

The year 1909 saw a rather more unusual responsibility placed on the police. On Palm Sunday of that year the congregation of St James' Catholic church conducted a procession through the streets of the town. It was perfectly orderly and caused no obstruction, but it caused members of the Evangelical Lay Churchman's Union to rise up in protest. They cited Acts dating back to the Reformation, prohibiting the wearing of Catholic robes or the conduct of popish religious practices in the street, and demanded that any such future inflammatory displays (inflammatory to them, at least) be banned. The Watch Committee at first saw no alternative but to do so, but a flurry of correspondence between the Catholic Bishop of Portsmouth, the Home Secretary and leading legal opinions led to the ban being lifted.

One other unusual role was given to the police in 1920, when they became the town's film censors, deciding which films were suitable to be shown in Reading cinemas. This was despite the establishment in 1913 of the British Board of Film Censors by the film industry, for the local authorities retained the right to override the BBFC's decisions. This was by no means a straightforward matter of banning anything sexually explicit or using bad language. The BBFC themselves laid down forty-three basic rules that film-makers should obey. While thirty-three of these were indeed concerned with 'morality' (that is, references to sex, bad language or bodily functions), ten were overtly political – so, for example, films depicting relations between capital and labour, or poverty, were taboo. Anything 'subversive' – criticising the monarchy, the government, the Church, the police, the judiciary or friendly foreign governments – was also frowned upon. As well as applying all these guidelines, the police censors also needed to bear in mind any peculiar sensibilities among their local councillors.

In 1912 the police took over the former University Extension College premises in Valpy Street. This was for a long time the centre of the town's police operations, though the growing range of activities this covered – including alien registration, crime prevention, lost property, licensing, firearms and statistics – overwhelmed the space available and overflowed into the former *Reading Standard* offices across the road.

One of the most serious breaches of the peace to occur in Reading was during the First World War, on the evenings of 24 and 25 September 1918. Railwaymen, dissatisfied with an agreement that had been negotiated on their behalf, voted for an immediate strike that left many commuters with a long and difficult journey home. The railwaymen were in a reserved occupation, safe from conscription and the trenches, and their action outraged a group of about two hundred wounded ex-servicemen and others living in Reading. They assembled at the Trade Union Club, the railwaymen's local headquarters at No. 40 Oxford Road, were refused admission and proceeded to smash the windows, break the door down and wreck the place. The few police present could not control the rioters, some of whom were using their crutches as weapons, and police reinforcements could not be assembled in time. The demonstrators then rampaged around the town, looking for railwaymen or places where they might assemble. The railwaymen wisely cancelled a planned meeting that night. The rioters assembled again the following night and trashed the Recreation Club next door. Both clubs claimed (and received) damages from the police for failing to maintain order. The local press was generally in support of the outraged rioters, except insofar as the ringleaders were thought to have been Bolsheviks.

Generally the First World War put a serious strain on the police force. Twenty constables were called up as reservists at the outset and another thirty-two volunteered. Some places were filled by Specials and retired officers returning to work, but by 1918 they were still thirty below their establishment of 113.

By the 1920s, criminals – along with other members of society – were getting more mobile. The Chief Constable had a radical idea:

> The need for mobility is urgent. The kinema [sic] is teaching English villains new ways of avoiding arrest; it must also teach us representatives of law and order not to think of these ways as too remote to be dealt with similarly.

Quoted in Wykes, page 15

He suggested the local force follow the American example and invest in a police car and, sure enough, in 1924 a 12-horsepower Austin saloon joined the force. However, this tended to be used for ceremonial purposes, and for ferrying the Chief Constable to his various engagements, rather than chasing villains. The motorised part of the force grew slowly, partly due to Government cut-backs, and by 1931 consisted of just two motorcycle combinations and a single Humber Snipe car. More generally, traffic and traffic accidents were becoming an increasing problem for the town. In 1921, 108 accidents (five of them fatal) were reported. By 1931 the total had reached 1,040. Traffic lights were seen as one answer to the problem and, in 1931, a manually operated set was introduced at the town's worst bottleneck, Cemetery Junction, to assist constables with point duty. Automatic signals were introduced at many of the town's key junctions during the 1930s.

Rapid communications remained a challenge for the force. The first police box, with a direct telephone link to Valpy Street, was opened on the south side of Caversham Bridge in 1928. By the following year there were five in operation across the town and they were later fitted with flashing lights to summon any nearby constable to receive instructions.

The Second World War saw a further loss of police personnel, with thirty-five officers joining the armed forces. Three lost their lives serving with the Royal Air Force, and one constable who remained with the force was among those killed in Reading's most serious air raid, on 10 February 1943.

A further leap forward in communications came in 1946 when the Watch Committee authorised the use of VHF radios in their police cars, having seen how useful they were in coordinating operations during the war. However, technical problems to do with sharing transmitting equipment with the Berkshire Police Force, and a lack of funds, meant that radio cars were not in operation until the end of 1952.

The police force was by no means an entirely masculine preserve. In 1914 the watch committee considered whether a female officer might help in preventing prostitution in the town, and otherwise assisting in the carrying out of their duties in regard to women. Pressure was brought to bear, in the form of a group of socially conscious ladies who formed the Reading Women's Patrol Committee, and the chief constable was persuaded to let them patrol the streets and see what they could do to help. They were soon overwhelmed by the amount of prostitution and female delinquency they uncovered and in 1917 were replaced by two dedicated women police officers, trained in London by the new Women's Police Service.

Their services proved invaluable, though not invaluable enough for the watch committee to allow them the same pay and conditions as their male counterparts. It was 1941 before the first two women were sworn in as actual constables. But the watch committee made up for lost time and, by 1952 the Women Police Department had an establishment of fourteen, thought in percentage terms to be the largest of any force in the country.

One other group who made a particular contribution to the policing of Reading were the Specials, ordinary unpaid citizens who were given uniforms, some training and who assisted the regular police at times of peak demand on the service. They have had a long history in Reading. In 1868 the mayor boasted of having a hundred citizens sworn in 'to assist the police with the crowds at the hustings and on similar occasions when there are extensive movements in the town'. The 'uniform' of the 1868 Special consisted of a badge and a

truncheon. They were particularly valuable to the service in the manpower shortages of two world wars and during the General Strike, and from 1923 they have had parliamentary recognition as a police reserve. The volunteer Specials are distinct from modern Police Community Support Officers, who are generally full-time paid staff, albeit with fewer powers than a regular constable.

By 1966 it was clear that the increasing sophistication of (at least some of) the criminal classes needed to be matched by larger and more sophisticated police forces, and Home Secretary Roy Jenkins announced his intention to do so. It took two years to organise but, in 1968, the Reading Borough Police Force merged with the Berkshire Constabulary, the Oxford City Police and the Oxfordshire Constabulary, to form the Thames Valley Police. Serving 2.18 million people and covering an area of 2,200 square miles, they are the largest non-Metropolitan police force in the country, but even they merged some of their services with the neighbouring Hampshire Constabulary in 2012.

Prison

Standing, as it does, on the rising ground at the entrance to Reading, and close to the site of the venerable abbey, this new prison is from every side the most conspicuous building, and, architecturally, by far the greatest ornament to the town.

The Illustrated London News, 17 February 1844

One of Reading's more dubious claims to literary fame is providing the 'inspiration' for Oscar Wilde's *De Profundis*, written over three months in 1897 while he was serving his sentence for homosexual offences in Reading Gaol, and *The Ballad of Reading Gaol*, written in France after his release from prison. The current prison is a prominent landmark in the town, but Reading's history as a place of imprisonment goes back much further. The medieval abbey had its own prison, a suite of three rooms called the Compter, above the main gateway to the abbey, next to St Laurence's church. There were also other lock-ups in the town at different times – up until 1403 anyone could set up a prison, and they were almost completely unregulated.

It was in that year that Henry IV decreed that Justices of the Peace should only commit prisoners to the common gaol, controlled by the County Sheriff. In 1537, the county gaol consisted of a set of subterranean cells on the site of what is now St Mary's church, Castle Street. It housed a toxic mixture of prisoners on remand, awaiting trial, serious felons from across Berkshire, debtors, religious dissenters (John Bunyan was one such), victims of the navy press-gang awaiting the start of their new 'career opportunity' and petty criminals from Reading itself.

These early days of the prison service, and its barbarities, need not concern us as far as the making of modern Reading is concerned. Our starting point should perhaps be 1844 and the erection of the current (albeit now much changed) prison building on the Forbury. It was built on the site of the previous county gaol, which had been designed in the 1780s by the eminent architect Robert Bressingham (whose other claims to fame include Longleat House and Reading's High Bridge). Eminent he may have been, but his prison was

jerry-built and by the 1840s it was also grossly overcrowded, with 142 prisoners occupying a space designed for 100.

The prison numbers around this time were temporarily swelled by a selection of the lawless navvies engaged on building the Great Western Railway, and the bargees on the Kennet and Avon offered a more regular supply of inmates. The race meetings at Ascot also added substantially to the prison population. Generally, the Victorians had relatively few alternatives to prison for minor offences, and much of the prison population consisted of society's inadequates, serving relatively short sentences for sub-criminal or petty offences. The prison population could also include children as young as seven, like little Frank Stockwell, imprisoned for the offence of arson in July 1884.

It was decided in 1842 to replace the old building with a new gaol, following as far as possible the design of the New Model Prison at Pentonville. Architects were invited to submit schemes under a nom de plume, to avoid any possibility of favouritism. The successful scheme turned out to be by another prestigious architect, George Gilbert Scott and his partner William Moffatt, whose other work included (or would include) the Home Office, the St Pancras Station Hotel, the Albert Memorial (and, more locally, the reconstruction of the collapsed gateway to Reading Abbey). In the finest tradition of all major construction projects, the cost steadily escalated from the £15,000 originally estimated by the Inspector of Prisons (who priced it without having seen the plans) to an initial £24,000 (based on the plans) to a final total of £43,648 (based on the bills). There appeared to have been more than a hint of incompetence in the original costings, such as the architects forgetting to include their own fees, as well as omitting the cost of heating and ventilation equipment in the estimates, and the Justices were not best pleased.

Demolition of the old prison began in August 1842, as soon as alternative accommodation for the prisoners – and the staff who had accommodation within the prison – had been found. The building was finally handed over on 1 July 1844. It resembled nothing so much as a medieval castle (it was said to have been inspired by Warwick Castle) with turrets, crenellated walls and even what looked like arrow slits around the main gate. It remained so until its 1971 remodelling, which owed more to twentieth-century brutalism than medieval romance.

One original design feature that was not required at the time of the remodelling was the flat roof above the gatehouse, used to conduct public executions until they were discontinued nationally in 1868 (Reading's last one was in 1862). The first hanging at the new prison, of a child poisoner named Thomas Jennings in 1845, drew a crowd of 10,000. Many of them gathered in a small paddock where St James' church now stands, or spilled over onto the nearby railway embankment. JP William Darter witnessed several executions:

> Women respectably dressed, some with children in their arms formed a large element of the crowds, whose spirit of levity and brutality stung more and more the conscience of the community.
>
> W. S. Darter (1888) quoted in Southerton, page 104

After 1866, executions were carried out in private, though any Justices of the Peace with a taste for such things could still gain admission. Crowds continued to gather outside on

execution day, and were informed that the execution had taken place by the raising of a black flag and the tolling of a bell at St Laurence's church. The last execution of all to be carried out at Reading prison was in February 1913.

The death sentence was not always reserved for murderers. In 1800 there were no less than 220 crimes punishable by death, including the theft of property valued at one shilling (5p) or more. Juries would sometimes refuse to convict prisoners for some of the more minor offences, knowing what the sentence might be, and prosecutors would try and get round this and secure a conviction by valuing the goods stolen at slightly below the death penalty threshold. But by 1808 at least some of the more minor of these offences had had the death sentence replaced by transportation, and all of those executed at the current Reading Gaol were convicted murderers.

The death sentence was not always inevitable for murder. From 1837 the power to commute the sentence rested with the Home Secretary. (Prior to that it rested with the monarch, but Queen Victoria was considered too young (not to mention her being a lady) to give consideration to such gruesome matters). Until 1861, the trial judge also had powers to commute a death penalty. The hangman, by contrast, had the power to make matters worse, if such a thing were possible. William Calcraft was thought to have been Reading's longest-serving executioner (from 1829 to 1874) and was notorious for his preferred use of the short drop. With this, most of his victims slowly strangled to death, rather than having the merciful release of an instantaneous death from snapped vertebrae.

Pentonville prison (on which Reading was based) was designed to operate on the 'separate' system of prison discipline, whereby prisoners were kept apart from each other as much as possible and discouraged from communication at other times. Outside the solitary confinement of their cells, prisoners were made to wear a form of cap with a large visor that pulled down over their eyes. This had narrow eye slits in that limited their field of vision. Even church attendance by the prisoners took place in separate cubicles, rather than on pews.

The regime in the new prison differed in some respects from that in Pentonville. The latter was designed to prepare prisoners for transportation, who would generally be young, fit and resident in prison for long enough to learn a craft as a means of making an honest living overseas. The county gaol's inmates would be much more mixed, in terms of age, health and mental capability, and were often not inside for long enough to make training a viable option. The authorities would therefore concentrate on deterrence, rather than reform. The approach seemed to work, for word soon seemed to spread that Reading Gaol was not to be recommended and the incidence of serious crime fell (though others thought there were more complex reasons for the decrease). It was also a cheap system to administer, once the additional cost of providing a suitable building had been discounted. On the negative side, it was said that some prisoners had gone mad from the prolonged silence and isolation, which could last for as long as eighteen months.

The spare capacity built into the prison came in useful in various ways. It housed the overspill from Pentonville's transportation cases and in 1848, the year of famine and revolution, took large numbers of men and women imprisoned for vagrancy and workhouse offences.

Prisoners were made to spend long hours in Bible study. In addition, ways were sought of occupying the prisoners with hard labour, following criticism of its absence by the

authorities. Hand mills were installed, to produce the flour from which the prisoners' 'coarse but wholesome bread' was made. Chopping up old railway sleepers to make kindling wood was another favourite and, from 1863, they introduced stone breaking for road-making. Despite using unpaid labour, they somehow contrived to make a loss on the latter in its first year. Entirely pointless hard labour took the form of 'shot drill', repeatedly picking up and putting down a 25-pound cannon ball, for no discernible purpose. For breaches of prison discipline, prisoners could be sentenced to a flogging, a deterrent which was limited from 1898 to serious breaches of discipline (such as violence towards an officer or mutiny) but was not finally removed until the Criminal Justice Act 1967 abolished all corporal punishment in prisons. There was also the dark cell, where prisoners could be kept for days, deprived of all light and fed only bread and water, with heating and ventilation controlled by the warden.

One of the harsh aspects of the new Poor Law regime after 1834 was that breaches of the workhouse rules became breaches of the criminal law, which could be punishable by between seven days and a month's hard labour in prison. It speaks volumes for the regime in the workhouse that vagrants generally found conditions in prison far easier, and there was a constant stream of them winding up in prison for minor breaches of workhouse discipline. In 1909 the prison governor suggested that this be addressed by making the workhouse regime no harsher than that of the prison.

Reading's most famous prisoner was not a convicted murderer, but a man found guilty of gross indecency under the Criminal Law Amendment Act 1887. Oscar Wilde was convicted in May 1895, and served the first part of his two years' hard labour at Pentonville and Wandsworth. His transfer to Reading in November 1895 was prompted by concerns about his declining physical and mental state. He was even assessed for admission to the mental hospital at Broadmoor, but it was decided that Reading offered a more appropriate regime. On arrival he was assigned to cell 3 on the third landing of C wing, and it was under the pseudonym C3.3 that his *Ballad of Reading Gaol* was originally published.

Wilde was unfortunate in his first prison governor. Lieutenant Colonel Henry Isaacson is remembered as:

> … an unimaginative administrator noted for the frequency with which he would award quite severe punishment for even minor breaches of prison discipline. Avowed that he would 'knock the nonsense out of Oscar Wilde' his favourite punishment was to deprive his distinguished inmate of the books which he valued so greatly.
>
> Southerton, pages 110–111

Wilde, in a later letter, described Isaacson as:

> … a mulberry-faced Dictator, a great red-faced, bloated Jew, who always looked as though he drank, and did so … Brandy was the flaming message of his pulpy face.

Fortunately, a younger and more liberal governor replaced Isaacson in July 1896. Wilde was also on better terms with some of his warders. They augmented his meagre prison diet and he helped them with their newspaper competitions, using his literary skills to win a silver

tea service and a grand piano for two of them. Wilde was finally released from prison in May 1897, having been secretly transferred from Reading to Pentonville the night before, to avoid a press melee. He soon left for France, which is where he actually wrote *The Ballad of Reading Gaol*, and where he died in 1900.

Details of attempted escapes tend not to be widely publicised, but a few are known. In May 1879, a female prisoner named Esther Chamberlain managed to escape by means that were never fully understood – the first prisoner to do so in thirty-five years. She remained at liberty for eight days until she was recognised and rearrested at Goring-on-Thames. During the First World War there were several escapes. One of them, a Belgian named Louis Claas said to have had strong pro-German sympathies, later turned up at the prison in the uniform of a British Army private, enquiring about property he had left behind. Another young man named Johnson unscrewed the bars on the gymnasium window, improvised a ladder from gym equipment with which he scaled the boundary wall and descended into the Forbury Gardens using a climbing rope. His freedom lasted two days. One escape in 1969 was well witnessed. The escapee dropped into the Forbury Road and disappeared into the rush hour traffic. He was detained the following day, about a mile from his London home.

Two consequences of the outbreak of the First World War were first that it created an unprecedented number of job opportunities, not least in HM Forces. Secondly, it provided a socially-approved outlet for anyone with violent tendencies. Both of these meant that the prison population began to fall quite rapidly. By November 1915 just seventy-one prisoners were detained at Reading. At the same time, large numbers of enemy aliens living in Britain, and even some from neutral or friendly countries suspected of pro-German sympathies, were being interned for security reasons (19,000 of them by the spring of 1915). The authorities put two and two together, decanted the remaining prisoners and HM Prison Reading became HM Place of Internment. They soon had sixty-eight male aliens in residence.

The prison regime was relaxed somewhat, and the food improved, though particular attention was still paid to incoming and outgoing correspondence. It was a multi-national, multi-lingual community, drawn from sixteen countries and every stratum of society. Work was optional, though welcomed by many to fill the time, and those who opted to do so could potentially earn 14*s* (70p) a week, much more than a front-line soldier.

In July 1916 a group of thirty-seven Sinn Fein supporters were admitted, most of them involved in the Easter Rebellion in Dublin. The authorities did not know whether to treat them as criminals or political prisoners, and they were subject to a hybrid regime, more generous than a prison in some respects (such as food and free association with each other) but stricter in others (no correspondence or visits were initially allowed). The authorities were however fearful of unrest, and stationed an armed guard of soldiers in the prison, where they remained until the end of 1917. A further group of militant Irish prisoners was admitted in the spring and summer of 1918, many of them mutineers from Lewes prison. They were predictably difficult to handle, particularly since recruitment to the armed forces had reduced prison staffing to near breaking point. The last Irish detainees were returned home in March 1919 and the rest of the internees were gone by the end of the year.

For years the prison stood empty, while local people campaigned for it to be turned into flats, a hotel, and new civic centre – anything other than it being left vacant. However, it

remained empty – except for some bizarre uses such as a driving test centre (1936), an army recruitment office (1935), a secure food store and an army surplus clothing depot (1925) – until in the Second World War it was commandeered by the army and given over to the Canadian military for use as a military prison. This ended in 1945, but the boom in crime after the war ensured that Reading prison would not stay empty for long. Since then, it has had a mixed life, serving as an overflow prison for men serving short terms, a place of corrective training for young people and as a Borstal for young offenders. The Borstal closed in January 1969, having developed an unsavoury reputation for violence and brutality, and the establishment was re-designated as a prison. It was at this time that the prison buildings underwent their extensive modernisation, which also gave the opportunity for an archaeological dig, the prison being built on part of the medieval Reading Abbey site.

The use initially proposed for the modernised prison was to house what Southerton called 'socially inadequate' prisoners – those who are threatened, rejected or ostracized by their fellow prisoners (such as paedophiles, informers and corrupt policemen). In 1980 a rising prison population caused the government to reclassify it again, this time to a Category B prison – much the same role it had in Oscar Wilde's day, taking prisoners young and old, convicted or on remand, from a wide catchment area. It soon became one of the most overcrowded prisons in the country. By the end of 1984, over 350 people were in an institution designed for 184, with three people sharing a one-man cell in some cases.

Yet further change came in 1992, when it became a remand centre for young offenders. It was in this guise that the centre suffered a serious riot on Boxing Day 1992. Staff were assaulted, inmates tried to escape using the prison van, a fire was started and parts of the prison severely vandalised. A total of £153,000 of damage was done and staff in riot gear had to be used to reclaim control. The ringleaders of the disturbance got up to five years' additional imprisonment.

Following this, the gaol was upgraded and reclassified yet again, this time as a prison and young offender institution with a focus on rehabilitation. It finally closed in November 2013 and at the time of writing is vacant, its future uncertain. It is a Grade II-listed building and is said to be costing the Ministry of Justice £20,000 a month to maintain. The difficulty is knowing what to do with it. One suggestion was to convert it into a theatre, but (a) would it lend itself to such a use and (b) would such a use generate enough income to maintain the building? A decision is awaited with interest.

Workhouse to Welfare State: Reading and its Poor

Poverty Before 1834

Like most communities, Reading has always had a gulf between rich and poor throughout its history. Going right back to 1524/5, for example, 1 per cent of the town's population owned a third of the town's movable goods, while over a half of the population were living at the barest subsistence level. In this chapter, we look at some more modern examples of poverty in the town and at what was being done to alleviate it.

In his history of early nineteenth-century Reading, Childs devotes several pages to the condition of the town's poor at that time, focussing on their basic needs. Bread fluctuated wildly in price in the period 1809–1815 (between 1s 7d (7p) and 3s 2d (16p) for a gallon loaf – (reckoned to be sufficient for one person for one week) but, even at its cheapest it was expensive relative to average wages. Beer, an essential part of everyone's diet in the days before clean drinking water, was between 5d and 6d a quart in 1816, though its price fell after the Beer Act of 1831. Long spells of frost, when the canals froze and industry went into hibernation, drove coal prices through the roof, while rents on a modest house could be between 2s 6d (12p) and 3s 6d (17p) a week. Compare this with a typical labourer's wage in 1813, of 2s (10p) a day, or even a skilled artisan's 30s to 40s (£1.50 to £2) a week, and it was not hard to see how 'a bad season, a hard winter or a depression in trade resulted in sharp distress' (Childs, page 79).

The winter of 1813/14 was particularly vicious, with twelve weeks of almost continuous frost and snow meaning that no coal reached Reading between Christmas and 9 March. Most businesses had to close down and door-to-door collections were made for the relief of the starving. Charitable aid for those unemployed who were not covered by poor relief was minimal – perhaps 1s (5p) a day for a man and his wife. People pawned what few possessions they had to pay for the most basic food.

At the same time, people were scandalised by reports of the relatively luxurious and indolent lifestyle of the inmates of the pre-reform workhouses, who were alleged to enjoy a generous diet and large quantities of drink in return for no work. The *Reading Mercury* described what it understood to be conditions for the inmates of the workhouse:

The workhouses were clean and kept in good order. Food was not stinted and good beer provided. The sexes were separated at night but during the day all classes young and old, needy and undeserving would meet in the workhouse yard. The poor were

said to be better off than half the rate payers in the town. Outdoor paupers received nearly the same income without work as independent labourers could obtain by hard work.

Reading Mercury, 15 April 1833, as recounted by Kneebone

Small wonder that only death generally got them to leave the workhouse, and it seemed to some that '... the idle and vicious were able to live in more comfort than the industrious and virtuous' (Childs, page 83).

The total cost of poor relief became an unacceptable burden for many of those who had to pay for it. In St Laurence parish the Poor Rate doubled between 1804 and 1830, and by 1817 it was costing the population of Reading as a whole about £1 a head each year.

The New Poor Law

This all changed from 1834, when the Poor Law Amendment Act radically reviewed the creaking parish-based Elizabethan legislation. The aim of the review was to create a regime so harsh and unpleasant that none but the most desperate would have recourse to it (thereby reducing its cost). The old and sick would still be cared for but the able-bodied pauper 'shall not be made really or apparently as eligible as the situation of the independent labourer of the lowest class'. Anyone receiving parish relief should work as hard for less money than independent labourers. Individual parish provision was replaced by (what was hoped to be more efficient) groups, or unions, of parishes. In Reading's case, the three Reading parishes were grouped together, along with Southcote and Whitley, to form the Reading Union.

The workhouse diet consisted of two meals a day, with meat served only three times a week (even this 'privilege' could be withdrawn, and the meat replaced with bread, for minor transgressions). The official 1867 food guidelines for the workhouse at least sounded more generous, though they were notable mostly for their vagueness. According to them, the food should be:

> ... plain and wholesome, the quantity sufficient without being excessive and the composition and cooking such as to render it palatable so that waste can be avoided either from the food being more than the inmates require or from the food being distasteful to them.

Railton and Barr (2005), page 20

The guidelines also specified that tea should not have both milk and sugar, and that beer should only be given to the patients in the infirmary on the Medical Officer's direction. The total cost of maintaining an indoor pauper in 1867 was 5s 10d (28p) per week, and the Guardians were constantly on the lookout for economies. One that was not successful was Australian tinned mutton. It was ½ d per pound cheaper than the meat it replaced, but the inmates hated it and much of it was found to have gone rotten. Three other workhouses that bought it found that only 12 pounds out of the 144 pounds they had bought were edible. Generally, the food was bought by competitive tender, so quality tended to be sacrificed for price.

One thing the Reading workhouse did not stint on was beer. In 1870, it was found that they spent more on it than any other Union in Berkshire – £1 4s 3d (£1.21) per head per year, compared with the lowest spender, Wallingford (who spent 7s 6d, or 37p). Portion sizes were set down in detail in the workhouse regulations and strictly measured at each mealtime. Even more detailed prescription was introduced in 1901, when twelve different classes of pauper were introduced for dietary purposes (twenty, if one includes sub-categories). Each required their own diet and portion size. This must have been a nightmare for those preparing and serving the meals. The diets were still notable for the preponderance of bread and cheese and the relative lack of meat.

Not just food, but all the residents' needs had to be catered for (and competitively tendered for). For example, they employed their own barber, who for £20 a year gave each resident who needed it a shave twice a week. They even sought tenders for funerals – the winning bidder would despatch someone under eight weeks old for 15s (75p), while anyone over fifteen got the £1 17s (£1.85) funeral.

Most unions addressed their overcrowding issues within a few years of being established, but Reading took about thirty. At first they coped as best they could, using some of the old pre-1834 facilities (the workhouse for St Laurence's parish was closed and its residents distributed among the other two parish workhouses. Tramps – or the 'wayfaring and vagrant poor' – were housed in an old granary in the Forbury until 1892, when they were moved to the Oxford Road site of the new workhouse).

By the 1860s the population of Reading had grown by a third since the new Poor Law came in, and the Union was experiencing severe overcrowding. Men were sleeping two to a bed and the Poor Law Inspectorate's annual report was scathing:

> The only remedy for the most defective state of the accommodation ... is the erection
> of a workhouse which will remove the discredit which the existing buildings bring
> upon so important a union as that of Reading.
>
> Quoted in Railton and Barr (2005), page 5

The Guardians finally agreed in 1864 to build a new workhouse. An 8-acre site, straddling what was then the borough boundary at Oxford Road, was acquired and an architectural competition organised. The penny-pinching overseers made this process a nightmare, with the architects having to design down to a price rather than up to a standard, and to build a scheme that was far too small for the town's needs. Nor was the design finally chosen (that of a Mr Woodman, one-time Borough Surveyor and the man responsible for the restoration of the old Town Hall) the one preferred by either the public or the Poor Law Inspector. The Poor Law Board forced many aspects of it to be redesigned but, even so, the workhouse had to be further extended within three years of its opening, and many design faults were evident from the start. There was no provision for married couples to stay together; the dining hall was too small and the infirmary so cramped that contagion would spread like wildfire, along with a host of more minor faults. All the alterations meant the total cost escalated from the hoped-for £6,700 to £13,747.

Relations between the Poor Law Guardians and the Royal Berkshire Hospital were sometimes fraught. The Medical Officer of Health and the Poor Law Board both

recommended the Guardians to subscribe to the Royal Berkshire Hospital, to give them access to the more advanced facilities available there. The workhouse had had dealings with the hospital in the past, when people suffering accidents and being sent to the hospital made themselves casual paupers as a result. The hospital tried to get the Guardians to pay 7*s* (35p) a week towards the care of each one but the Guardians declined, on the grounds that their own medical officers were contracted to look after all the parish's sick, wherever they may be languishing.

But medical science was advancing rapidly, and operating theatres, anaesthetics and antiseptic treatment were just some of the facilities the workhouse infirmary could not offer. By 1867 Reading was the only workhouse in the area not subscribing to the hospital, but they finally changed their minds when faced with the need to amputate one of their inmates' legs. Care for patients in the infirmary tended to be fairly rudimentary. Patients were all too often left in the care of untrained and unpaid fellow paupers.

Special provision had to be made for tramps (or 'casuals', as they were called). Reading received a good few of these, and provided bed and breakfast – or, to be accurate, a straw mattress, bread and water – in return for manual labour, picking oakum. The tramps were not popular with local residents, since some of them used to loiter around the Oxford Road, awaiting admission (once the casuals' accommodation had been relocated to the main workhouse site). Cleaning up the verminous tramps was a major challenge for the workhouse staff; some tramps would arrive late, specifically to avoid bath-time, with the result that future occupants of their beds would themselves get infestations. Bath-time had its own hazards, for it emerged in 1904 that up to four tramps had to take it in turn to use the same bathful of water (whereas male imbeciles had the relative luxury of sharing three to a bathful).

The stigma of the workhouse clung to the infirmary throughout its life. As we saw, early attempts to get mass vaccination against smallpox struggled, because the vaccination was administered by the medical officers for the workhouse, and to accept it looked to some as if you had in some way sought parish relief. Similarly, before the town got its own fever hospital, people would refuse to be admitted to the infirmary's facility for the same reason. One girl who returned from London, having contracted smallpox, refused to go into the infirmary and stayed at home, with the result that several of her family also went down with it.

It was also felt by many to be shameful for a child to be born in the workhouse, so mothers would leave the place of birth section of the birth certificate blank. This became illegal after 1904, so mothers would record the place of birth as No. 344 Oxford Road, the postal address, without making any reference to the institution. A further stigma was the uniform that inmates were required to wear. Attempts to have the uniforms abolished completely were rejected by the management, though they did at least concede a 'less distinctive' uniform for the over-sixties and those going out from the workhouse into the community. Last but not least, the term 'pauper' was felt by the inmates to be degrading, and this got changed in the official-speak of the early twentieth century to the 'chargeable poor'.

Reading's growing population, further fuelled by its boundary extensions, meant that the workhouse had an ever-larger clientele. From an institution that catered in 1867 for 250 people, the workhouse grew by 1911 to one with a capacity of 650. The site also grew, from

the original 8.5 acres to 36 acres by 1909. Not all of this land was used for new buildings. Some was given over to a 'most productive' garden, producing vegetables which fed the inmates or were sold in the town (they also kept a cow and some pigs). Other parts were given over to space which could be devoted to providing labour for the unemployed. Like many Victorian towns, Reading suffered from seasonal unemployment, the victims of which could end up becoming a charge on the Poor Rate. For their part, the Guardians approached the Mayor in 1882, to see whether the Urban Sanitary Authority could provide work for the unemployed, which would save on outdoor relief and thus reduce the Poor Rate. Over the years, the Guardians were themselves pro-active in making land available for publicly-funded unemployment relief, or even finding work within their own site that could be undertaken by the seasonally unemployed.

Regulation of life within the workhouse could be tiresome. Until 1892 smoking was banned, except on special occasions, meals had to be eaten in silence and written permits were needed for inmates to venture out of the workhouse.

There were some groups for which the workhouse did not care directly. Orphaned or abandoned children were sent to a residential District School at Wargrave, run jointly with the Wokingham Union. This institution was abandoned in 1901, in favour of smaller 'scattered homes' (more like what we would call foster homes). As for the mentally ill, 'idiots and harmless or chronic lunatics' (to use the politically incorrect terminology of the day) were housed in separate wards in the workhouse, while more serious, criminal or violent cases had to be sent to a purpose-built asylum.

The Guardians were constantly on the lookout for ways of reducing the numbers claiming poor relief. One such involved the ninety-five children who were placed at the Wargrave District School at the Reading Union's expense (£80 to £100 per year) in 1870. It was decided to send a batch of them, aged seven to thirteen, to a new life in Canada. Ten girls were sent initially, followed by a party of ten boys the following year. Nothing seems to be known of what became of them, though the workhouse appears to have sent further groups over the following years. Another money-saving measure was aimed at easing pressure on the infirmary. It involved the opening of a Union Dispensary at Thorn Street in 1873 that would dispense medicines, medical advice and medical appliances, all aimed at preventing those patients receiving outdoor relief being hospitalised. Some questioned how wise it was to extend free medical care beyond the pauper class, on the grounds that it would be an additional burden on the public purse and would diminish self-reliance.

One good reason for avoiding going to the infirmary was the health risk involved. The rudimentary nature of care there is referred to elsewhere, but it also suffered from chronic overcrowding for much of the time. The beds (themselves only 2 feet 9 inches wide) were crammed too closely together and in one ward, full of very ill patients, 'the heated atmosphere, combined with the effluvia rising from so many sick persons was almost intolerable ... and how a sick person could live there was a mystery' (Railton and Barr (2005), pages 29–30).

For those patients who failed to survive the workhouse infirmary, one final potential indignity awaited. Before 1832, the only legal source of bodies for scientific purposes, or for teaching in medical schools, was executed criminals. The medical schools nationally needed about five hundred a year and the arrangement worked, so long as that many people were

being executed for a host of relatively minor offences. However, by the nineteenth century, the reduction in the list of crimes carrying the death penalty meant that executions fell to about fifty-five a year. The shortfall gave rise to the trade of body-snatching and the Resurrectionists. The stealing of bodies from their graves was considered only a minor misdemeanour, one often overlooked by the authorities (whereas stealing of artefacts from the grave that the deceased had hoped to take with them into the afterlife was a more serious felony). The business got even more out of hand when the likes of Burke and Hare shortened the supply chain, by cutting out the undertaker and murdering people to provide the bodies they then supplied to science. Activities like these resulted in the Anatomy Act 1832, which widened the potential sources of bodies to include such things as unclaimed corpses or those donated by relatives.

In 1892 Oxford University approached the Guardians with a request for any unclaimed bodies of dead paupers to be forwarded to them, for dissection in their schools of anatomy. A previous request had been turned down, but this one was accepted (the Guardians had the power to do so under the 1832 Act). The bodies were to be sent by train to Oxford and, after dissection, the pieces would be interred in Holywell churchyard 'in a decent and orderly manner'.

Something else that could not have benefited the inmates' health was the workhouse's sanitary arrangements. The cesspit system failed early on, in January 1868 (partly due to the inmates being unfamiliar with the workings of such luxuries as flushing toilets and running water, and misusing them). A connection to the mains sewer was considered too expensive at £1,225, so a primitive system of earth closets was used. With this, solid waste matter was mixed with earth and spread across the workhouse gardens to fertilise them. Waste liquids were allowed to drain along open channels, to irrigate the workhouse grounds.

Come the First World War, and the whole of the workhouse (except the casual wards) was taken over in March 1915 for a war hospital (one of the largest in the country). As for the original workhouse inmates, the Guardians used Grovelands School as a make-do infirmary, put the aged and infirm in Prospect Park Mansion House and turned the casual wards into receiving wards, where incoming patients were assessed. Those workhouse inmates who could not be housed locally were boarded out to Newbury, Wallingford, Basingstoke and Hungerford. It was not only the workhouse that was requisitioned. By the end of 1914 the government looked to Reading to provide over a thousand bed spaces for wounded soldiers, and the Battle, Wilson, Redlands, Katesgrove and Central schools were also turned into makeshift hospital accommodation. If the disruption of moving were not enough, most of the male staff of the workhouse joined up, and the Guardians found themselves having to employ women clerks for the first time.

The workhouse itself was turned into a 400-bed war hospital, and was soon receiving convoys of up to 150 wounded soldiers at a time. It became one of the best-equipped war hospitals in the country and was visited twice by the king during the war years. The buildings were eventually returned to the Guardians after the war and in 1921 the workhouse became Battle Infirmary, dedicated to the care of the infirm and aged poor. It would continue to perform this role until 1953, well into the National Health Service era.

The Guardians and the local authorities had, over the years, taken on a range of additional health-related responsibilities, and post-war governments began to think about

rationalising these. As early as 1920, a government committee under Lord Dawson was envisaging something that looked very much like a National Health Service, but economic conditions at that time prevented it coming to fruition. There were, however, efforts to integrate the services better. The voluntary hospitals, the Poor Law Guardians and the local authorities all had overlapping health responsibilities and the period from 1922 to 1926 saw the government encouraging greater cooperation between the Royal Berkshire Hospital and Battle Infirmary, with Battle making some of its surgical beds available to reduce the waiting list at RBH. There was some initial resistance to this at first from the RBH, with some of their staff regarding Battle's facilities as inferior (possibly a hangover of the workhouse stigma). But the transfers got under way from 1928, and thirty-six of the 103 operations performed at Battle in that year were referrals from the RBH.

Life at the post-war Battle Infirmary was rather more relaxed than hitherto. The inmates were now called patients, there were more entertainments and the food improved, the uniforms went and patients were allowed to go out of the institution without prior permission. By the 1920s the site was being run more like a hospital than a workhouse, and it seemed incongruous still to have the casuals' (tramps') wards on the site. A new 12-acre site for a casual ward was eventually found, just off the Bath Road at Woodley (near the present day Norwich Drive). Wokingham Council and the local residents were up in arms at this, complaining that tramps were 'a most undesirable class of individual' who would cause 'serious depreciation of the value of property' and be 'a menace to the health of the community'. Wokingham Council even tried to refuse the plans, but they were firmly overridden by the government.

Unemployment after 1918 put a great strain on the Guardians' finances, as they paid relief to the families of the unemployed. At one stage some three thousand people in Reading were receiving Poor Relief and ninety people were being directly employed by them to carry out earthworks to reclaim parts of the workhouse site. They also supported hunger marchers from Oxford, coming through the town in 1922 and 1923, by providing them with food, blankets and baths. By 1924 unemployment relief accounted for 88 per cent of the Poor Rate. Eventually they were forced to cut the rates of payment, prompting an angry response from those in receipt of them. Some of the Guardians had to get a police escort out of a meeting when they were met with showers of stones.

The end of the Poor Law Unions came with the Local Government Act of 1929, which transferred their responsibilities to the local authorities. The Guardians held their last meeting on 31 March 1930 before handing over a 580-bed infirmary with 36 acres of grounds for the local authority to use to provide public health services. It was no longer part of the Poor Law regime, the patients were no longer limited to paupers and the staff became council employees overnight. What had been Battle Infirmary now became Battle Hospital.

The casuals' wards for tramps were still based in Oxford Road as the handover took place. They were not allowed to have more than one old penny about their persons as they entered, or they would be required to pay for their accommodation, so they used to bury any valuables they had in a grassy bank near Valentia Road, marking the spot with a secret symbol. (Small boys used to delight in switching the symbols around). They finally got to move to their new accommodation in 1931.

The old casuals' wards were still vacant when, in the summer of 1935, Reading suffered its worst outbreak of diphtheria since 1911. There was a shortage of isolation beds throughout the town, and the casuals' wards were able to play a significant part in managing the crisis. More generally, the Battle Hospital and the RBH continued to cooperate ever more closely, though there was still a tendency for some RBH staff to look down their noses at the relatively limited facilities Battle could offer. Efforts to address some of the accommodation shortages at Battle, such as the shortage of adequate nurses' accommodation, were first delayed then put on hold indefinitely as, from 1937, the town's hospitals began concentrating on putting themselves on a war footing.

The war years brought the town's two hospitals ever closer into cooperation, and did much to ease the 'them and us' tensions between them. Come the end of the war and chronic staff shortages began to emerge, in particular of nursing staff. The lack of nurses' accommodation, which had not been properly addressed since the Poor Law days, was particularly unhelpful in this respect. Things got so bad that volunteers had to be brought in to help the over-worked nurses feed semi-conscious patients. Attempts to recruit locally were unsuccessful and moves were made from 1946 to attract recruits from the colonies, something that would become vital to NHS staffing in years to come. Nor were the equipment shortages of the immediate post-war years helpful. The Post Office was unable to move the hospital switchboard for a year and, when the hospital's ambulance caught fire, Austin quoted them a six-month delay in repairing it.

In 1948 Battle Hospital became part of the National Health Service, a general hospital. This represented a new opportunity finally to shake off the stigma of the workhouse. The National Assistance Act 1948 did away with the last vestiges of the old Poor Law, placing a responsibility on local authorities and the National Assistance Board to house and meet the subsistence needs of the disabled, sick, aged and others in need. But there was a declining but still significant number of such people living at Battle, and this created a tension. They came to be seen as 'bed-blockers', preventing the hospital (which was itself severely short of beds) from fulfilling its health role. In addition, some of these inmates were being kept in highly unsuitable conditions, with children with mental health problems being kept among groups of senile destitute old women. These 'Part III' inmates, as they were called, needed to be rehoused into old people's homes or other more suitable accommodation.

It was always clear that Battle as a hospital would play second fiddle to the Royal Berkshire. A 1947 study ruled out the option of concentrating Reading's medical services onto the Battle site. Nonetheless, they added a new maternity unit in 1952 and another block in 1972. But in 2005 Battle Hospital was closed and all its services switched to the Royal Berkshire. The hospital has since been demolished. Today, the only therapy practiced at the Battle hospital site is retail therapy, courtesy of a new large supermarket subsequently built on the site.

Living in Poverty

In the autumn of 1912, at about the time that the Palmer family were making their £150,000 donation to what would eventually become Reading University, A. L. Bowley, a lecturer at the University College, conducted a survey of the living conditions of Reading

people. He took a sample of 840 houses in the borough (about one in twenty) including about 600 working-class homes. These were visited, and compared with conditions for working people in three similar towns (Northampton, Stanley and Warrington).

In relation to housing conditions, they took a space standard of one adult per habitable room (children counted as a fraction) as the acceptable maximum. On this basis, less than one Reading house in seven was deemed to be overcrowded – worse than any of the comparison towns, but still lower than for most county boroughs. However, rents were high, taking almost 25 per cent of the wages of those earning between 20s and 30s (£1 to £1.50) a week. 67 per cent of Reading's working class families paid 6s (30p) a week or more for their accommodation (more than any of the other towns studied – the figures for which were 54 per cent or less).

He found that Reading had an unusually high proportion of low-paid unskilled workers, the worst of the study towns. This was partly due to the town having a significant unskilled agricultural sector. Huntley & Palmer were by far Reading's largest industrial concern, employing between a quarter and a fifth of the town's working-class population. In the course of recent industrial unrest, they had revealed that their average male employee was making 24s 2d (£1.21) a week, including overtime and lost time – so half of the group earned less than this.

From this, Bowley was able to calculate that more than one working class person in four in Reading (and nearly one in five of all Reading families) were living in primary poverty – that is, below the minimum level of income needed just to maintain physical health. This minimum figure, Bowley calculated, was 22s a week (£1.10) for a family with two young children and 24s 9d (£1.24) with three. This meant nearly half the town's schoolchildren and 45 per cent of those under school age lived in impoverished households. Half of those Reading households living in poverty had breadwinners whose wages were too low to support a family of three or more children. With 20.4 per cent of the working classes below the poverty line, Reading scored far worse than Warrington (11 per cent) or Northampton (6 per cent).

Bowley revisited Reading in the 1920s and found a marked change. Average working class wages, which in 1913 had been between 21s and 23s, had risen to between 42s and 46s (£2.10 and £2.30). Reductions in average family sizes had also helped reduce the numbers in poverty, which in Reading had fallen to 8 per cent. The reduction in household sizes was most marked among those households who had aspired to home ownership – less evident on the town's local authority estates.

Reading suffered less than most from the effects of the inter-war depression, but was not entirely immune. Many of the unemployed turned to the Poor Law Guardians and at the height of the recession the council (who by then had inherited this responsibility from the Guardians) found themselves paying out £850 a week in outdoor relief, plunging them into a budgetary crisis. A voluntary group was set up to provide allotments to help the unemployed feed their families, and the Reading Tuberculosis Dispensary Care Association reported a large increase in the disease among the unemployed. An extra wing had to be provided at the Park Isolation Hospital to cope with it. A camp for the unemployed was set up at Sutton Courtenay and the Prince of Wales (the future Edward VIII) visited it in July 1933. He joined them for an al fresco cold lunch, shedding the formality of hat and jacket to do so, and offered the campers advice on sunbathing. Berkshire County Council prepared

its own schedule of unemployment relief works, which had the jobless cutting back roadside verges and clearing the waterways under bridges.

In February 1934 hunger marchers from South Wales, en route to London, planned to make an overnight stop in Reading and the council's help was sought to accommodate them. It led to a rather unseemly debate:

> There was a somewhat heated discussion at Tuesday's meeting of the Reading Town Council on a proposal to provide accommodation for the unemployed marchers who are to pass through the town on 18 and 19 February. The Estates Committee had offered the lairage hall at the Reading cattle market, where a similar body of men slept on a previous occasion; members of the Labour Party objected, stating that the men would get no comfort, and the hall would not be heated. The Reading Solidarity Committee, who applied for the accommodation, wrote that they would like the Corn Exchange, and if not that, the town hall or some other suitable building.
>
> The Chairman of the Estates Committee (Alderman Maher) said there was insufficient sanitary accommodation for four hundred men at the Corn Exchange and there would be great difficulty in cleansing the place after the men had left. He pointed out that the Labour Party were doing nothing for the hunger marchers. After a lengthy debate the recommendation of the Estates Committee that the men should be granted the use of the lairage hall was approved.
>
> *Berkshire Chronicle*, 9 February 1934

The Borough Surveyor was authorised to provide straw for bedding, sanitary conveniences and water for washing. Fires were not to be allowed. Alderman Maher said that 'with four hundred men there it would be quite unnecessary to have any artificial heat in the place'.

The hunger marches were largely promoted by the National Unemployed Workers' Movement (NUWM). This was a body set up in 1921 by members of the Communist Party of Great Britain, to highlight the plight of the unemployed and to campaign against the Means Test. Their involvement meant that the Labour Party, fearful of any association with communism, did relatively little to support more radical measures to help the unemployed in the inter-war period. This did not stop the Reading branch of the NUWM making ambitious demands on behalf of their unemployed brothers. They called in June 1933 for:

- Provision of work for all unemployed persons in Reading at trades union rates of pay, or full maintenance until such work is provided;
- Abolition of the Means Test;
- Abolition of all social service centres;
- Abolition of the Mayor's Fund;

In the (near-certain) event that these would not be conceded at once, they demanded as a fall back:

- Immediate relief of 15s 3d (76p) a week for all men disqualified under the Means Test;
- Women ditto 10s (50p);
- An additional allowance to each unemployed householder of 25 per cent of the house rent;
- Provision of suitable footwear for all children of unemployed parents, this to cover the holidays, as well as when the schools are open;
- Provision of one hot meal a day when schools are open and in holidays for the children of unemployed parents;
- A day's outing to the seaside with free meals and amusements for ditto.

Reading Mercury, 1 July 1933

Housing for the Poor

Housing is one of the major concerns for people on lower incomes, and Reading Council has had powers to intervene in the housing market ever since the Public Health Acts of 1872 and 1875. However, these were purely permissive powers, and depended upon the local authority taking initiatives. Despite the best efforts of Reading's first Medical Officer of Health, and in common with many local authorities of the day, such initiatives were few and far between. In 1890 the Housing of the Working Classes Act gave authorities powers to set up improvement schemes and actually to provide working class houses. But by 1898 the council had only managed to establish a Housing of the Working Classes Sub-Committee, which reported that the 'cumbrous and difficult' nature of the Act made comprehensive clearance and redevelopment of slum areas virtually impossible. Until 1906, the council restricted itself to piecemeal closures of unfit houses and requiring improvements to individual substandard private rented properties. By 1906 the sub-committee went so far as to ask the Borough Surveyor to report on the costs of providing council housing at economic rents. But nothing happened until 1914, when a scheme to build a council housing estate to relieve overcrowding was overshadowed by events on the continent.

The era of council housing began in Reading with the passing of the Housing and Town Planning Act 1919 and the establishment of Reading's own Housing and Town Planning Committee. A wartime proposal to acquire land at Southampton Street for council housing had come to nothing, but 1917 saw Ewart Culpin, the Secretary of the Garden Cities and Town Planning Association, commissioned to report to the council on the housing of the working classes. He evaluated the suitability of various development sites for housing and the options for making up what the Ministry of Housing saw as Reading's housing shortfall of 500 houses. He looked at either a lot of little infill sites in the town, or a single big housing estate on the outskirts. Unsurprisingly, given his garden city background, he preferred the single estate option, not least because it was easier to supply new development with the social infrastructure it needed, if the housing was in one area, rather than scattered throughout the borough. Culpin attached much importance to this aspect of the new housing:

It is not safe to prophesy, but we may well take it for granted that in the future the workers will demand a larger share of the better things of life and more provision for the enjoyment of education and recreation.

Housing of the Working Classes, page 4

The council agreed with Culpin's analysis, and resolved to prepare a comprehensive scheme 'for the provision of about 500 houses, on the Garden City principle, in the southern part of the Borough'. Culpin was re-engaged to take the matter further, and reported back to the Housing and Town Planning Committee on 18 November 1918:

The only area that seems suitable for the carrying out of a properly-designed scheme is that known as Ayres Farm, on the east of the Basingstoke Road, south of Long Barn Lane and opposite the Corporation's property at Manor Farm. The land is pleasing in character, is well situated for drainage, is within about ten minutes' walk of the existing tram terminus and is on a bus route.

It was also downwind of the sewage works, with its notorious 'Whitley whiff'. But Culpin had dismissed this, when considering an extension of the housing onto Manor Farm itself, saying that he did not find that the inhabitants of the houses in the neighbourhood had any special complaint. However, he did acknowledge that the method of sewage disposal was about to be changed and recommended that no housing should be built on Manor Farm until that change had taken place and could be reviewed.

Labour politicians were among those who were less than convinced by Culpin's proposal and managed to get the Ayres Farm site rejected. Instead, the council went for two of Culpin's other sites, at Shinfield Road in the south and the Norcot estate in the west.

It was a frenetic time for public sector house-building. The post-war government had promised 'homes fit for heroes' and, putting housing needs aside, saw house-building as one means of alleviating the chronic unemployment that followed the end of the war. Local authorities were told to prepare and submit a scheme for meeting local working-class housing needs. It would become a duty to do so under the Housing, Town Planning &c Act 1919, the so-called Addison Act, which aimed to build 500,000 houses nationally within three years. But the Association of Municipal Corporations urged councils to go further, and submit their proposals without waiting for the Housing Act to pass into law.

In their search for housing land, the council was aided by enterprising private landowners, and sites on every corner of the borough (and beyond) came under the spotlight. They included Honey End Farm, land at Kings Road/Orts Road, the part of the Caversham Park estate fronting onto Henley Road, 45 acres of the Balmore estate in Caversham and no less than 1,150 acres of the Bulmershe estate. Some, such as Blagrave Farm at Mapledurham and land at Shinfield (as opposed to Shinfield Road), were dismissed as being 'too far distant from the Borough to be suitable for dwellings for workpeople employed in Reading'. One sale that did go ahead was 46.5 acres of the Whitley Park estate. This was offered to the council by the Palmer family, who were sufficiently keen to see the scheme go ahead that they reduced their original asking price of £200 an acre to £150. Arthur Newbery also sold housing land in Whitley to the council in 1929.

The council raised its target of 500 houses to 600. Not everyone was delighted at this; the Chamber of Commerce petitioned the council:

> To take every precaution in their housing scheme that the number of houses they propose to erect are actually required in view of the fact that Reading has had a swollen population during the war and the present requirements are not evidence of future needs.
>
> Minutes of the Housing and Town Planning Committee, 6 October 1919

The council airily replied that the number was sufficient for both present and future needs, prompting the chamber to respond more forcefully:

> [The Chamber] strongly protests against the policy of building houses for prospective needs that may not be realised, and urges the Town Council to build only those houses that are actually required at the present time.
>
> Ibid.

This made the council even more resolute, saying that 600 was the minimum for which they could plan. By 1921, 101 local authority houses had been built and occupied in Reading. Ironically, at a time of serious unemployment, there was an equally serious shortage of skilled building tradesmen, and this was delaying the house-building programme. Local authorities were even given powers to delay non-residential building projects, where these were felt to be holding up house-building. In Reading this affected a variety of schemes, including the works on the Vaudeville Cinema on Broad Street and what was referred to as the new super cinema on Friar Street, the new Reading Post Office in Friar Street, a clubroom at the Prince of Wales pub in Prospect Street, Caversham, a restaurant and bedrooms in the Great Western Hotel, the Midland Bank in Broad Street, right down to some sheds on the Huntley & Palmer site.

Where jobs were being created by the state housing programme, the Minister of Health told local authorities that, in engaging men for this work ex-servicemen should be exclusively employed or at any rate definite preference given to such men. But house-building was not the only weapon in the government's programme to counter unemployment. A proposal was made to turn part of the Norcot estate into allotments so as to alleviate possible distress in the borough due to unemployment.

Progress during the 1920s and 1930s was patchy, due partly to the stop-go policies of successive governments and partly to economisers on the council resisting any form of local authority spending. As the 1919 Chairman of the Housing Committee put it, 'the most wasteful and extravagant of all systems is state management; the next [most] wasteful is municipal management'.

None the less between 1931 and 1939 the council declared thirty-five clearance areas, the occupants of which needed to be rehoused somewhere. However, Clapson suggests that many properties may have been condemned between the wars but not pulled down because of the housing shortage. This would reflect the situation nationally. Certainly, the 1920 criteria for Reading's housing waiting list identify a whole series of priority groups

(former members of the armed forces, widows and other dependents of the war dead, right down to the overcrowded and to people living out of Reading but employed in the borough) but make no mention of those living in condemned slum housing. But if the housing authorities did not regard them as a priority, the slums were certainly on the mind of the Medical Officer of Health, who saw them as potential death-traps for their occupants:

> ...insanitation, deficient water supply, lack of adequate lighting and ventilation spelt disaster at time of confinement
>
> Phoebe Cusden papers, quoted in Clapson, page 26

Of the 21,000 houses in the borough in 1920, 17,400 were classed as working class houses, of which 600 were sub-standard (many of them more than a hundred years old):

> Many are back to back or so as to render through ventilation impossible. Most of the houses are damp and in a dilapidated condition. No water is laid on anywhere inside of the houses, there being as a rule one tap and one water closet to every three or four houses. In the knowledge that their day was past, very little money has been spent on those houses in recent years, and their condition is subsequently deteriorating further.
>
> Annual Report of the Medical Officer of Health, 1920, pages 44–5

The town's slum landlords (some of whom had connections with local Conservative politicians of the day) nonetheless opposed action against the slums, claiming that their properties were not the worst in the town, and promising to carry out (long overdue) repairs and improvements. They also opposed the construction of a large local authority-rented sector, which they feared would depress the rents in their properties. By 1931, there were still some 3,000 households on the council waiting list and over 600 households living in condemned accommodation.

Meanwhile, at least some of the new local authority housing was going either to professional people or to the more skilled, more highly paid members of the working class with regular incomes – as Hattersley put it, 'meeting the needs of articulate clerks and artisans who got the vote in 1918'. Skilled working class families had moved from London to Reading during the First World War, and the local middle-class population itself grew between the wars. Many slum dwellers would struggle to pay the higher rents charged for suburban local authority housing, especially when the cost of commuting back to work in town centre jobs was factored in (though this was a much greater problem in somewhere like Manchester, where both rental differentials and the distance and cost of commuting were that much greater).

Only after 1930, when slum clearance became a national housing priority, did the council start to make serious inroads into the problem. By 1932, six clearance areas, involving 105 houses, had been approved. Clapson described conditions in one such – the Coley Clearance Area:

> ... their dampness and poor ventilation, their tiny windows and dark interiors, low ceilings, small rooms and absence of proper water supply and gas. Some dwellings did not even have a sink.
>
> Clapson, page 34

As more former slum dwellers began to find their way onto local authority estates, reformers like Phoebe Cusden favoured a well-meaning but paternalistic management regime, whereby the rent collector doubled as a kind of social worker. In Cusden's view, women were particularly suited for this work:

> In addition to securing the regular payment of rent [the woman estate manager] must be able to encourage the maintenance of a reasonable standard of housewifery, and this can only be done by establishing mutual respect.
>
> Phoebe Cusden papers, quoted in Clapson, page 42

This is not to say that such paternalism was necessarily misplaced, for some tenants found their new environment hard to cope with:

> Experience has shown that the removal of tenants from a squalid slum dwelling to the unaccustomed surroundings of a new, airy, well-equipped council estate will not in itself completely achieve higher standards. The tenant's lack of experience in the use of new appliances, combined with the deep-rooted habits of a lifetime, all too often results in deterioration of the new property and the creation of what comes dangerously near to the old slum conditions.
>
> One of our rehoused tenants vacated his cottage on a new estate. The house was found to be in a filthy condition, overrun with vermin, with fittings damaged and the bath in such a condition as to indicate that it had never been used for its original purpose.
>
> Ibid., page 57

Draft planning schemes covering most of the town were prepared in 1937, though once again the onset of war frustrated their good intentions. Moreover, there was new evidence that new housing alone was not the complete answer to the town's accommodation problems. It seems the council had not followed the advice about building not just housing estates but complete communities given by Ewart Culpin in 1918:

> The Reading Town Council has put back for further consideration the proposal to build a hall, clinic and dispensary on the Corporation's housing estate in Whitley. The reason is that there are new social schemes in the air regarding housing estates. Fresh problems are being created by the wholesale removal of people from slums and other parts of towns to new housing estates where there are not the amenities which are to be found in the other parts of a town.
>
> The building of nearly two million and a quarter new houses during the last seventeen years [nationally] has caused what can be described without much exaggeration as a social upheaval. The greater number of the houses are grouped together in 'housing estates': some of them have populations as large as 25,000; more than one half of the population are under eighteen years of age; and the income of the residents is almost invariably low, allowing them only a narrow margin of money with

which to create social amenities among the new townships that have arisen almost like the proverbial mushroom.

Berkshire Chronicle, 10 January 1936

In turn, the Second World War added to the demand for Reading's housing, by designating the town to take up to 12,000 overspill population from London. The council's bid for extra money to build more housing for them fell on deaf government ears, but the war added to the pressures on a housing stock that was already feeling the strain. A survey of the Whitley estate in 1943 concluded that it was:

In need of a considerable amount of attention if it is to fulfil its function as a desirable locality for the family life of the population and as a community creditable to the town and satisfactory to its inhabitants.

Quoted in Hylton (1996), page 93

They found that 20 per cent of all homes on the estate were unclean to a major degree. The atmosphere of filth and squalor was, they said, striking and there was a gross degree of overcrowding. A further 20 per cent suffered from these problems to a lesser degree. The survey got rather political when it was alleged that Ian Mikardo, then the Labour parliamentary candidate for Reading, had leaked the survey to the national press in order to get the council to spend more on the area. For their part, the council wheeled out the Medical Officer of Health and others to show that the survey was 'ill-informed, vague and misleading'. The poor vicar and doctor who had initiated the survey, no doubt with the purest of motives, were unused to this degree of political intrigue and ended up disassociating themselves from the survey.

During the war towns were invited to submit their proposals for post-war reconstruction. Reading's was hardly imaginative, limiting itself to repairing the limited town centre bomb damage, revitalising a length of the riverside and expanding the suburbs, rather than focussing on housing need. This may have reflected the limited wartime bomb damage the town had suffered, or was it a pragmatic view of what they might realistically achieve, rather than what they might like?

When hostilities finished, 3,750 families in Reading were listed as homeless, and housing was in such short supply that, in 1946, eighty families took to squatting in the huts of the vacant Ranikhet Army Camp in Tilehurst. (The camp had been used by the American army in the build-up to D-Day and was named after a hill in northern India where the Royal Berkshire Regiment was stationed in the 1920s.) These huts were still in residential use until the end of the 1950s, though the squatters' protests got them an electricity supply sooner than some legitimate council tenants. As for new building, post-war shortages of skilled labour, money and materials meant that it was July 1950 before the 1,000th post-war council house was handed over to its new tenant.

As austerity eased, a number of large council building projects started to spring into life. A 150-acre estate was started at Southcote in 1950, with the first tenants moving in two years later. Large parts of Tilehurst disappeared beneath the Meadway and St Michael's estates; the pre-war Whitley estate was extended southward towards Whitley Wood and

north of the river Emmer Green got a council estate. Reading's perennial shortage of housing land within its boundaries also led to the council opting for high-rise development. An eight-storey block of flats was completed in Southcote in 1959 and two fifteen-storey blocks went up in Coley, the following year. Outside the borough boundary, Woodley and Earley both saw rapid rates of housing development.

The period from 1945 to around 1970 was marked by relative consensus between the parties over house-building, with both main parties nationally vying with each other to see who could promise to build the most housing. Locally, political disputes centred on relatively peripheral matters like rent policy and the respective merits of council direct labour versus private builders. But by now, in addition to providing new housing, the council also needed to upgrade its older stock. In 1954 they faced a bill for £53,800 for providing electricity to all its pre-war housing. The tenants would eventually pay for it through increased rents, though this would be spread over a fifteen-year period.

The drive to sell off council houses in the 1960s and early 1970s threatened to open up a serious divide between the parties, until Labour decided to come out in favour of the sales, on the grounds that they now thought they had enough stock to allow some room for manoeuvre, and that they believed (wrongly) that the take-up would be small. The first sales took place as early as 1947, with further releases in the 1950s and 1960s. But it was the Housing Acts of 1974 and 1980 that variously promoted the mass offloading of the council stock to housing associations, and the large-scale sales to individual tenants. Around 3,000 of Reading's council tenants signed a petition against the disposal of local authority homes, but to no avail. By April 2010 the local authority stock stood at around 7,500 homes.

In 1950, with much of the immediate post-war housing shortage not yet addressed, there were over 4,000 households on Reading's waiting list. By the end of 2013 the number had reached 9,375, having risen (according to the *Evening Post*) by 81 per cent in ten years, as both owner-occupation and private renting in the town became increasingly unaffordable for large groups of the population. Agents now predict that future prices will continue to rise faster than the national average, especially with Reading about to become the western terminus of Crossrail.

Housing Conditions

It is not altogether straightforward to measure changing housing conditions over time, since expectations change and, with them, the information gathered in the various censuses. Where once they wanted to know who had exclusive use of a cold tap and an inside toilet, today they may be more interested in whether people have central heating.

The 1951 census revealed that 6,477 Reading households either shared or lacked a piped water supply, 4,070 shared or lacked a cooking stove, 4,712 shared or lacked a kitchen sink, 5,499 shared or lacked a water closet and a staggering 17,555 shared or lacked a fixed bath. While most of these facilities would have been shared, rather than completely absent, it still paints a disturbing picture of the housing conditions so many people endured in those early post-war years.

The 1971 census focused on a hot water supply, a fixed bath or shower and an indoor water closet. It found that 3,155 households still had no hot water supply, 4,290 no fixed

bath or shower and there were even 105 houses recorded as being with no toilet (not to mention the 4,340 whose toilet was outdoors).

In 2013, the council conducted its own survey of the town's private sector housing. For the purpose of this present chapter, its interest lies in the findings for the private rented sector. This represented some 14,863 properties, of which 5,241 were houses in multiple occupation. The private rented sector represents a younger, more mobile population, with 51 per cent of households headed by a person of less than twenty-five years old. Of those household heads 4.6 per cent were unemployed and 20.4 per cent were students. It was reckoned that about 34.8 per cent of private rented households were living in a 'non-decent house', roughly in line with the national average. This measures such things as disrepair, lacking modern facilities and services and failing to provide a reasonable degree of thermal comfort. Around 1,806 private-rented tenants (8.2 per cent) were dissatisfied with their current accommodation and 1,594 (7.2 per cent) with their local areas.

While the bar may have been raised over the years as to what constitutes satisfactory housing, life is still less than comfortable for those at the bottom of the pile.

Travel and (Public) Transport

Today Reading – with its award-winning bus services and state of the art railway station – is a showcase for the best in modern public transport. But how did it get to be so?

Reading and the Railway

The railway came to Reading in 1840, and not without controversy. Vested interests in the field of transport (like the canals, turnpikes and stagecoaches) feared the competition it would bring; major landowners saw disruption looming for their privileged way of life; many respectable citizens feared the arrival of the terrifying and lawless navvies who built the railways, followed by the opportunities the railway would create for the criminal and disreputable classes to come into their community, commit foul deeds and make a swift getaway. Other concerns included the dramatic changes that would take place to the landscape and to areas of rural beauty; the dangers associated with high speed and high-pressure steam, and pollution.

By the time the Great Western Railway Bill was making its way through the parliamentary process, the commercial success of the first real railway, the Liverpool & Manchester, could hardly be denied. But still some questioned the very need for this new mode of travel to come to a place like Reading; this correspondent to the *Reading Mercury* for one:

> Here there is no manufacture, nor is it within the range of probability that any can flourish here; nor can the trade of the place be improved; it now supplies the country around with everything, and more it cannot do.
>
> Quoted in Hylton (2007), pages 163–4

As we know, this analysis was utterly wrong, and one way of understanding the importance of the railways to modern Reading is to look at how they facilitated Victorian Reading's transformation from a small market town into a nationally important manufacturing centre, famous for the three Bs – beer, biscuits and bulbs.

As the Great Western opened as far as Reading in 1840, the business that would become Huntley & Palmer was still in its infancy – but it was a healthy, growing infant, already selling its products to more than a hundred retailers in the south of England. They set up

their factory close to the railway (but also close to the Kennet and Avon Canal since they felt the gentler motion of the canal barges was kinder to their products and led to fewer broken biscuits).

Huntley & Palmer continued making some use of the canals for delivery right up until the end of the Second World War; but as their market area extended, to become first nationwide and then worldwide, rail distribution came to dominate. By 1900 they had 24 acres of private sidings and a small fleet of their own locomotives, and by the 1930s their 7.5 miles of sidings handled some 15,000 wagons a year. At its peak, Huntley & Palmer employed over 6,000 people, equivalent to a quarter of the working age population of Reading, and their livelihoods depended upon the railway moving their products throughout the country and to the ports that carried it beyond. Between 1878 and 1899, over 75 per cent of British biscuit exports came from the Huntley & Palmer factory and, right up to 1956, two-thirds of that output was transported by rail.

The company, and the family, had other connections with the railway. Ernest Palmer (1858–1948) was deputy chairman of the Great Western Railway from 1906 to 1943. Also, in the days before restaurant cars were introduced, first-class passengers joining the Great Western at Paddington were issued with a small packet of Huntley & Palmer's biscuits to sustain them on their journey, with instructions to look out for the factory from whence the biscuits came, as they passed through Reading.

Suttons, the seed and bulb merchant, had its origin in a business as a corn and seed supplier, set up by John Sutton in 1807. But the modern business owes more to one set up by Martin Hope Sutton in 1837, just three years before the Great Western reached Reading. Also at this time the nationwide Penny Post was established, and Sutton took advantage of both the postal system and the railway network to make his a national business. His catalogues, distributed by mail and rail from 1840, dispensed gardening advice as well as advertising his products, which themselves gained an enviable reputation for reliability at a time when adulteration of seeds was widespread.

Simonds' Brewery – Reading's third B – had less of a national market, though some of their contracts were with the army and would have involved rail despatch to barracks across the land and to ports for overseas consumption. The brewery was originally located on the south side of the town centre. This was inconveniently placed for using the town's existing railway goods facilities, which were concentrated to the north, and would involve having to send their wagons through the narrow, congested, tram-infested town centre streets to get to them. The Great Western Railway's original goods sidings at Kings Meadow were even less accessible to Simonds than the rival facilities of the South Eastern Railway, at Forbury Road. GWR were encouraged to build a second Reading goods yard by the promise of Simonds giving them a large proportion of their beer transporting business.

Thus in 1908 the Coley branch line was opened, serving the Coley goods yard, with lines going into Bear Wharf on Fobney Street, within a stone's throw of the Simonds brewery and other industrial users to the south-west of the town centre. The yard continued in operation until 1983, by which time brewing at the old brewery had ceased (in 1980). In addition to beer, among the other products transported via the goods yard was jam (up to forty wagon-loads of it a day) from the neighbouring Co-operative Jam factory, until its closure in 1968.

Other activities essential to the growth of Reading themselves depended upon the railway. In the days before electric light, most of Reading was lit by gas, made by the Reading Gas Company on a site in east Reading. The company received two trainloads of coal a day into its half-mile of sidings, adjoining those of Huntley & Palmer. This continued until 1966, when gas production ceased and natural gas started being piped in from Southampton.

Earley Power Station was conceived during the war years and commissioned in 1946 (making it rather late to perform its function as a wartime reserve generator, in the event that Battersea was knocked out by enemy bombing). It, too received its coal supplies for electricity generation by rail, until the commissioning of Didcot Power Station led to it being closed in 1976.

The Opening Day

This is a contemporary account of the day the railway age came to Reading:

Further extension of the Great Western Railway to Reading – this line was opened to the Reading public on Monday morning last, when the first train, drawn by the 'Fire Fly' engine, started for Paddington at 6 o' clock. The novelty of this delightful and expeditious mode of travelling, coupled with the extreme beauty of the morning, attracted a vast number of our country friends to the town; indeed, we have seldom witnessed a greater number of visitors than thronged Friar Street on this truly interesting occasion. At the station-house, every accommodation was afforded to the spectators that could reasonably be expected or desired by them, the extensive platform immediately adjoining the offices having been thrown open to the public, and seats provided, in a most handsome manner, for their convenience – a privilege which was not unduly appreciated by them. Trains were progressing to and fro at all hours of the day and the passengers were quite as numerous as could have been expected at the commencement, as some of the Bristol coaches have not yet made Reading their terminus; an increase, however, may shortly be relied on. The method, so strictly adhered to at each station on the line, is, perhaps, one of the most admirable lineaments of railway travelling, and it is highly important that the public should bear in mind the absolute necessity of passengers procuring their ticket at least five minutes before the departure of each train ...

Several thousands of onlookers were congregated on Forbury Hill and in the immediate visinage of the railroad, the former beautiful elevation affording a most excellent view of the arrival and departure of the trains, though their utmost speed of progress cannot be ascertained from that spot. The distance between this and Paddington station is 35 ¾ miles, and the time occupied in completing the same, including four or five stoppages, may be averaged at one hour and a quarter; a new and powerful engine, named the 'Wild Fire', made its debut yesterday, occupying one hour and ten minutes in its journey and on Thursday one of the engines completed the whole distance in an hour and five minutes ... it has now become a prevailing

topic of conversation with many, whether, from the opening of the railway, Reading will experience benefit or injury and therefore (though we offer no opinion on this question at present) it becomes doubly necessary that no means of improving it should be lost sight of by the inhabitants.

Reading Mercury, 4 April 1840

Reading Station

Today, Reading railway station is one of the most important in the country. It had 15.7 million passenger movements in the year to March 2014, making it the ninth busiest in the country outside London. But it was even more important as an interchange. In that same year, 3.8 million people changed trains in Reading – a figure exceeded, outside London only by Birmingham New Street. But Reading station started off in a very modest manner in 1840, as one of Brunel's eccentric single-sided stations. This was an idea he used in several places where almost the entire population of a settlement lived on the same side of the tracks, and involved putting both the up and down platforms on the same side of the tracks. Brunel saw the advantages of this being convenience for the passengers, by not having to cross the tracks to board their train, and the ability of express services to by-pass the station area completely.

This was however very dangerous for the trains, requiring them to weave across each other's paths at a time when signalling and safety measures were in their infancy. On one occasion, the non-stopping 'Flying Dutchman' express service was mistakenly directed into the station at 55 miles an hour. It was a tribute to broad gauge stability that it did not come off the tracks. Some of the Railway directors anticipated these problems from the outset and Brunel was asked 'to submit another plan for Reading Station with sheds either side'. Unfortunately, Brunel managed to persuade them to his way of thinking. The shortcomings with this arrangement only got worse as standard gauge lines were mixed in with the broad gauge. The line from Reading West to Paddington was converted to mixed gauge in October 1861.

The council and local people frequently complained about the condition of the old station and the accommodation provided there. In 1864 the potential for a major railway accident there even got raised at the Reading Quarter Sessions, but improvement was a long time coming.

The rebuilding of the station got off to a fairly haphazard start in 1858, when an opened door on a passing goods wagon brought down the columns holding up the station roof. The introduction of mixed (standard and broad) gauge tracks involved building two additional lengths of platform at either end of the broad gauge platforms. This could potentially have led to the nonsense of the station having four separate ticket offices, but instead the Great Western centralised ticketing in the Italianate yellow brick and Bath stone station building we see today. This was built on the site of the old up-station entrance and was opened in 1870. The finial on top of it is a replica of those found on the earliest railway signals, and was in its day one of the tallest structures in the town. But this rebuilding did not address the bigger nonsense of the one-sided track layout.

Brunel eventually saw the error of his one-sided station idea and submitted plans to change it as early as 1853, but these were not taken up until the wholesale and long-overdue reconstruction of 1896–99. Various minor changes had been made to the track over the years to accommodate the introduction of mixed gauge lines, until the last broad gauge tracks were phased out completely in 1892. The minor additions over the years left the impression of the station as a wooden shanty town, but it was finally decided to commission a comprehensive redesign of tracks and platforms, and a contract to carry out the works, costing £6,000, was let in 1896. It shows what a mess the old station layout was, that they had to go from one long platform to ten to achieve a satisfactory arrangement.

The new Reading station may have been provided with some of the longest platforms on the Great Western, and in the area outside the new station (according to a GWR guide of 1899) 'modern streets and boulevards of continental aspect now cover the open space'. But the reconstruction did not please all of its critics. In particular, the failure to provide an overall roof for this important station (limiting weather protection to the derisively named 'tin umbrellas' over the platforms) annoyed the likes of W. J. Scott, writing in *Railway Magazine*:

> ... even so fine a station as the new Reading, for lack of an overall roof, looks only a magnified and glorified 'roadside intermediate'.
>
> *Railway Magazine*, 1899

Readers may be surprised to know that Reading station has long had a status as an international destination. As long ago as 1907, it was being advertised for its connections to Paris, Brussels, Cologne and Berlin (via Dover), enabling international travellers to and from many parts of Britain to avoid London. When the Channel Tunnel was being projected in the 1960s, Reading was for some time considered as one of the main terminals, to be fed from the electrified Tonbridge line. And from 1967, Reading station has been the starting point for travellers worldwide from Heathrow, using the Rail-Air coach service. By 1973 this was carrying over 250,000 passengers a year. There are also regular direct rail services to Gatwick airport.

The current modernisation of Reading station has also been a long time coming. A modernisation was promised in the railways' national Modernisation Plan of 1955. Plans were drawn up in 1960 but just before they were about to start work on them in 1962 the scheme was scrapped. A scheme re-emerged in 1982, to be funded in part by the giant pink confection that is the Apex Plaza office development. This would be built over the line to the old Southern Region station that had been closed in September 1965. Thereafter Southern Region services were run from a separate bay platform in the main station. In the 1970s, what was left of the old Southern station was used as a service station until work on the £20 million office scheme got under way in July 1986.

The new station concourse was opened by the Queen on 4 April 1989. The new building provided better ticketing and shopping facilities, but left unsolved bigger problems, in particular the fact that the track layout at Reading station made it a major bottleneck on the network. The previous station layout had eight terminal and just four through platforms, meaning that the track on either side of the station had roughly three times the capacity

of that through the station itself. The issue was brought to a head by the need to renew the signalling around the station. Either they would freeze the old unsatisfactory layout for a generation by renewing its signalling in situ, or radical changes needed to be made.

They decided to embark on a major (latest cost, £850 million) redevelopment of the station and its surrounds, including renewal of the Cow Lane bridges, flyovers to separate different traffic streams and a rebuild of the rest of the station, to give a total of nine through platforms. In addition, room was being created for six extra freight services a day, equivalent to taking 200 heavy lorries a day off the roads. At the time of writing, the Queen had opened the rebuilt station in July 2014 and the final stages of the work on the tracks around the station were under way. It was forecast that the redesigned station would give a 37 per cent improvement in train service performance in the Reading area by 2015 and an increase in capacity of 103 per cent by 2035.

In the midst of all the turmoil, electrification of the main line was promised by 2016. It would not be the station's first experience of electric traction. Electric services (of the third-rail Southern Region variety) have been running between Reading and London (Waterloo) since 1 January 1939.

But Reading was not just one station. The original station was added to by another (originally a temporary, completely freestanding one, near the Forbury) for the South Eastern Railway in 1849. It was this that eventually provided the potential for Reading to become part of a route between Dover and the Continent and the Midlands, referred to earlier. The Great Western itself got approval in 1845 for a Berks and Hants line, which reached a temporary terminus at Hungerford in December 1847. A further branch left the Hungerford line at Southcote Junction and went to Basingstoke, opening in November 1848. Reading was already becoming a focal point for the rail network, with connections to many parts of the country. Local and some longer-distance services were also provided from Reading West and Tilehurst stations.

In addition to passenger carrying, Reading was also a major centre for freight traffic. The Coley goods yard could take any Great Western locomotive, up to the very largest Kings, and from nationalisation in 1948 Reading became the railhead for an area of 1,000 square miles. By the early 1960s, before the Beeching cuts, Reading was receiving 500,000 tons of coal a year, 135,000 tons of general goods and up to 1,000 truckloads of livestock.

One of the consequences of this can be seen in Reading's architectural heritage. Before the railways (and, to some extent, the canals), builders were very dependent upon locally sourced materials – local stone, bricks where there was suitable local clay, and materials like timber and wattle and daub in areas without clay or stone. This gave some coherence to the local architecture. The railways gave much greater choice but, even so, most places would still have had convenient access to just one brickfield, giving a degree of uniformity to their brick buildings. But Reading via the railway had the pick of brickfields the length of the country, offering a variety of colours. In addition to the reds and greys that they could get from local brickfields, a range of other colours could be brought in from places like Wales and Staffordshire. Local builders took advantage of this to make patterned brickwork a feature of Reading's architecture.

Railways – The Makers of Modern Reading?

It can be argued that, more than any other single event, the coming of the railways made modern Reading what it is. Car enthusiasts may dispute this and, in any event, whether it is a good or a bad thing is open to argument. We will close this section with the views of an organisation that clearly had an axe to grind on the matter:

> Unlike every other place on the Thames, modern Reading is obviously a creation of the railway rather than the river; and its lack of architectural distinction and perhaps at once the price and the expression of its commercial prosperity. Abingdon and Wallingford petitioned successfully against the main line coming through them, and remain in a comely and decent poverty. Reading did not. Its reward is to have become, in size and wealth, the first town on the river, outside London. But in the process it has inevitably lost the charm which the smaller towns retain.
>
> *Salters Steamers*, page 66

Buses

Reading could not flourish for long without its buses and here are some reasons why. According to a report in the *Evening Post* Reading people made 16.2 million bus journeys in 2012/13, an average of roughly 103.1 bus trips for every man, woman and child. Only three towns in the country outside London have a higher rate of bus usage, and Reading's figure is 2.6 times the regional average. It is said that Reading is one of the very few towns where more people commute into the town centre by bus than by car. Reading also bucks the trend by having a growing bus market. Usage in 2012/13 was up 200,000 from the previous year, and only ten local authorities in the South East can claim any kind of growth (two of the others are Reading's immediate neighbours, Wokingham and Newbury, parts of which are also served by Reading Transport). But what are the origins of public transport on the roads of Reading and how has it evolved over the years?

One of the first forms of public transport to be seen on the streets of Reading would have been the stagecoaches, which supported the town's numerous coaching inns. Reading lay, among other things, on the major route between London and Bath and Bristol, made fashionable by Queen Anne going to Bath to take the therapeutic spa waters. Stagecoaches were essentially long-distance transport, for the town in about 1800 was not yet of a size that required local commuter services. But the days of long-distance stagecoach travel came to an abrupt end in the early 1840s, as the new Great Western Railway provided Reading with faster and cheaper alternatives.

Coachmen searched for some alternative sources of business, and some enterprising local innkeepers hit upon the idea of providing feeder buses, linking Reading railway station with the outlying parts of the town, and more particularly with their licensed premises. Reading's population by the 1840s had reached about 21,000, a size at which horse buses started to make some sense as an alternative to walking. Particularly enterprising was the landlord of the Peacock in Broad Street, who also ran horse bus services to the Prince of

Wales in Caversham, the Marquis of Granby at Cemetery Junction and the Queen's Head in Christchurch Road, Whitley, among others.

Tramways first reached British streets in 1860, and it was in 1878 that the Imperial Tramways Company obtained authority to build a horse-powered tramway between the Brock Barracks on the Oxford Road and Cemetery Junction. This 2.25-mile route just about covered the full extent of the east–west growth of the town at this time. The initial business plan was hardly mass transit, consisting as it did of just seven single-decker tramcars, each with a capacity of twenty-four people. However, they were soon carrying some 14,000 passengers a week and the company introduced double-decker trams (still drawn by a single, not particularly well-nourished, horse).

Fierce competition developed between the trams and the horse bus operators (with even the tram company supplementing its trams with horse buses). This in turn led to complaints about reckless driving, overloading, cruelty to animals and accidents. Another problem involved the steering of the trams; at junctions, the tram drivers were supposed to steer the horses, to ensure that the tramcar was led down the right track. Some of them were none too good at this, and their tram horses could find themselves nose to nose with another on the same piece of track, going in the opposite direction. All of this caused the council in 1898 to conduct a wide-ranging review of the tram service. The review was highly critical of it and the council, rejecting the company's own plans to improve and extend the service, decided instead to exercise its right under the 1870 Transport Act to take it into public ownership.

The *Berkshire Chronicle* sided strongly with the Economisers – the group on the council that resisted spending public money on virtually anything – be it transport, sanitation, street lighting, or the alleviation of poverty and ill-health. In an editorial headed 'Reading Ratepayers Beware!' they warned that the electrification of the trams could cost the town £200,000 or more (the actual figure was £223,000) and went on:

> This is a policy which we have condemned and shall continue to condemn. It is the kind of policy which has in the past landed the town into the extravagant expenditure on the sewerage scheme, the sewage farm and the lowering of the Kennet, and the result will be the same in this case. It is the duty of the Town Council to take the ratepayers into their confidence before committing them to such an enormous expenditure and this they have not done ... We notice that our radical friends have advocated not just the Tramways Bill, but the purchase of the Electric Lighting Company, the incorporation of Caversham and other extravagant and expensive schemes ... the Borough debt already amounts to over £650,000. What will it be if these extravagant schemes 'in the air' are carried out and what will the rates be?
>
> Quoted in Hylton (1999), page 7

Two years of haggling over first the legality of the takeover and then the price followed, until in October 1901 the council became proud owners of thirteen double-decker tramcars and eighty-five horses (two of which died almost immediately and fifteen of which needed urgent replacement) for the grand sum of £11,394. (The council had originally offered £10,105, which the company countered with a claim for £24,000 – arbitration came down

on the council's side). The rest of the service was in as ramshackle a state as its horses, and the council were able to improve conditions for both drivers and their horses over the eighteen months they ran the horse-drawn service, while planning its extension and electrification.

On 22 July 1903 much of the town's population turned out to marvel at the technological wonder of the age, as the first electric trams ran through the town in a ten-car cavalcade. They carried the local council members and invited VIP guests, who also enjoyed a good luncheon and numerous speeches. The mayor even got to drive the tram (this opportunity was apparently a major factor in persuading Alderman Bull to accept a third term of office). Once the dignitaries had had a go on the trams, there was an unseemly scrum as members of the public vied with each other to be the first fare-paying passengers. Not everyone was pleased with the new service – strict Sabbatarians wanted Sunday services to be abolished or reduced. This was not conceded, but drivers were at least instructed to drive quietly near churches, so as not to distract the worshippers, and a more silent track-bed was installed in those parts of the network. Oddly enough the principled opposition of the *Berkshire Chronicle* to the scheme had by now entirely disappeared, as their opening day editorial demonstrated:

> Wednesday was a red-letter day in the history of Reading, for the electric tramway system, the completion of which has been so eagerly awaited and desired, was at last a fait accompli and the mayoress switched on the current at the generating station and declared the tramways open … There is no town in England which can surpass Reading for the excellence of its tramway system, either as regards the construction of the permanent way, the character of the generating plant or the arrangements which have been made for the convenience of the travelling public.
>
> Ibid., page 8

Among the features of the new service were one-penny workmen's fares, for use on the early morning services, and a parcels delivery service, using Parcels Agents – people who had business premises at key points along the tramway network, at which parcels were deposited for delivery and from which parcels were collected by the addressee. The agents were later dispensed with, parcels being dealt with directly by the conductor. The tram service was a financial success from the start, making a profit of £2,923 in its first full financial year.

Possibly the most popular services of all were the football specials, carrying fans to and from Elm Park for Reading Football Club's home games. It was not at all unusual for a forty-eight-seater tram to be carrying 100 football supporters, some of them clinging onto the outside of the bodywork, third-world style. This was still an issue in 1930, and this irate correspondent to the *Berkshire Chronicle* seemed less concerned about the scope for accidents than the fact that the conductor could not get around the tram to collect the fares, and the effects of this on his rates:

> As the Reading tramways are municipally owned, it follows that a great many passengers must obtain free transport at the expense of the ratepayers of the Borough, in addition to which extra expense must be met in repairs to rolling stock, necessitated by undue wear owing to frequent overloading.
>
> *Berkshire Chronicle*, 3 January 1930

The new depot and power generating plant for the service was at Mill Lane (the depot being on the site of the former Saxon St Giles Mill and what is now part of the Oracle shopping and cinema complex). New lines reached out towards Caversham, Tilehurst, Whitley and Erleigh Road. Not every expansion plan was successful; attempts to take the trams over Caversham Bridge and into what was to be the town's new northern suburb foundered on the opposition of Caversham residents to paying for the necessary road widening. The only way trams ever reached Caversham was after they had been withdrawn from service and were sold on to Caversham residents as garden sheds or summer houses.

The boundary extensions of 1887 and 1911 (discussed elsewhere in the book) more than doubled the size of Reading, and left parts of the extended town unserved by public transport. The first debates began to take place in 1913 about the respective merits of further tram routes, electric trolleybus services, or petrol buses. This came down in favour of a network of trolleybuses, whose routes were finally approved in the Reading Corporation Act 1914. However, the distractions of a World War prevented them being implemented immediately.

The trams played their part in the town's war effort. For example, a number of the town's schools were redesignated as war hospitals, with the result that large numbers of schoolchildren had to be ferried to alternative schools on the opposite side of town. Additional tram services had to be found to carry them. In addition, part of the tram depot was given over to munitions manufacture and as a training school for members of the Royal Flying Corps. Around 150 men, some 75 per cent of the pre-war tramways staff, joined the forces, three of whom lost their lives, and losses of male staff to the armed forces meant that women had to be recruited as conductresses, and some even trained as tram drivers. Despite staff shortages and other wartime difficulties, during financial year 1916/17 the numbers of passengers exceeded 10 million for the first time. Numbers of tram passengers continued to increase until 1929/30, the last complete year in which the entire tramway network was in operation, when it carried 12,225,100 passengers.

By the end of the war, the enthusiasm for trolleybuses seemed to have waned somewhat, and petrol buses started operating some of the routes originally intended for trolleybuses, between Tilehurst and Caversham Heights, and Shinfield Road and Lower Caversham. Other petrol bus routes followed.

The tramways enjoyed generally good industrial relations over the years. The one exception was the 1926 General Strike, when national trade union action called out the tramways staff from 4 to 12 May. The general manager and nine members of staff who did not come out on strike provided a skeleton service under police protection, though they suffered no more than a few broken windows from protesters. At the end of the strike, all the striking workers – except a few who had been arrested for trying to prevent tramcars leaving the depot at the end of the strike – were re-employed.

It was not until April 1934 that the transport undertaking took a more fundamental look at the choice of vehicles for its future operation. By this time, much of the track, rolling stock and power generating plant of the tramway was considered to be life-expired or of limited life. No new tramcars had been commissioned for thirty-one years. Trams were in any event by now considered to be out-of-date – they were noisy, slow (16 mph), inflexible,

had limited capacity (unless you were a football supporter) and were an obstruction to other road users. The contraction of the tram network had already started with the closure of the Bath Road route in March 1930 and by 1934 only two routes remained in operation. The renewal of the tram network was one option that was quickly ruled out. That left three options for the review to consider:

> The petrol omnibus: The great increase in the use of this type of vehicle in post-war years has been one of the phenomena of the transport world and, of course, it is the type of vehicle which today is the one most used by the Transport Department … The great advantage of the petrol-engined omnibus is its mobility and there is no doubt that the vehicles of the most recent type, some of which are in operation in Reading, are extremely comfortable and quiet-running but their great disadvantage is the taxation and the fact that the vehicles depend for their motive power upon a commodity, the price of which is anything but stable … a fluctuation of 1d a gallon in the price of petrol meant a fluctuation in the expenditure respecting the omnibuses of £1,150 per annum.
>
> Heavy oil engined omnibuses [have] proved from the point of view of fuel costs to be a vehicle which is more economical to run than a petrol-engined omnibus. Where a petrol-engined omnibus will run five miles to a gallon of petrol costing 1s 0d [5p], a heavy oil-engined omnibus will run nine miles to a gallon of heavy oil which costs 6d [2½ p]… Heavy oil engines however are in their infancy … They cannot be regarded as having reached perfection [and cannot] be considered as an efficient and practical substitute for a tramcar or a petrol-engined omnibus.

They also raised fears that, as it became more widely used, heavy oil (diesel) would become as highly taxed as petrol and that the running costs of heavy oil vehicles would increase to equal those of petrol.

That left one other option – the trolley bus, which was then being introduced by many municipal transport undertakings. The report spelt out the pros and cons of the trolley bus:

> The trolley vehicle has its disadvantages. Like a tramcar, it is route bound inasmuch as it can only operate where there are overhead wires. Again a trolley vehicle travelling in a particular direction cannot overtake another trolley vehicle going in the same direction and, unless special arrangements are made, it cannot be turned round like an omnibus. Further, to run the vehicle would mean the erection of poles and overhead wires in parts of Reading where they do not exist at the moment.
>
> 'The future policy of the Transport Undertaking' – minutes of Transport Committee,
> 12 April 1934

But the trolleybuses had advantages which, the report thought, outweighed these quite considerable drawbacks. Electricity prices were relatively stable and it was produced by the Corporation's own generating facility; they were cheaper and easier to repair; they were clean-running, quiet and had quick acceleration; unlike the trams, they could be brought

alongside the kerb; they were easy to keep clean and had at least a ten-year life. Last but by no means least they were not, unlike the buses, subject to the scrutiny of the Traffic Commissioners, allowing the Corporation to be more of a master in its own house.

It seemed all the council had to worry about was the cost of replacing the trams, estimated at £200,000 (including sixty trolleybuses at £2,000 a time), spread over a number of years. The last tramway was due to be phased out in 1941 and the changeover would be complete by 1942 – in fact, Reading's last tram ran in 1939. A few omnibus services were to remain.

Reading had some particular constraints for the public transport operator. The Corporation had never been able to operate closed-top double-decker trams along the main Oxford Road route because of the limited headroom under the Oxford Road railway bridge. For years the bridge had large signs, warning passengers on the open upper tramcar decks to keep in their seats. There were similar height constraints under the Vastern Road and Caversham Road railway bridges, which meant that Lower Caversham had to be served by motor buses, until either:

- The bridges were replaced (Oxford Road was rebuilt in 1938, just as the trams were being phased out, and that over Vastern Road was not rebuilt until 1976);
- The roads underneath them were lowered (this was done on Caversham Road in 1938); or
- Special 'low bridge' trolleybus types of bodywork were used; (these tended to be unpopular, because of inconvenient seating arrangements and limited passenger headroom).

As was the case with the trams in 1903, the people of the town turned out in droves in July 1936 to watch the council and their guests having first go in the first new trolleybuses. As new trolleybus services were introduced around the town, so the tram services that were their predecessors were withdrawn. The last to go was the 'main line' service along the Oxford Road, where the final tram ran on 20 May 1939. It made its way into town amid a swarm of cyclists, and near the town centre the crowds got so dense that the police had to be called in to clear a way for it. It was replaced the following day by trolleybuses. But not everyone was a fan of the trolleybuses – some objected on aesthetic grounds, as in this letter to the *Chronicle*:

Trolley buses may be the cheapest and they may also be the easiest to run and keep in order, but I shudder to think what some of our beautiful residential roads – to say nothing about those in the town itself – will look like when they are all fitted with poles and the network of double wires necessary to run this system of transport.

Berkshire Chronicle, 15 June 1934

There was much lobbying to have particular roads excluded on aesthetic grounds. But there were soon more important things to worry about. Within months Britain was engaged in the Second World War, and all public transport suffered the privations of modern warfare. Drivers could not see where they were going in the blackout; would-be passengers could not tell whether the oncoming vehicle – without an illuminated destination board – was

their service or not; conductors could not see to collect their fares (there was a marked increase in the amount of dud foreign coinage used for fare-dodging); passengers, once on board, could not tell where they were meant to get off; there was the uncertainty connected with air raid warnings while the bus was en route; and, to complement it all, it was difficult on a silent-running trolleybus in the pitch dark to tell whether it had come to a complete stop. Many a passenger was injured stepping off a moving vehicle.

Even in daytime, the trolleybuses' destination boards were changed, so as not to give a clue to any invading Germans as to where they were. Thus Caversham became known as Promenade, Tilehurst became Bear Inn and Wokingham Road was The Three Tuns. Even the word 'Reading' was painted out on the bus logo and the big stone sign at the Mill Lane bus depot was boarded over, so as not to give the name of the town away to foreigners. And when the government wanted scrap metal, the old tram tracks were torn up from the town's streets.

After the war, Reading still had plans to extend its trolleybus network and needed more vehicles. In those days of post-war austerity new trolleybuses were virtually unobtainable and the authority was reduced to shopping for used examples. Most of those on the market were either ancient pre-1930 models or in questionable condition. Few can have been more questionable than the twelve examples Reading bought, most of which needed a more or less complete rebuild and only six of which ever found their way into service. Another area of shortage was the structural steel needed to build a trolleybus depot for their fleet, which led to the transport undertaking acquiring an air force surplus aeroplane hangar in Cambridge, dismantling it and reassembling it on a site in Bennett Road.

Even electricity was in short supply immediately after the war, as domestic use increased. This led to a series of scheduled power cuts, which could leave trolleybuses – especially those without back-up batteries – stranded. It was not unknown for passengers to be called upon to push their lifeless transport into the kerb, to get it out of the way of following traffic. Despite everything, Reading's trolleybus fleet reached its peak in June 1950, when fifty-eight trolleybuses were in service.

By the latter part of the 1950s most transport authorities were starting to phase out their trolleybus services. But Reading was still making enhancements (admittedly mostly relatively minor) to theirs. In March 1957, faced with a need to replace some twenty-five pre-war trolleybuses, they chose new trolleybuses over the motor bus alternatives. By 1965 trolleybuses had become more expensive to run than motor buses (19p a mile, compared with 17p) but, strangely enough, were still the more profitable part of Reading's fleet. In the year to March 1965 the trolleys made a profit of £18,344, whereas the motor buses lost £12,074. But more telling was the fact that trolleybus equipment manufacturers, faced with a dwindling market, were pulling out of that line of business. New vehicles and spares were getting ever harder to obtain. Worst of all, BICC, virtually the only supplier of overhead cables, announced that they were ceasing their manufacture.

In February 1966 a story appeared in the *Chronicle* headlined 'Trolley Buses May Be Axed'. It touched upon a political divide within the finely balanced council, and talked of a £300,000 bill for replacing the trolleybuses with petrol equivalents. In short, Labour wanted to keep them and the Conservatives to scrap them, on the grounds that they were getting – and would get – increasingly costly to run. Eventually the council agreed in July 1966 'to discontinue use of trolley buses over a phased programme'.

Other factors than cost influenced the decision over the future of the trolleybuses. The town was at the time experiencing some of its worst traffic congestion, in the days before the M4. Westbound traffic was drawn instead along the A4, which ran through the centre of the town. The volume of this traffic was due to increase with the opening of the Severn Bridge. Prior to that, some of the traffic bound for Wales would have headed further north, to cross the Severn by the nearest available road bridge, at Gloucester. There were fears among the pro-trolleybus camp that their replacement by (smaller) motor buses would mean a net increase in the number of vehicles on the town's already overcrowded streets. Perhaps more tangible was the fact that actions taken by the council itself to manage the town's traffic would make it considerably more difficult for the trolleybuses to continue operating. These included proposals for one-way working past the former tram depot at Mill Lane, Britain's first contraflow bus lane along Kings Road and the construction of Phase 1 of the Inner Distribution Road.

Reading's last day as a trolleybus town – one of the last six in the country – was Sunday 3 November 1968, and not just crowds of local people but trolleybus enthusiasts from around the country gathered to see the service make its farewell. Some of its vehicles were scrapped, some sold on to the few remaining operators or to enthusiastic preservers, while one became for several years an extra classroom at Sonning Church of England Primary School. Within a month or so, almost all signs of thirty-two years of trolleybus operations in Reading had been removed from the town's streets.

Reading had run its first motor bus in December 1919 and became an all-diesel service from November 1968. But they did not have the bus market to themselves. Bee Line provided rival services, in Reading itself and in the Newbury area, until 1991/92, when Reading Transport bought them out, inheriting an assortment of mostly elderly vehicles in the process. In the 1980s, Reading Transport and their counterparts in Southend jointly operated a kind of bus-based Crossrail-type service, linking the two towns via central London.

Then in 1994 a completely new – albeit in some respects antiquated – rival appeared on the scene. Reading Mainline's fleet consisted of Routemasters – the traditional London bus dating back to the 1950s, with an open platform and two-man operation. Reading Transport's one-man buses had not been universally well received in the borough at first, with some passengers likening them to cattle trucks. Two-man operation allowed faster pick-up and hence offered shorter journey times, and the capital cost of their vehicles was a fraction of Reading Transport's. After a period of sometimes intense competition, Reading Transport exercised its financial muscle and bought Mainline out in 1998, paying just £250,000 for Mainline's forty ancient Routemasters (the biggest fleet outside London). More to the point, Reading Transport had to find £450,000 to pay off Mainline's debts and, for the first time in its history, Reading Transport made a loss. The Routemasters were all phased out by July 2000.

Today, Reading Transport has colour-coded buses which are wheelchair accessible, tell you which stop you are at and use environmentally friendly fuel. They run night services, carry passengers well beyond the borough boundary and win national awards.

Shop! Shop! Shop!

The Beginnings

For many people (including very many who live beyond the borough, for it has an estimated retail catchment population of 1.7 million) Reading is a place they visit to shop. So it has been since the earliest days of the town. The original retail heart of the town was the area around St Mary's church and St Mary's Butts. The earliest challenge to this came in the twelfth century when the Abbot Anscher of Reading (a would-be town planner and property developer) promoted the building of the Market Place and Friar Street (then known as New Street). The aim of these was to attract trade away from the St Mary's area, and rents in Friar Street were deliberately pitched lower than its rival in order to do so. The construction of London Street after 1254 was a further attempt by the abbot to draw traffic going along the London to Bath road into the Market Place.

Another new street appeared at about the same time, linking the northern end of St Mary's Butts with the southern end of the new Market Place. This was High Street (or, as we now know it, Broad Street). But for a long time, it was not uniformly broad. On the earliest surviving map of Reading (drawn in 1611 by John Speed) the eastern (Marks & Spencer) end of the street is divided by a row of properties into Fishe Strete and Buchers Rowe, denoting the main retail trades carried on there. The smell down these narrow lanes in warm weather and pre-refrigeration days can only be imagined.

The twelfth century also saw the building of an interconnecting route between Broad Street and Friar Street – Gutter Lane or, as we know it today, Cross Street. Other north–south routes between the two streets came later. Modern day Smelly Alley is an addition in the narrow tradition of Fishe Strete and Buchers Rowe. Its official name, Union Street, commemorates the union of England and Scotland in 1707. Queen Victoria Street was only completed during the early Edwardian years (1903). This was the product of enterprising local businessman and councillor Charles Fidler.

But for most of the period covering the making of modern Reading, Broad Street was the major focus of the town's shopping. For a long time this was a very agricultural affair, with sheep and cattle pens lining the street. But our focus in the following pages will be on the last 150 years, and the major changes in retailing that have been seen since the mid-Victorian period.

Shopping and traffic

One problem with Broad Street as a shopping centre was that it was for a long time also a prime route for much of the town's traffic, which meant that would-be shoppers on Broad Street took their lives in their hands whenever they tried to cross it.

In the immediate post-war years, car travel was seen as the nation's future, and Lord help anyone who tried to obstruct its progress. In 1950 the council was lobbied to close the pedestrian crossings on the Friar Street/West Street junction, which were delaying the motorist, and talk of traffic management in Broad Street involved not traffic calming, but fencing in the pedestrian, lest they dare to step off the kerb. Even after general traffic had been removed from the street in 1970, it remained the town's principal bus interchange, and a terror to those on foot.

It was not until the 1980s that moves were made to pedestrianise Broad Street. They were greeted with howls of outrage by bus interests, who claimed that it would mean the end of public transport as we knew it. A scheme for pedestrianisation and bus priority in the town centre was nonetheless drawn up and a survey was commissioned, to establish objectively how it would impact on visitors to the town centre shops. A cross-section of people were interviewed at bus stops, to establish (a) which bus service people were waiting for and (b) what was the last shop they had visited. From this it was possible to work out how much further they would have had to walk to their bus stop under the new scheme. The answer turned out to be an average of three metres.

The pedestrianisation of Broad Street was gradually introduced during the 1990s – first the western end, with buses being rerouted along West Street, Friar Street and Queen Victoria Street then, by 1995, the entire street. As we see elsewhere in the book, it has not so far led to the collapse of public transport, and it is hard to believe that there are now many who would want the town centre to revert to its previous traffic arrangements.

Shopping Indoors

Reading's experience of the indoor shopping arcade did not begin with the Butts Centre (what we now call the Broad Street Mall). Back in the 1890s Alderman J. C. Fidler was responsible for the development of the Market Arcade, Reading's first indoor shopping mall, running between Town Hall Square and Broad Street. Fidler deserves a special place of honour in any book on the making of modern Reading for, in addition to Market Arcade, he was also responsible (as we saw) for the building of Queen Victoria Street, which at last provided a direct link between the station and the prime shopping area of Broad Street. He also commissioned the rebuilding of West Street and was instrumental in the town acquiring Prospect Park for the benefit of the local people.

The Market Arcade was largely destroyed in the air raid of 1943 and rebuilt, as the Bristol & West Arcade, between 1957 and 1965. In 2006 plans were announced to redevelop it again, with a £7 million mixture of hotel, housing, shops and offices, but the scheme came to nothing. Meanwhile the existing arcade has gone steadily downhill, and is at the time of writing this no more than a boarded up and scruffy back entrance to a Broad Street supermarket.

In 1929 a local businessman, John Harris, developed another arcade, one which bears his name, running between Friar Street and Station Road. One of Mr Harris's businesses, Great Western Motors, occupied part of the site until it moved to Vastern Road, and it is thought that one of the shop basements was used as a brothel during the war years. One of the units, Sally's Café, became well known in the late 1950s and early 1960s. It was run by a Mrs St Nicholas (also known as Eva von Sacher-Masoch, the Baroness Erisso – the daughter of an Austrian count). Her teenage daughter was to become better known as Marianne Faithfull, whose circle of friends included the Rolling Stones. 'The boys', as they were known, were frequent visitors to the café. Another popular feature of the arcade for a time was an indoor market known as Traders.

The idea of a modern covered shopping mall in Reading town centre was first mooted in 1956, but it took around a decade to identify a site, acquire an assortment of old houses and shops (some of which were needed in any event for the Inner Distribution Road) and design a new centre with around 400,000 square feet of retail in eighty-five shops and with 740 parking spaces. The Butts Centre opened for business in 1972 at a cost of £3 million and promised the council a rental income for the site of £200,000 a year. The television magician David Nixon opened the centre, and apparently told people – ambiguously – that he had never seen anything like it. The name – Butts – refers to the targets at which archers used to aim. Edward IV decreed that every Englishman should have a longbow of his own height, and that they should practice in using them on appointed days in order to be ready for conscription in times of war. St Mary's Butts – the street adjoining the centre, was where that practice used to take place. The new development was originally referred to as the Reading Commercial Centre. The Butts Centre later became the Broad Street Mall, one small problem being that the mall was not actually on Broad Street. The council was prevailed upon to rename the eastern end of Oxford Road as Broad Street, to get around this difficulty.

It was to the Reading Commercial Centre that two stars of television soap opera – best known to their fans as Elsie Tanner and Len Fairclough of *Coronation Street* – came in September 1972. They had been hired to open a new lighting shop, called Lampshades, but can hardly have been ready for what confronted them. Four thousand fans – 80 per cent of them women – had assembled and, as soon as the chauffeur-driven Bentley drew to a halt, a mad scramble began for a better view of them. The door of the Bentley was ripped off, three women crushed in the melee had to be taken to hospital, two plate glass windows were smashed and over £1,000 worth of damage was done to the premises. The stars themselves had to be rescued and later, from the safety of a secure upper-storey room, threw autographs down to the assembled masses.

By the 1980s Reading's town centre retailing was under threat, not least from the possibility of a major out-of-town retail mall on its borders. At the same time, 1980, a town centre retail opportunity presented itself, in the form of the closure of the old Simonds brewery. At first, would-be developers were only interested in a predominantly office development, which they were granted on appeal in 1982. But the scheme was never built and by 1988 their ideas had moved on, to a scheme involving a larger element of retailing. By 1989 and 1990 retailing and leisure were by far the largest components of their revised scheme.

The scheme was to be called the Oracle. The name comes from another building of the same name, which stood on part of the site until about 1850. The original Oracle was the result of a bequest by John Kendrick, a Reading man who made his fortune as a clothing manufacturer in London. When he died in 1624 he left £7,500 to Reading Corporation, for them to build a workhouse where the unemployed might be put to work making clothing. Its subsequent history need not concern us, but there remains the question of why the original building was called the Oracle? Apart from the dictionary meaning (a place where mortals may ask the gods for advice), other suggestions are that it is a corruption of the words 'work hall', or of 'oricello' (a yellow Italian dye, used in clothing manufacture). Another idea is that it derives in some way from the word 'oriolum', meaning a porch or entrance. The archaeologists who investigated the site as it was being redeveloped found plenty of evidence of Reading's past. As well as the foundations of the original Oracle they found a fifteenth-century tannery, the foundations of a twelfth-century house and a carved stone head of the same vintage.

The development process took twelve years, cost £250 million and is said to have made Reading for a time one of the top ten shopping destinations in the UK, increasing the town centre's retail floor space by a third. The Oracle opened in September 1999, and the public descended on it en masse. They recorded over 100,000 visitors on the first day and 420,000 over the first weekend. Stores reported record sales, one taking a month's expected takings in one day, and some retailers had such a run on stock they doubted whether they would be able to open on day two. One restaurant sent out an urgent call for eighty additional members of staff. In total, about 3,500 people work in the Mall.

The commercial success of the Oracle today can be judged by its car park, which frequently operates to capacity at weekends and other peak shopping times, with tail-backs of would-be parkers that block the Inner Distribution Road.

The Age of the Department Store

The latter part of the Victorian era and the first half of the twentieth century can be categorised in shopping terms as the age of the department store. One of the first, and one of the few to survive (albeit under different management), started life as a small draper's shop on Minster Street in 1854. The proprietor was John Heelas, and his sons John and Daniel joined him in the business as he diversified into everything from furniture to funerals. The business was successful and began to expand; by 1866 they had taken over the adjoining Methodist chapel and school and by 1870 acquired the Black Boy Inn, giving them a prime Broad Street frontage. Queen Mary shopped there, as did the management of Reading prison, ordering uniforms for their inmates.

It remained a family business for almost a century. Then in 1947 the millionaire Charles Clore bought them out, and the business was then owned in turn by the United Drapery Group from 1950 and since 1953 by the John Lewis Group. But only in recent years has it come to be known by the generic John Lewis brand name and it will forever be known by a generation of shoppers as Heelas.

When it opened its new building in 1903, McIlroys department store on the eastern end of the Oxford Road (that is now Broad Street) was one of the wonders of the age. Its vast

expanse of brightly-lit windows at ground and first-floor level earned it the nickname of Reading's Crystal Palace. It even won the rare distinction (for a shop) of inspiring a poem. On its opening, local poet Mr J. Mosdell sent a long and fawning letter to William McIlroy, from which the following is extracted:

> Will you kindly permit me to offer you my most hearty and respectful congratulations upon the magnificent pile of buildings which you have erected in the town, and the more magnificent business which made such prodigious buildings necessary. They are indeed a splendid monument to your industry and business ability, besides being a most ornate and valuable acquisition to the modern architecture of this ancient Borough of Reading. They are not only massive and imposing, but they are also extremely beautiful and reflect the highest possible credit upon all concerned in their construction ...
>
> *Reading Standard*, 2 January 1904

After more of the same, Mr Mosdell unleashed his paean of praise in verse to the man and his building. This is verse one (Readers of the *Reading Standard* got all twenty!):

> Stupendous building of superb design!
> Unique, original and unsurpassed
> Strength and utility throughout combine
> And in its every single detail shine
> Most beautiful, although so huge and vast.

The business had been at the site in Oxford Road since 1875, having started life as a boot and shoe warehouse at No. 50 Broad Street. It was one of a chain of eight stores, at Bath, Maidenhead and elsewhere, and the later proprietor, another William McIlroy, spent most of the years of the Second World War as the town's energetic mayor. As we will see, McIlroys ceased trading in Reading in 1955. It was just one of a series of department store closures during the post-war period. Bulls, the draper, milliner and supplier of furniture and household goods, were one of a number of stores whose proprietors served on the council, some of whom were also important benefactors to the town (providing Arthur Newbery Park and McIlroy Park). Bulls closed in 1954. Wellsteeds started life some time before 1870 as Wellsteed Moores & Company. They survived having their Minster Street frontage destroyed by a German bomb in the air raid of February 1943, but eventually sold out to the Debenham group in 1973. Debenhams in turn moved into a 145,000 square foot store in the Oracle, which provided that development with a frontage to Broad Street.

One of the last locally-based department stores to go was Jacksons, who gave their name to the junction of King Street, Kings Road, Market Place and Duke Street – Jackson's corner. At one time they had shops on both sides of that road junction. Edward Jackson opened his first shop there in September 1875, and went on to establish branches in the east, west and north of the town. He also found time to become a councillor and mayor of Reading. He was a paternalistic but stern employer, given to fining his staff for engaging in tittle-tattle or addressing each other by anything but their surnames. Four generations of Jacksons ran the business until its closure in 2013.

There were other, not locally-based, department stores that used to occupy the town's retail centre but are now gone. The Coop once had frontages on Cheapside and Friar Street, and on Broad Street Timothy White's went in 1971, Littlewoods in 1996 and Woolworth in January 2009.

Today's national chains of stores look to the mass media, and particularly television, for their promotions. Half a century and more ago, everything was more localised and Reading stores looked more to the Berkshire media to whip up interest. The arrival of Father Christmas (or, rather, the rival Father Christmases) in town as part of the run-up to Christmas could usually guarantee a sizeable turnout of shoppers, and the stores would vie with each other to come up with the most ingenious grotto and the most inventive means of transport to it. So in the run-up to Christmas 1950, Reading children would have been bewildered to hear that Santa was variously: landing in an aeroplane in Kings Meadow and being transferred by space ship to a moon rocket grotto in McIlroys, accompanied by a host of fairy folk; arriving with his band and Cinderella and staying at the Cinderella grotto at Heelas; travelling in the speedboat SS *Reading* to the Co-op; or accompanying Saba and Snowball to the frozen north in Wellsteeds.

The Make-Up of Our Shopping Streets

One way of seeing how our shopping streets have changed over the years is to look at who occupied them. From Victorian times to 1976 *Kelly's Directory* provided a regularly updated picture of the nation's high streets. The following sections look at the same section of Broad Street – the north side, between Cross Street and the junction with West Street: (a) in 1895, and (b) in 1956.

1895

* Here is Cross Street
Nos 24–5 Capital & Counties Bank
No. 26 Reading Liberal Association and Liberal Club
No. 27 Alfred Board, grocer
No. 28 John Maud, watchmaker
No. 29 William Neal, beer retailer
No. 30 John Line and sons, paperhanging warehouse
No. 31 Mary Marchant, baker
No. 32 Star Tea Company
No. 33 Sidney Stevens, grocer
No. 34 James Tutty, bootmaker
No. 35 Dan and company, photographers

* Here is Land Place (Queen Victoria Street did not exist at this time)
No. 38 Ebenezer Hill, leather goods dealer
No. 39 Farrer and sons, stationers

No. 40 Henry Pecover, ironmonger
No. 41 Dukes Head public house
No. 45 Nisbet and sons, tailors
Nos 46–7 Bowsett brothers, family brewers and beer sellers
No. 48 Charlie Watson, butcher
No. 49 William Archer, grocer

* Here is Union Street
No. 50 William McIlroy, boot dealer
No. 51 Peacock public house
No. 52 William Bennett, grocer
No. 53 S. J. and E. Kirk, bootmakers
Nos 54–6 A. H. Bull, draper
No. 57 William Dyke, draper
No. 58 Robert Thompson, provision dealer
No. 59 A. H. Bull, clothier
No. 60 Richard Paice, confectioner
Nos 61–2 Richard Sadgrove, ironmonger
Nos 63–4 Harry Williams, ladies' tailor
Nos 65–6 G. and W. Morton, bootmakers
No. 68 Charlie Watson, butcher
Nos 70-1 George Hazell, grocer
No. 72 Frederick White, tobacconist
No. 73 Stephen Gardiner, watchmaker
No. 74 The Vine public house

Note the more or less complete absence of chain stores; nearly all the businesses look to be locally-run family affairs. Note also how many of the stores are selling goods that most of us today would look to buy in a single stop at a supermarket (a form of trading whose time was yet to come). Thirdly, public houses can still afford to maintain a significant presence in one of the town's prime retail frontages. Moving forward half a century to 1956, here is the same section of Broad Street:

1956

* Here is Cross Street
No. 24 Lloyds Bank
No. 26 Sands, milliners
No. 26 Liberal Association and Club
No. 26 Hawkey and Moffat, auctioneers and estate agents
No. 26 Amberley Hire Purchase Company
No. 26 Robert Cross and Co., export concessionaires
No. 26 South Midland Council of Grocers' Associations
No. 26 Slater and Hardie, jewellers

No. 26 Geoghegan, watch repairer
No. 28 Midland Bank

* Here is Queen Victoria Street
No. 35 Freeman Hardy and Willis, bootmakers
No. 36 International Tea Company, grocers
No. 37 Etam, ladies outfitters
No. 38 Hill and sons, leather goods, baby carriages, etc
No. 39 W. H. Smith, booksellers
No. 40 J. Lyons, caterers
No. 43–5 Jas Barrington, costumier
No. 46 Dolcis, shoe company
No. 46 A. Salisbury, leather goods
Nos 47–8 Gaumont Theatre, café and restaurant, cinema
Nos 49–51 William Archer, hardware merchants

* Here is Union Street
No. 50 H. Samuel, jeweller and watchmaker
Nos 51–2 Prices, tailors
Nos 52–53 Wolfe and Hollander, house furnisher
Nos 53–58 Littlewoods, departmental store
No. 59 John Quality, grocer
No. 60 Barratt and co., bootmakers
Nos 61–4 F. W. Wallworth, departmental store
Nos 65–6 Mac Fisheries, fishmonger
No. 67 Home and Colonial Stores, grocers
No. 68 H. Wilson, milliners
No. 68 Alan Adamson, dentist
Nos 70–1 W. Cumber, butchers
No. 72 Wallis and Co., costumiers
No. 73 A. Finlay, tobacconists
Nos 73–4 Montague Burton, tailors
Nos 73–4 Law Society (area headquarters)
Nos 73–4 Royal Insurance Co. Ltd.

This has become much more familiar territory. Many of the retailers are branches of national chains, some of them still existing, others at least remembered. By 1976 the individual trader would have almost completely disappeared from this part of the town centre. The supermarket has made its appearance. John Quality at No. 59 was described as a grocer, but was one of the first to give Reading the chance to experience self-service supermarket shopping, in 1951. Home & Colonial at No. 67 may sound like a quaintly imperialistic anachronism, but it was in its day a massive national force in grocery retailing. Around the time of this survey, they were the twenty-seventh largest company (in any sector) in the United Kingdom, and eventually formed part of the Safeway supermarket group. The

numbers of specialist retailers within the grocery sector may have diminished substantially along this stretch of shop-front through competition with supermarkets, but there was still enough interest in ladies' hats to support not one but two milliners.

One other product once sold in the town centre but now banished to the suburbs is the motor car. In the early days of the last century, the junction of Broad Street and Minster Street was the headquarters of the Speedwell Motor Company. This is not the American-built model, produced between 1907 and 1914, but a British and, more specifically, Reading-built car, manufactured between 1900 and 1906. In that year, they changed their name to the New Speedwell Motor Company and transferred the business to London.

Great Western Motors, a car dealer rather than manufacturer, set up business in Station Road (near the Great Western Hotel) in the early twentieth century and traded there for many years, before moving to Vastern Road and eventually closing in the 1980s.

Vincents started life as a coach-building business in the horse-drawn days (1866) at Arborfield. In 1899 they moved to Castle Street, Reading, where they diversified into providing bodies for the new-fangled motor cars. Over the years they coach-built bodies for everything from horseboxes to Rolls-Royce motor vehicles. They were soon providing a variety of car-related services, including a taxi service and (in those pre-petrol station days) delivering petrol to motorists' homes in two-gallon cans. They were also agents for many of the leading makes of cars. After the First World War they had a showroom on Broad Street, graduating by 1928 to one of the largest and most modern showrooms in the country, immediately opposite the central railway station. In the 1970s the town centre site was disposed of, in favour of a repair site at Burghfield Bridge and a showroom on the Oxford Road. The business closed in the late 1980s.

The age of the supermarket

In 1951 a strange new idea was revealed to the women of Reading (via the ladies' page of the *Chronicle*). An entirely different approach to shopping was being launched in the town's food stores and so alien was it that the newspaper felt obliged to explain it in detail:

SELF-SERVICE SHOPPING POPULAR
Are Reading's shopping habits changing? Recent months have seen the changeover of half a dozen of the town's stores to self-service methods and the latest development is the opening of a self-service tea bar. Almost without exception, the new style of shopping has pleased both customers and store keepers and there has been remarkably little reluctance to accept the experiment.

The basis of the new method is 'visual appeal' – a sound piece of 'sales psychology' now applied to every phase of advertising and selling. If a woman sees an article she is more likely to buy it than if she has to ask for it. Self-service means that the housewife walks into a spacious shop, takes a basket and wanders past tiers of goods, uniformly displayed with everything clearly marked. She finds the things she originally wanted and is given a reminder of others as her eye is caught. Finally an assistant checks her purchases and she transfers them to her own basket.

One local shopkeeper reports a threefold increase in turnover and felt that the new method would become universal, since salesmanship was a dying art among retail staff. Another advantage is a definite decrease in shoplifting and it saves time waiting to be served.

Berkshire Chronicle, quoted in Hylton (1997), page 17

Not even an institution like McIlroy's department store could resist the tidal wave of enthusiasm for self-service. McIlroys closed its doors in 1955 and the following year the premises re-opened as another gleaming new supermarket. For some reason, the newspaper felt obliged to explain the workings of them again:

This gleaming contemporary store, with its huge plate glass windows, yards of refrigerated display and stacks of brightly coloured groceries, brings new convenience and ease to household buying … The supermarket is not merely a new kind of grocery. It aims to cut out numbers of trips to separate shops and provide under one roof the widest possible variety of goods. Here is a long counter of fresh vegetables and fruit, the vegetables washed and pre-packed in transparent paper with the price and weight already marked… The shopper will have a wheeled double-decker basket to push around the store. Seven checkouts will cut down waste of time in paying for goods and wrapping them … In addition there will be something you will probably be surprised to see – nylons. Yes, nylon stockings and at astonishingly low price and high quality. These always sell very well at American supermarkets.

Berkshire Chronicle, quoted in Hylton (1997), page 77

But the enthusiasm for town centre supermarkets was relatively short-lived, as congestion and lack of parking made it ever more difficult for an increasingly car-owning clientele to do their shopping centrally. Town centre supermarkets gave way to ever larger units, surrounded by acres of surface-level parking, out in the suburbs and beyond. One survival that bucked the trend was the Sainsbury store in Friar Street, opened in 1963 and still trading. Only in recent years has the trend towards decentralisation been reversed, as a new generation of smaller town centre supermarkets courted town centre office workers, who were doing their grocery shopping on a more day-to-day basis.

Earth Hunger – Reading's Boundaries

In 1801 the built-up area of Reading was roughly defined as a triangle whose base was formed by Friar Street and its apex by Whitley Hill. The earliest surviving map of Reading, dating from 1611; shows a very similar built-up area. The borough was about a fifth of its present size, and the census of that year put its population at 9,421. Areas like Whitley, Caversham and Earley were freestanding settlements. How did the town take on its modern size and shape?

The 1887 Boundary Extensions

Some of the first real pressures for changes to the borough boundary came after the council acquired 760 acres of land at Whitley for use as a sewage farm. The town had been growing quickly, particularly to the east in Newtown, to house the ever-expanding workforce of Huntley & Palmer. Many of these housing areas discharged their sewage directly into the River Kennet, (near to where it joins the Thames) but the Thames Navigation Act of 1866 outlawed this practice. An alternative had to be found.

The obvious solution was to connect their sewers into Reading's system. But many of these areas lay outside the borough boundary of the day and Reading was unwilling to have them using the town's sewers unless it was paying for them through its rates. Dr Shea was Reading's Medical Officer of Health, but also held a similar position with Wokingham's adjoining Rural Sanitary Authority. He was keen from both perspectives to see the connection made, and pointed out to Reading that 'an undrained suburb is always a standing menace to the town to which it is joined'.

There were differing schools of thought as to how ambitious any boundary revision proposals should be. Should they simply take in those outlying areas that were already developed or developing? Or should they try to incorporate a wider area, recognising that outward expansion would very soon turn these neighbouring areas into building sites, themselves needing access to the sewerage system?

There were also the opinions of the neighbouring authorities to take into account. Private legislation of the kind involved in boundary changes was far more likely to succeed if it were not strongly opposed. In this case, the neighbouring sanitary authorities were the Poor

Law Guardians of Wokingham and Bradfield. They had a statutory duty to provide for the disposal of sewage, a service which was paid for from the rates, a property tax. Reading's boundary extensions would take away some of the most recently built and often highest rated property. The sanitary authorities would still have to provide sewerage to the rest of their areas, but without the rates income from the areas into which Reading planned to extend. The Wokingham Poor Law Guardians were the most implacable opponents of extension, despite the fact that their area had been unable, after ten years, to comply with the sewage requirements of the Thames Navigation Act. In the end a compromise was made, to the effect that Wokingham would not object provided the Extension Bill did not make any change to the Poor Law funding arrangements for the extension area. That way, Wokingham got to keep at least part of the Earley tax base. Reading's approach, also in 1911, favoured the limited approach to expansion, on the basis that the neighbouring authority lost less of its tax base and was therefore likely to be less vehement in its opposition.

A public meeting was held in the town hall in November 1886 to outline the council's expansion plans – the Reading Corporation Bill. The local press summed up the outcome:

> The meeting began at seven, and after an exciting debate was not over till half-past ten, when the resolution to proceed with the Bill was negatived by a large majority, but a poll was demanded.
>
> *Berkshire Chronicle*, 27 November 1886

This was surprising, in that the detailed newspaper report of the debate suggests to our modern eyes that the Bill's supporters had by far the better of the argument. It was opened by the mayor, who made it clear at the outset that only ratepayers and property owners were allowed to speak, though others could stay and listen. He said that, for sanitary reasons alone, that the extension of the borough was very essential. There was danger at their doors. To remain as at present would place them in much the same position as the man who cleansed and painted his house and then allowed accumulations of dirt to remain outside. Figures were quoted to show how the fall in Reading's death-rate had coincided with the introduction of a proper sewerage system.

The sanitary arrangements in the neighbouring areas were compared unfavourably with those in Reading. As one speaker pointed out, the outfall of the Earley sewer was not necessarily into the Kennet. In summer time, when the water was low, the outfall was onto the banks of the Kennet. The mud was then saturated with sewage. The odour was not very pleasant, and the germs of disease might be blown over the town.

The illogicality of the current boundaries for Poor Law and healthcare purposes was also referred to. The poor of the growing area of Newtown had to go to Wokingham for Poor Law relief and to Sonning for medical aid, while those in the areas of Tilehurst proposed for incorporation currently had to go to Theale for the doctor, to Tilehurst for Poor Law registration, and to Bradfield for actual relief.

The poll decided upon by the meeting took place in December and some vigorous lobbying took place in the meantime. However it was evidently not enough to get everyone to vote:

A poll was taken in Reading on Saturday to decide whether the ratepayers were in favour of the Corporation Bill. The mode of election was by voting papers. Just as there are a great many persons who will not take the trouble to go to the polling booth, so it seems that a considerable portion of the ratepayers will not devote a minute or two to the duty of filling up a voting paper. Around 1,800 ratepayers did not vote at all ... Of those who did vote, the majority was decidedly in favour of the Bill. If the poll had been taken two or three weeks ago the majority probably would have been on the other side. At first there was a strong feeling against the Bill, and the measure was condemned at a large meeting of ratepayers which was recently held at the town hall. It is said that at that meeting the sturdiest opposition to the Bill was offered by persons who were not entitled to be present. It was alleged that people had come from the outlying districts and had got into the jury box although they were not on the Panel. Their verdict was that the separation between Reading and its neighbours was a judicious separation and that any attempt to unite the parties would end in unhappiness and disaster.

Berkshire Chronicle, 25 December 1886

But no matter that the turnout was only 48 per cent, the poll gave the council a majority of 1,885 for the Bill. Armed with this ballot in favour of the boundary extension, the council persevered with its application. The boundary changes, bringing parts of Earley, Whitley and Southcote into Reading, were approved by Parliament in 1887.

The 1911 Boundary Extensions

Caversham is a well-to-do suburb – Reading's Richmond.

Salter's Guide to the Thames, 1912

Reading has only one 'natural' boundary – the River Thames, which for a thousand years formed the northern boundary of Berkshire. The 1887 boundary extensions left Caversham untouched, since it was seen as a freestanding village in a separate county, and one that did not favour incorporation into Reading. By 1911 Caversham functioned more as a suburb of Reading, even though, since 1894, it had been run by an urban district council (with some of its services delivered by the county council from Oxford). Opinion about incorporation with Reading also seemed to be more divided, with Caversham approaching Reading about joint schemes for sewage disposal and a new Thames crossing, and Reading supplying Caversham with mains water and gas.

Sewage also featured large in the boundary discussions of 1908–11. Tilehurst had continued to grow after its eastern part was incorporated into Reading in 1887. The council described this new population as 'an outgrowth of the Borough, a large proportion of the residents being employed or otherwise connected with the Borough'. Like their neighbours to the east, this new population also wanted to be connected into Reading's sewerage system, and the council again said this could happen only if the parish became a part of Reading. The council knew that Tilehurst (or, rather, Bradfield RDC) had already had its

proposal for its own system of mains drainage rejected by the Local Government Board. It would have involved building a new sewage works, and their preferred site was at Scours Lane, between the railway line and the river. Just downwind of it would have been the Thames Side Promenade, which Reading council had just acquired as a recreational amenity for its citizens. Manor Farm had sufficient capacity to deal with Tilehurst's sewage, and Bradfield's scheme made no sense in environmental, administrative or public health terms.

Caversham also had problems with its growing volumes of sewage. In 1894 their local board had resolved to buy nine acres of riverside land from William Crawshay, the wealthy ironmaster who owned the Caversham Park estate. The plan was to run a sewer across it and dump Caversham's waste into the Thames at some point downstream of Caversham lock. The land was eventually bought, after difficult negotiations, but the Thames Navigation Act saw to it that this would not be a long-term solution to their problems. As we saw, Caversham local board had also approached the council about disposing of its sewage at Manor Farm, although nothing had come of this initial approach.

The case for Caversham's incorporation rested more on its general dependency on Reading. It had once been a freestanding village in the days when almost none of Reading lay to the north of the railway. But, as Reading expanded northwards, Caversham began to look increasingly like one of its suburbs, separated from it only by a narrow stretch of water. Almost half of Caversham's working age population (including half of Caversham UDC's councillors) had jobs in Reading, many of its children were schooled there, and they used Reading's amenities (libraries, art gallery, parks and museum) and services (public transport, water and gas supplies).

The bridge across the river would also figure large in the debate. The provision and upkeep of this was the joint responsibility of the two authorities, and many in Caversham wanted to see the replacement of the inadequate iron bridge that had been in place since 1869. They recognised that the best chance of this happening would be if both banks of the Thames were under the same control, since there had been centuries of fruitless wrangling between the two authorities over responsibility for its upkeep, prior to the erection of the iron bridge.

At the same time, there were many in Caversham (in particular, many of the great and the good) who strongly opposed incorporation. Their argument was, at heart, a financial one. They paid lower rates than Reading and also felt that their property would somehow be devalued by incorporation. They would inherit part of Reading's debt which, they said, was per capita three or four times that of Caversham. As one illustration of Reading's reckless indebtedness they cited the £305,000 that they had spent on their sewage system (the same system to which Caversham had sought to be connected). As a further incentive to local opinion, Caversham also promised all sorts of improvements, for example to the water supply, the roads, the fire brigade and a new hospital for infectious diseases (one effect of which would have been to cancel out much of the difference in indebtedness between the two authorities). These promises were partly a response to Reading's criticisms of the services the UDC was currently providing, but they tended to strengthen, rather than weaken, Reading's case.

For their part, Reading was able to argue that many of Caversham's services (delivered by Oxfordshire County Council from Oxford, 28 miles away) were inefficiently run and

could be better delivered from next-door Reading; that, in addition to being inefficient, they were also run to a lower standard. Animals condemned for human consumption in Reading would be taken to be slaughtered and sold in Caversham. Caversham even had a lower school leaving age than Reading – thirteen, compared with fourteen. Perversely, some Reading parents sent their children to school in Caversham so that they could leave school and start earning a year earlier. Incorporation would also give Caversham access to other Reading facilities, such as the Park Fever Hospital (Lower Caversham suffered an outbreak of scarlet fever in 1908).

The editor of the *Reading Standard* saw some particular advantages flowing Caversham's way as a result of incorporation:

> The ultimate effect of the opposition to the Bill in the House of Commons will be that the improvement to the main streets of Caversham will be carried out on a scale of great and permanent value. The existing bridge over the Thames and the adjacent streets in Caversham are to be widened to a considerable extent. The bridge will also be so strengthened as to permit of tramcars being run over it, and the enlargement of Bridge Street, Church Street and Church Road will, in addition to getting rid of a dangerous corner, give to Caversham an appearance of prosperity and importance which is its due. At present anyone making a first acquaintance with Caversham by entering it from the Berkshire side cannot fail to be impressed with the mean and meagre look of the main thoroughfare. He certainly would not expect that it served a population of 11,000 people, a number which would be largely increased as time goes on. These improvements will be very costly. They could not have been carried out by Caversham alone.
>
> *Reading Standard,* 8 July 1911

Caversham UDC's refusal in 1899 to foot the bill for the road widening was a major reason why the electric tram network had not been extended into Caversham. This led to massive pedestrian flows across the river to catch the trams to work. The editor was more ambivalent with one of the other provisions of the Bill:

> A new vehicular bridge linking lower Caversham with Reading, and bringing its inhabitants within a quarter of a mile travelling distance of Reading Town Hall, would have been of greater utility than the footbridge which under the terms of the Bill has to be erected; but the nearness of the Great Western Railway to the river presents a difficulty, and some doubt exists as to whether the utility of a larger bridge would justify the expense …
>
> Ibid.

But, ultimately, he saw a moral justification for the boundary extension (one that some of those being incorporated may not necessarily have shared):

> The enlargement of the Borough boundaries will be a means of preventing wealth escaping its fair share of the burden of governing the Borough. In the industrial

world, the tendency of the amassers of wealth is to get further and further away from their sources of income. This step is usually dictated by two reasons, one to escape from the grime of the town and the other to avoid the heavy rates inseparable from the administration of a great urban community. When the latter motive leads to residences being secured just beyond the borders of the town, the justice of extension is apparent… the inclusion of Caversham and Tilehurst within the borough will serve to restore the balance of municipal burdens between rich and poor.

<div align="right">Ibid.</div>

However, the new residents of Reading were spared making up 'the balance of municipal burdens' – at least in the short term. One concession made to Tilehurst's objections took the form of preferential rating, whereby the newly incorporated residents paid only three-fifths rating for seven years and two-thirds for the next eight, with an understanding that connection to the drainage scheme would be started as soon as they were incorporated.

The order incorporating Caversham also included preferential rating, with Caversham ratepayers getting a discount of nine old pence (4p) in one pound for fifteen years, in return for the Oxfordshire authorities withdrawing their objections. It also required Reading to widen or reconstruct the existing vehicular bridge at Lower Caversham within five years of incorporation, and to construct a new footbridge. The new footbridge eventually became the vehicular Reading Bridge. The one major landowner to successfully oppose incorporation of their property into Reading was the Crawshay family, the owners of Caversham Park. They did so largely on the basis that the Caversham Park estate would never be developed.

The order for incorporation took effect on 9 November 1911 and shortly before that, Caversham Urban District Council held its last meeting. They approved the abortive expenditure that had gone to oppose incorporation, made a presentation to the council chairman, Mr Harold Dryland, who had led that opposition, then retired to the Caversham Bridge Hotel for a smoking concert, their work forever done. But this would not be the end of Alderman Dryland's championing of Caversham's cause. When the First World War forced Reading to seek an extension of the deadline for completing the bridge-building and other works required as part of the boundary extension, he lobbied (unsuccessfully) for Caversham ratepayers to get a similar extension of their preferential rates reduction.

Post-War Extension Proposals

The Second World War was still in progress when the coalition government published proposals foreshadowing a nationwide review of the status, boundaries and areas of local authorities. A Local Government Boundary Commission (LGBC) was set up to carry it out. Reading, which had seen further expansion just outside its boundaries at Tilehurst, Earley, Woodley and Caversham since 1911, saw this as an opportunity for further growth, but this time the initiative was less with the council and more driven by a reforming post-war Labour government. The Minister of Town and Country Planning, Lewis Silkin, visited Reading in June 1946 and encouraged the council 'to make a comprehensive plan for the town looking at the need for joint planning of the whole area'. The sting in the tail

of his message was the need for the Reading area to take account of the Greater London Plan's aim to overspill some of London's population into Berkshire.

The council published its most ambitious ever expansion plans in 1947. It abandoned the authority's previous cautious incremental approach to boundary change, proposing to increase the borough by over two and a half times in area (but only 17.5 per cent in population). It would have incorporated Purley, Burghfield, Three Mile Cross, Earley, Woodley, Sonning, Binfield Heath and Mapledurham. As such, they would have incorporated virtually all of the expansion of the Greater Reading area that was to take place over the rest of the century, and probably more. In the event, the proposals came to nothing; the government announced that it was unable to legislate for a comprehensive review of local government and in 1949 the LGBC was abolished. Had the council gained territory through this review, it may have done so at the cost of losing powers, for the LGBC was contemplating it becoming a new type of county borough, one which lost its powers in town planning, major highways, fire and police to the county council.

But Reading still faced a major shortage of land to carry out its much-needed housing programme. Its target of 3,400 houses in five years could only be achieved by going beyond existing borough boundaries. A certain amount of shadow boxing went on, with the council threatening to promote a boundary extension through a private member's bill, until the neighbouring counties bought them off by agreeing to help Reading find housing sites outside the borough.

A further opportunity for boundary extension came when the Local Government Act 1958 created a Local Government Commission to conduct boundary reviews around the country. In 1965 its attentions shifted to the Reading area. Reading's proposal this time was based on the work done in 1947, but rather more modest in scale. That earlier work had identified a 'blue line' – an area around the town jointly agreed by Reading, Berkshire and Oxfordshire as being suitable for future development. Even so, it would have almost doubled the size of the borough and increased its population by a third, to 164,691. But once again the government called a halt to the work of the commission in early 1966, before they could come to a view on the merits of Reading's case.

There was one final chapter to the story of Reading's boundaries. As we saw, the Caversham Park estate was spared incorporation into Reading in 1911, mainly on the grounds that the great Crawshay estate would never get built upon. It stayed in the family's ownership until 1922, when death duties forced its sale, to the Roman Catholic Oratory School. In 1926 the house suffered another serious fire, one which, incidentally, illustrated the nonsense of Reading's then boundaries. Being outside Reading, the town's fire brigade could not respond to the fire alarm, and this was left to the Sonning fire brigade. This was a voluntary body and took half an hour to assemble, by which time the fire was well under way.

At the outbreak of the Second World War, the house was originally going to be used as a war hospital, but instead was taken over by its present occupiers, the BBC Monitoring Service. They continued to use the house after the war, but had little need for the extensive estate. At first, the planning authorities resolved to keep it undeveloped, to prevent Caversham spilling over into Oxfordshire. But Reading was still desperately short of housing land and was looking for overspill sites. By 1959 they were close to making

a compulsory purchase of 137 acres of the estate, at a price of £45,000. But last-minute changes to the compulsory purchase rules meant that they would have had to pay market price for it, increasing its value by at least tenfold and putting it out of the council's financial reach.

Instead, the private developer Davis Estates bought it and began a development of some 1500 houses in about 1964. As was the case for the rest of Caversham in 1911, it made no sense for many of the local services to be administered from Oxford, rather than next-door Reading, and in 1977 Caversham Park finally became part of Reading.

So Reading today is in a similar position to that it has been in for more than a century past. With no natural boundaries to dictate the outer limits of development, the built-up area of greater Reading has extended far beyond its administrative boundaries. One difference today is that there appears to be little active pressure – either from the borough or its neighbours – for a boundary review. However, were a future government to ask the question, who knows what ambitions might be revived?

The Rivers

Even Reading, though it does its best to spoil and sully and make hideous as much of the river as it can reach, is good-natured enough to keep its ugly face a good deal out of sight... The river is dirty and dismal here. One does not linger in the neighbourhood of Reading.

> Jerome K. Jerome, *Three Men in a Boat*, 1889

... it is unfortunate for the reputation of Reading that the portion of the Thames which flows past it should be regarded as the chief blot on the river between Windsor and Oxford.

> W. M. Childs, 1922

Reading itself is generally avoided by those seeking a quiet holiday in the Thames Valley and its reputation has suffered because many people pass through it on the A4 or the railway or visit it as a shopping centre, without being aware of the rivers.

> Reading Waterways Plan, 1978, page 5

The rivers Thames and Kennet were a major part of Reading's original *raison d'être*, and were for centuries one of the most important of its arteries of trade, but what part have they played in the development of the Reading we know today? What should be our starting point? It might be the point at which the rivers ceased to be primarily a corridor for trade, and became primarily one for recreational boating. One landmark for the decline of trade might be 1852. The Great Western Railway, having captured much of the Kennet and Avon Canal's commercial traffic (much of which also passed along the Thames), actually bought the canal in that year. This marked the start of the canal's decline, to a point where it became navigable neither for trade nor recreation.

One of the objections raised to the coming of the Great Western Railway in the 1830s was that it would also lead to the disuse of the Thames. But just about the time the railway was opening for traffic, one sign of a growing recreational use of the Thames came in the shape of the town's first regatta, held in 1842. Unlike its counterpart at Henley, this was initially an egalitarian event, at which gentleman amateurs and artisans including professional watermen could compete with each other. It even included a punt race. But with only five events at hourly intervals at the first regatta, some felt it a little short on entertainment value, and called for other diversions, such as donkey races, to be laid on.

Fortunately, the ladies among the 10,000 spectators provided their own diversion, in the form of a fashion parade:

> On the Oxfordshire side of the river a considerable unity of the beauty and fashion of our good town had congregated giving a charm to the scene which, lovely as it is at all times, we may safely affirm it never excessed.
>
> *Berkshire Chronicle*, 1842, as quoted in www.reading-amateur-regatta.org

There have been various intervals in the staging of a regatta over the years, due to financial and other problems, but the Reading Amateur Regatta as it is now known seems to have a healthy future. It has had royal patronage since 1896 and applications to compete comfortably exceed the number of entrants the organisers can accommodate.

There was other evidence of the growing shift towards recreational use of the river. By the 1880s there were some 250 steam pleasure launches operating on the Thames, cordially hated by traditionalists for their noise, speed, wash and the attitude of their drivers. In the same decade, naptha-powered boat engines became popular. They were light, relatively cheap to run and compact, but the offensive smell they made used to cling to people's clothes and hang about in locks. A 1904 regulation forbad them from using the locks at the same time as other boats. Petrol-engined boats came later, but also had their problems. Edward VII set the trend by buying his in 1903 and by 1912, 547 such craft were registered on the river. The main concern about them was fire. Sand bins were placed at all locks to help extinguish flames, but they still caught fire. For this reason, petrol-engined boats were also forbidden to enter the locks at the same time as other craft.

Chartering of boats and day excursions were also coming into their own. A piece of legislation, the Thames Preservation Act 1885, acknowledged the changing role of the river:

> The Thames is a navigable highway and has come to be largely used as a place of public recreational resort: and that it is expedient that provision should be made that it should be preserved as a place of regulated public recreation.

The late nineteenth and early twentieth centuries may have marked a high point in the rivers' recreational use. Yet, ironically, this was also a period when much was done to make Reading's river frontages as unprepossessing as possible. Take for example *Lock to Lock Times* magazine's lament at the building of a new boathouse, opposite Fry's Island, in April 1891:

> Another new boathouse is in the course of erection at Reading adjacent to the headquarters of Reading Rowing Club. Like its neighbour, the newcomer does not promise to become a thing of beauty but at the same time it will be in harmony with its immediate surroundings, where the demon of ugliness seems to reign supreme.
>
> *LTLT*, 4 April 1891

These visions of loveliness were joined over the years by such amenities as a sawmill, a timber yard, a depot for the Reading Electricity Supply Association, until *Lock to Lock Times*

was able to despair of the entire south bank of the Thames below Caversham Bridge:

> The stretch of bank alluded to bids fair to equal in ugliness any other between the source of the Thames and the sea.
>
> *LTLT*, 8 April 1893

Some attempt was made to save this reach of the river from the complete ravages of development, by a group submitting a proposal for an esplanade along the bank. The council initially threw this out, though a promenade, upstream of Caversham Bridge, was provided instead. The land for this was bought in April 1906 and the Borough Engineer came forward with a £3,320 scheme for landscaping it. By 1908 a gravel riverside path and a portable bandstand and chairs had been provided.

Another eyesore (or possibly the word is eyeful) was offending the sensibilities of Victorian Reading in the late nineteenth century. There was a tradition of male nude bathing in the Thames near Caversham lock that went back at least to 1834. A bathing facility had been provided just to the west of the Kings Meadow Road (to the rear of the modern day Reading Bridge House). Complaints were starting to be made about boys and men practicing naked bathing in that stretch of river. Typical was this complaint from someone signing him or herself 'disgusted':

> It is simply a disgrace to the authorities that they allow the public to be so gratuitously insulted and to have their sense of decency so flagrantly abused.

It seemed some of the guilty parties were deliberately out to shock, if this complaint to the *Lock to Lock Times* is to be believed:

> ... seeing we had a lady on board – my wife – they pulled their boat ashore within about twenty yards of us and then commenced to strip themselves, which done, they sported with each other in the way that I think only English blackguards would do under the circumstances ...
>
> Quoted in Burstall, page 155

Not content with keeping their nudity below the waterline, they would run about on the bank to get dry. One of their number even laid down on the bank, reading the *Daily Mail* in a state of undress. He collected a £1 fine for his brazenness, for the Thames Conservancy had been forced in 1889 to issue a byelaw, stating that:

> No person shall bathe without proper dress or drawers unless properly screened from view.

As if all of this were not bad enough, some of the miscreants used 'language of the most indecent and disgusting description' and made insulting references to the ladies in passing boats. River-related businesses were afraid that respectable customers would be driven away. Nor even was it just a seasonal problem, for Reading had a hardy group of winter bathers.

One of them, a Mr Jack Eighteen, made a point of going into the water with his bathing drawers on his head, since the byelaw did not specify on which part of the body they were to be worn.

But by 1934 it seems that it was lady bathers who were exercising the minds of river users. The Thames Conservancy were carrying out the first review of their by-laws since 1898, at which time lady sunbathers in swimming costumes had not been an issue. But now it seemed female sun-worshippers were disturbing the peace in the locks. An official explained:

> The Board has always attempted to understand modern conditions. We have no objection to sunbathing, provided it takes place where it does not annoy other people. When boats are crowded together in locks we think the more scantily attired bathers should have some considerations for their neighbours, and in the locks we have decided to insist on regulation costume, which is what is known as a 'university' costume, over which must be worn a mackintosh or coat. The Board intend to prosecute bathers who wear only shorts.
>
> Quoted in Hylton (1999), page 56

The male bathing area was unsatisfactory in a number of other respects. It drew its water from the river, but could not discharge it back there without pumping it. The bathing water also tended to become stagnant. In 1888/9 the council announced plans to upgrade and enlarge the facility. The new open-air swimming pool (now a Grade II listed building) was to be a ladies-only facility. It too drew its water from the river, but at least it had a filter to stop fish entering. Completed in 1903, it did not have long to wait (1911) before it faced competition from the indoor swimming facility at the Arthur Hill Memorial Baths in Kings Road. One further annoyance for riverside landowners was the horde of small boys, who used to run through fields of standing crops to reach their favourite bathing places. One Reading landowner sought to discourage them by dropping cartloads of broken bottles into that stretch of the river.

During the Second World War this stretch of riverside (Kings Meadow, Christchurch Meadows and the Promenade) was an important part of Reading's Holidays at Home scheme, whereby the civilian population were encouraged to spend their holiday time being entertained in their home towns, rather than travelling in overloaded trains to the mined and barbed-wired coastal resorts. For at least part of the war years, and again between 1949 and 1954, one of the attractions of Reading's riverside was a miniature steam train, run by a local businessman and steam railway enthusiast named Harold Judd.

The name 'Promenade' even formed part of the town's wartime defences. As we saw, when German invasion threatened, in an attempt to bewilder any invaders arriving in Reading, all clues as to where they might be were removed. Signposts were taken down, station signs painted out and any public notice giving a clue as to the location obliterated. Public transport had any reference to Reading hidden and even the destinations of the trolley buses were changed to coded landmarks that only the locals would understand. Thus, the trolley bus bound for Caversham Bridge had the word 'Promenade' on its destination board. There are stories of wartime visitors to the town getting off the bus at Caversham Bridge

and asking for directions to the seafront. Post-war, the promenade continued to attract visitors. As the town's official guide for 1947 put it:

> The promenade by the Thames has been beautifully laid out as a public park and truly, the Thames has become one of the finest assets of the town.

The peak for pleasure boating was said to have been in the early 1890s, when anything between 500 and 1,000 boats a day could pass through Caversham Lock at peak times of the year. Compare this with the annual figures for 1965 (16,614 craft) and 1975 (31,621). But the busiest stretches of the Thames would always be at Henley and further downstream.

By the early twentieth century, it was thought that the craze for bicycling and an increase in steam launch trips took some of the customers away. Possibly the physical effort of rowing or the inconvenience of stoking your own steam engine told against them? The arrival of the first petrol-driven punt in Caversham in 1903 promised something of a renaissance of interest in boating, though locals were initially sceptical that they would catch on. But such was the increase in numbers that, by 1905, the Thames Conservancy felt obliged to issue regulations governing their use.

But traditional punting also remained a popular activity, even among visiting celebrities. Gracie Field was just one of the theatrical people who took to the water when working in Reading. Gracie had theatrical digs close to the river, in Greyfriars Road, and had a punt named *Violet* permanently reserved for her use during her visits. This was despite the fact that punting in the reach below Caversham Bridge was apparently difficult, due to the depth of the water.

Kennet and Avon Canal

The Kennet and Avon Canal has had two lives. The first of these, as a key artery for the town's industry and commerce, has little bearing on the making of modern Reading. Our interest begins with its dramatic decline and subsequent rebirth. The canal had enjoyed a brief period of prosperity, from its opening to Bristol in 1810 until 1840. It even saw increasing business between 1835 and 1840, part of which was due to carrying materials for the Great Western Railway, which was then under construction along a route that paralleled that of the canal.

But it was a false dawn. Once completed, the railway took much of the canal's trade, being able to compete with it on price and being more than competitive on speed of delivery. In the first year of the railway's operation, the canal's receipts fell from £51,000 to £40,000. The canal company tried all sorts of ways to reduce their costs, some of them disastrous. Their attempts to push a greater volume of trade through the canal led to water shortages, which in turn meant draught restrictions that reduced, rather than increased, the volume of traffic that could be carried. They reduced tolls by 25 per cent and shareholder dividends by 50 per cent. Staff were cut, as was spending on maintenance and repairs. As early as 1845 they even investigated the possibility of turning the canal into a railway to rival the Great Western.

But it was all to no avail. By 1851, they had no option but to offer the canal for sale to the railway. The Great Western had an interest in buying it, if only to stop it becoming a rival railway. The GWR undertook 'to maintain the navigation and associated works in a condition suitable for its continuing use' and in 1852 the necessary parliamentary approval was obtained. The railway paid £211,000 for a canal that had cost around £1,000,000 to build. For about a decade they tried to run the canal as a complementary business to the railway, specialising in high volume, low value goods that were not sensitive to delivery times, but they too could not make it work. To add to their problems, some of their traditional cargoes – like Somerset coal – also started to be exhausted. Eventually they started to breach the undertaking they had given in 1852, and actively discouraged trade. This led to disputes with the remaining operators, some of which ended up as court cases. By 1906, the Kennet and Avon was making the biggest loss of any comparable waterway.

The canal continued to decline from neglect, but this did not stop the owners having the temerity to increase tolls by a staggering 150 per cent in 1920. Six years later they took the final step and announced their plan to apply for the abandonment of the waterway. This caused such an outcry that, in 1928, the railway company abandoned the abandonment and instead embarked on a major programme of repairs and improvements. However, at the same time they were selling off the canal's wharves, buildings and other assets. By the Second World War the canal was still just about navigable but with almost no trade along it. Its main role in the war years was not for transport, but as a defensive line (reinforced by pillboxes and other fortifications) designed to hold up German forces in the event of an invasion.

Wartime neglect only increased the downward spiral of the waterway and, by the time it was nationalised in 1948, maintenance crews sometimes had to be bought in to secure a passage for those few intrepid navigators still trying to negotiate a passage. It was the government, rather than a private owner, that announced plans to abandon the canal in 1955.

Once again, the forces of protest were mobilised, but by now there was a much better appreciation of the leisure potential of the inland waterways. A Kennet and Avon Canal Association (forerunner of today's Canal Trust) was formed. A petition was collected, bearing 22,000 signatures of people living near the canal, and it was decided to deliver it the length of the canal and hand it to the Queen. The petition left Bristol on 4 January 1956, and, by a combination of cabin cruiser and canoe (and people carrying the canoe along stretches where even it could not be paddled) it reached Westminster twelve days later. In a separate court case, the British Transport Commission (BTC) was found guilty of failing in their statutory duty to keep the canal navigable. Undeterred, the BTC published a Bill seeking the abandonment of the canal in late 1955.

Meanwhile, pressure from canal enthusiasts around the country had led the government to set up the Bowes Committee, to review the future of the whole inland waterways network. The BTC got their Act of Parliament in 1956, but it came with a condition that the canal be kept open (and maintained) until 1960. A further government committee was set up to review the future of individual canals on their merits, with the Kennet and Avon at the top of its list for review. Their conclusion emerged in the spring of 1962; the Kennet and Avon was to be saved, with a combination of waterways staff and canal associations overseeing its restoration. The £40,000 annual budget then reserved for annual maintenance was to be divided between maintenance and rebuilding, with voluntary labour augmenting paid staff.

For various reasons, there were delays in giving legal effect to these recommendations, but the newly-formed British Waterways Board applied a policy of cooperation with other canal interests, enabling restoration works to start. In 1966 it was revealed that many of the assumptions on which canal closure proposals had been based were false. Asset values had been greatly inflated to make the financial case for closure, and the authorities belatedly realised that large sections of waterways like the Kennet and Avon were in fact rivers, and that spending on them could not be abandoned, even if the canal parts were closed. It would be 1968 before a new Transport Act made the new policy law.

Restoration was to begin at either end of the canal and worked its way towards the centre. It was a long and labour-intensive task but, in August 1990, the Queen was able to go to Devizes to declare the entire waterway open. Within days, a delegation of canoeists arrived in Reading, bearing greetings from the Mayor of Devizes and the news that the entire stretch of canal was reopened. But Reading already knew that – it had just held the first of many waterways festivals, with dance, music, crafts, food and other entertainments, not to mention a small armada of decorated boats. The canal has become a picturesque addition to the town centre, forming the centrepiece of the new Oracle shopping and leisure centre, where once it weaved its polluted way through a passage called the Brewery Gut, a heavily industrialised area without so much as a towpath to give public access. The shopping centre stretch of the canal won a Waterways Renaissance Award in 2004.

The Waterways Plan

For years, there was pressure on the council to do something about the state of Reading's waterway frontages. This was redoubled by the formation of the Reading Waterways Trust in 1970. It led, in 1978, to the production of *Reading Waterways: A Plan For the River Landscape*. This took a reach-by-reach look at all of the town's waterways, their problems and their potential and set out policies for their future development. In this, they included the Holy Brook (a tributary of the Kennet, partly canalised in medieval times to provide Reading abbey with water and power for their corn mill) and the Foudry Brook (which wended its way via the town's sewage works and its rubbish dumps, and whose interest was felt to be limited to whatever bird life could survive there).

The plan was not altogether complimentary about the waterways as they found them: of the Scours Lane area they said:

> The condition of the carriageway of Scours Lane and the fences to the adjoining properties
> is deplorable and the area as a whole is an unwelcome local eyesore to users of the river.
>
> Waterways Plan, page 36

As for the southern bank of the Thames below Caversham Bridge:

> For much of its length the bankside scene is of sites that present an unsightly rear
> elevation to the river.
>
> Ibid., page 58

Or the south bank below Reading Bridge:

> The adjacent housing (in Borough ownership) is nearly derelict and the river frontage
> is mainly occupied by a cleared industrial site, future proposals for which are uncertain.
>
> Ibid., page 66

Even those parts that were supposed to be ornamental came in for criticism:

> Christ Church playing fields are of considerable size and full exposure to the
> view from the high office blocks has added to the already somewhat uninviting
> environment. The riverside promenade is a tarmac path with a few derelict seats ...
> As a park, it fails to provide the discriminating town dweller with an attractive urban
> space that is a reasonable alternative to the surprises and subtleties of the countryside.
>
> Ibid., page 58

The Kennet was judged no more kindly. Take the north bank, near where it joins the
Thames:

> The north bank is largely devoid of architectural character and represents a typical
> instance of industrial development with no regard for the river setting.
>
> Ibid., page 79

And:

> The Kennet between High Bridge and Huntley and Palmer is the most accessible
> part of the waterways in the commercial centre of the town. However, architecturally
> it is impoverished and this is accentuated by the number of vacant sites which border
> both the canal and the river.
>
> Ibid., page 84

Undaunted, the plan highlighted the potential of each reach and drew up plans to realise
that potential. For the past thirty years, the Waterways Plan and its successors have been
one of the council's guidelines for negotiating planning permissions. Much has been
achieved, but the slow progress also highlights what a long process is involved in reversing
equally long periods of environmental neglect.

The Great Flood

But, as well as being a place of recreation, the river could have its dangers. On the morning
of 15 March 1947 the residents of Reading awoke to find that the River Thames had risen
by 15 inches overnight. For some 1,600 households this meant that the river was in their
houses. Two hundred of them had to be evacuated. The Thames Conservancy explained why
it had happened:

The cause of the flood is to be attributed to three factors, snow, frost and rain, all operating over quite a protracted period. The severe frost throughout February created an impervious surface which, on receiving a heavy rain, was responsible for an unprecedented run-off, at least twice what it would be in normal practice. Superimposed on this, a constant quota of melting snow and ice was fed continuously by every ditch and watercourse and even by footpaths and roads direct into the tributaries and the river.

In short, it was the worst flood in living memory. To add to the misery, a howling gale had uprooted whole trees and hurled them against the weir. Gosbrook Street was knee-deep in water as far up as the Westfield Road playing fields and Gosbrook Road was impassable beyond Mill Lane. It took a week for the flood waters to clear and, meanwhile, life was disrupted in all sorts of ways. For a time it looked as if Caversham could be cut off from Reading entirely and ferry services were put into place, using punts, dinghies, high-wheeled lorries and amphibious military vehicles. Drinking water supplies had to be boiled and the voluntary rationing of water was called for. The sewage works were close to being put out of operation by flooding.

Heating was a problem for those flood victims using solid fuel, as their coal supplies disappeared under the water and their coke simply floated away. Businesses and schools in the floodplain were closed down and telephone communications were knocked out until an emergency line could be laid across Caversham Bridge, to carry at least part of the telecoms traffic. Emergency accommodation was provided at Battle Hospital, though most of the homeless went to friends or family. The School Meals Service and the Women's Voluntary Service produced hundreds of hot meals for those whose kitchens were out of use.

The Caversham and Reading Bridges

Caversham Bridge is a longstanding landmark in the town. A bridge has been known to have existed there since at least 1231, when Henry III referred to it in a letter. For much of its existence it has languished in a ruinous state, as the rival authorities on opposite banks argued about whose responsibility its upkeep was. For centuries, this dispute manifested itself in a timber bridge across the Reading half of the river joined to a stone structure, wide enough for just one cart at a time, on the Caversham side. There was not even agreement on the Caversham side about whose responsibility their part of it was. For example, at the Berkshire Assizes of 1812, the County of Oxford was found guilty of not repairing the bridge, but at the following year's Gloucestershire Assizes Oxfordshire managed to offload the responsibility to the Earl Cadogan, in respect of his land-holdings in Caversham. It was a ruin picturesque enough for Turner to paint, but not until the Caversham Bridge Act of 1868 was the responsibility for its upkeep and replacement clarified. This was given to Reading Corporation and Oxfordshire County Council was given the responsibility for paying 50 per cent of the cost. This clarification was an important date in the making of modern Reading.

Before the opening of Reading Bridge, the only crossing of the river at that point was a rickety footbridge known as the Clappers. This had briefly become notorious as the place

from which Victorian baby murderer Annie Dyer threw her infant victims into the Thames. The council carried out a census of traffic across the Clappers one day in 1905, and recorded 4,836 pedestrians, nineteen trucks, 130 bicycles and seventy prams. What is not clear is whether (and, in which case, how) this information influenced the decision of the council to replace the Clappers with a road bridge, rather than just another pedestrian crossing, as the 1911 boundary extension legislation required.

For, in 1913, the Reading Corporation Bridge Bill sought powers to construct not one but two bridges, one of them a replacement for the 1869 Caversham Bridge. The provisions of the Reading Extension Order required that the new Caversham Bridge had a clear width between the parapets of not less than 45 feet. The old 1869 bridge had had just a 20-foot carriageway and two 5-foot pedestrian routes across it and its lack of capacity was one of the reasons why the tram network never extended into Caversham. Some £6,000 of the cost of Reading Bridge was contributed by a Caversham resident, Charles Marten Powell. The engineers who designed the bridge did not stint on its specification, which perhaps explains why it is still going strong almost a century later:

> We have calculated for an assumed load of as many traction engines, weighing twenty tons each, as the roadway will carry in addition to a load of 150 pounds per square foot of footpath surface.

Reading Corporation Act 1913

And that is precisely how they did test it, by filling it with every traction engine they could lay their hands on.

A Bridge Too Far?

As we saw elsewhere in the book, it was in 1928 that the idea of a third Thames river crossing at Reading was first mooted by the planning authorities in Reading and Oxfordshire, and they have been fighting about it ever since. Successive plans have been produced in Berkshire, setting out such a proposal, only to be frustrated by the Oxfordshire authorities' resolute opposition and, as long as the opposing local authorities occupy opposite banks of the river, a solution to the problem does not seem to be imminent. Oxfordshire's concerns may be summarised as:

- Fears that the new road would increase development pressures in Oxfordshire;
- Concerns about environmental damage caused by the extra traffic; and
- Worries that the bridge would make the B481 Peppard Road an attractive link between the M40 and the M4 for long-distance traffic.

Berkshire County Council set out the case for the bridge as part of the Reading Highway Strategy in the 1980s. First in 1984, they tried to assuage the concerns of their neighbours by explaining that the bridge was a local solution to local problems, not an addition to the strategic highway network:

The Reading Highway Strategy is based on the explicit proviso that unrestrained traffic growth cannot – and should not – be catered for and so the proposed new crossing is based upon a single carriageway link subsidiary to, and not an extension of, the strategic network.

It is considered that the limited capacity of the proposed new crossing will allow unwelcome new development to be resisted and that traffic management measures can be used to deter any traffic from using local routes (including the proposed new crossing) instead of the strategic network.

They backed this up with a traffic survey, showing that around 47,000 river crossings were made on a typical 12-hour working day (24,000 over Caversham Bridge, 14,500 over Reading Bridge and 8,500 over Sonning Bridge). The overwhelming majority of traffic crossing the river was local, with three-quarters of trips having their origins or destinations within eight miles of the bridge.

Having made the case (at least, to their own satisfaction) for the bridge as a local facility, they looked at the various possible locations for it. They soon dismissed the option of increasing the capacity of the existing Caversham and Reading bridges. The areas on either side of them were built up and additional capacity would have involved a lot of demolition. Second, the two existing bridges were too close together (less than half a mile apart) and increased capacity would simply attract more traffic into an already congested town centre. The junctions on the approaches to the bridges were also close together and more traffic on those routes would have seriously increased congestion. On the Caversham side, the roads leading to the bridges tended to cut the shopping centre off from the main residential areas and more traffic would make this worse.

They then looked at what they called 'distant' crossings, well to the east or west of central Reading (going either east of Sonning or somewhere between Pangbourne and Purley). Both proved to be long, expensive and affected areas of high landscape value. They were also far from where people wanted to get to and, it was forecast, would not attract enough traffic to be viable. That left two options – a western crossing between Chazey Heath and Tilehurst, or an eastern one between Caversham Park and Earley. The eastern one was preferred, because it relieved Sonning better, attracted twice the traffic of the western option and got more traffic out of both Reading and Caversham centres.

Whatever one may think about the merits (or otherwise) of these arguments, it remains a fact that they fell upon deaf ears in Oxfordshire, like others before and since. Almost ninety years since it was first mooted, the third Reading Bridge remains no more than a gleam in the eye of the traffic engineers south of the river (and a nightmare for those on the other bank).

Monuments, Memorials and Parks

Over the centuries, many people have contributed to the town's stock of monuments and memorials, be they statues, buildings, public open spaces or other reminders of the donors' association with the town. Whether their motive was purely philanthropic or an attempt to carve out a little piece of immortality for themselves will not be for me to judge (though others have done so in some cases). The following are a selection.

The Soane Monument, Market Place

One case where accusations of ulterior motives were made stands in the middle of the Market Place; it is a slightly curious 25-foot triangular column, surrounded by railings and with ornamental brackets attached to it. It was designed by a local architect of national repute, whose other work included the Bank of England – Sir John Soane. It was paid for by Edward Simeon, who lived nearby at No. 22 The Forbury (in a seventeenth-century house later demolished to make way for the 1962 Prudential development). Simeon was a Governor of the Bank of England, a man who did much charitable work in the town and was given the freedom of the town in 1805.

You may well ask 'what is it?' It does not appear to be a monument, since it does not seem to commemorate anything, nor does it conform to the strict Egyptian definition of an obelisk. Contemporary critics were equally bewildered, one of them condemning it as a 'paltry gee-gaw thing without use, or name'. Others, less polite, called it a 'p*****g post' or, as we would more politely say, a place for urination. Possibly they saw it before it was finished, the brackets were fitted and some words of explanation attached. These read: 'Erected and lighted for ever at the expense of Edward Simeon Esquire as a mark of affection to his native town AD 1804.'

For the monument is no more or less than a lamp-post, albeit a very ornamental one, and very possibly an early example of its kind, since the first recorded use of the word in the *Oxford English Dictionary* was only in 1790. There was no doubt a need for extra illumination in that location. The Reading Improvement Act of 1785 provided for 156 oil-burning street lights in the town, but all of these were fixed to buildings and their feeble light would not have reached into the centre of an open space like the Market Place. Even with its purpose made clear, some of Simeon's critics were not satisfied, claiming his motive for erecting it was to ingratiate himself and his family with the citizens of Reading (and,

in particular, those with the vote – since his brother John had lost his seat as Conservative MP for Reading in 1802 and wanted it back).

The monument (or whatever it is) has not been flattered over the years by the setting for it provided by the civic fathers. In its time, it has variously been adorned with a cabman's hut, car parking, market stalls, an air raid shelter and a public convenience. Its original function, of illuminating the Market Place, ceased in 1911 but has been resurrected on various occasions since; it has had new lamp brackets (in about 1845) and new railings (in about 1880). Writing in the *Daily Telegraph* in 2003, one of its modern critics, Keith Miller, described it as 'a strange tripodal stalk of limestone … all that is left is a rather clumsy bit of masonry, revered by Soane fans, ignored by everyone else'. Only in 2007 was the current landscaping scheme for the Market Place completed, including a £60,000 restoration of the column itself, giving it at last a rather more dignified and appropriate context.

Vachell Almshouses, Castle Street

Sir Thomas Vachell (or Vachel) was a member of one of Reading's leading families, whose association with the town goes back at least to the year 1261. He inherited extensive estates in Reading in 1610 and lived at Coley House. Our interest in him for present purposes is that in 1634 he had some almshouses erected at what is now No. 67 Castle Street, for 'six aged and impotent men, without wives'. He endowed the properties with £40 a year forever, for the maintenance of these poor men. By 1867 the houses were looking (to judge from an early photograph) distinctly the worse for wear, and a combination of public subscription and a contribution from the Municipal Charities led to them being redeveloped. These ornate Victorian replacements were themselves modernised in 1960–2 and stand to this day. They still carry Vachell's original plaque from the 1634 properties.

Vachell himself died in 1638. His third wife, Letitia, who survived him, was a member of another of the great Reading families, the Knollys. She went on to marry John Hampden, a Puritan whose opposition to the Ship Money tax, imposed unilaterally by Charles I, featured large in the run-up to the Civil War. Hampden, who lived at Coley House, was one of the five Members of Parliament that Charles tried to have arrested.

Duke Street High Bridge

Plaques on the bridge commemorate not an individual, but the Corporation's decision to rebuild the ancient twelfth-century bridge in 1788. The replacement bridge still stands, and is today one of the town's few Scheduled Ancient Monuments. It was designed by Robert Brettingham, one of the leading architects of his day, whose other works (as we saw in the chapter on prisons) included the stately home at Longleat and (one he might have preferred to forget) the original jerry-built Reading prison.

The stretch of the River Kennet that flows underneath it was one of the most challenging parts of the waterway for the canal barges to navigate, and is today one of the few stretches of waterway to be controlled by traffic lights. The 'Duke' in Duke Street was Edward

Seymour, Duke of Somerset, brother-in-law to Henry VIII and Protector of England during the minority of Edward VI. He was a ruthless exploiter of his position and was eventually indicted for 'over-ambition' and executed.

Forbury Hill and Forbury Gardens

The mound in the Forbury Gardens is thought to be the last remaining part of the fortifications that surrounded the entire town during the extended siege of the Civil War years. In 1831, one Joshua Vines, a resident of No. 162 Friar Street, raised a subscription to pay for, and oversaw, works to beautify the hill, creating 'a tree-lined eminence from which could then be enjoyed a rural view over the Thames'.

A commemorative iron plaque was set into the side of the hill to acknowledge Mr Vine's efforts. The view from there across to Caversham was largely lost, courtesy of the embankment on which the railway later passed through the centre of Reading. From 1857, a two-ton cannon, captured at Sebastopol in the Crimean War, was placed on display on top of the hill. The council made the mistake of leaving it in working order, with the result that local hooligans used to let it off on high days and holidays, breaking nearby windows.

As for the Forbury Gardens themselves, they are largely built on the forecourt to Reading Abbey. Much of the land was acquired for £1,200 by the council in 1854, for use as a pleasure garden. This doubled as a job creation scheme, to relieve the suffering of the unemployed during a recession. The council was not anxious to pay for expensive planting schemes, and appealed to the public for any surplus shrubs or plants they could donate. The gardens opened in 1856, and soon were attracting over 3,600 visitors a day. Shortly after this, in 1861, the abbey gateway collapsed in a storm, a victim of old age and centuries of neglect. The eminent Victorian architect George Gilbert Scott was brought in to restore (for which read 'improve' it). With a restoration cost of £1,800, some wanted to demolish it entirely, but wiser counsels prevailed and the works were completed in 1862. The remaining western part of the Forbury was acquired by the council in 1860, but it was not until 1873 that the Forbury Gardens as we know them today were opened to the public.

Maiwand Lion

One other feature that visitors to the Forbury Gardens cannot help noticing is the world's largest statue of a standing lion, measuring 31 feet nose to tail and 13 feet 11 inches high. It was made by George Blackall Simonds, a member of the local brewing family who took to sculpture, rather than beer. It commemorates a heroic rear-guard action fought by the 66th (Berkshire) Regiment in the Afghan campaign of 1879–80.

Of the Berkshires, 286 were killed and another thirty-two wounded. They were attacked by an Afghan force that outnumbered them by about ten to one at the Maiwand Pass, but they managed to hold them off for long enough to allow the rest of their army to reach safety. Their heroics were much celebrated at home. Rudyard Kipling and William McGonagall did so in verse, many paintings of the event were commissioned and Arthur

Conan Doyle apparently modelled Sherlock Holmes' partner Dr Watson (who was said in one of his books to have been wounded at Maiwand) on the 66th's medical officer, Alexander Francis Preston.

The statue was paid for by public subscription. It weighs 16 tons and had to be transported from the foundry in Pimlico in pieces, since Reading's bridges could not bear all the weight at once. It is commonly claimed to be standing in an anatomically impossible pose, but Simonds did numerous life drawings of lions, on which to base his sculpture.

St Laurence's Church

Thomas Rogers was clerk to the Local Board of Health and an ardent supporter of the Drinking Fountain Movement. In 1860 he presented to the town the drinking fountain that is still attached to the south wall of St Laurence's church. The water company undertook to supply it with water free of charge. It has a drinking fountain for humans and two beneath, for dogs.

Queen Victoria and her Golden Jubilee

It seems the town went celebration mad for the Queen's Golden Jubilee in 1887, with a full 'week's rejoicings'. There were church services, a public holiday, a fifty-gun salute in the Forbury, dinner for 1,800 of the town's aged, poor and war veterans, a variety of sports events, including swimming the Thames fully dressed (including shoes and a high hat), climbing a greasy pole, wrestling on donkeys and a wheelbarrow race, all wound up with a grand firework display.

More relevant for our present purposes, not one but two monuments were commissioned for the occasion. One was the statue of the Queen by George Blackall Simonds, which stands outside the old Town Hall. The marble from which it is carved got temporarily lost en route from Carrara, leaving the sculptor just five months to complete the commission. Local folklore has it that it faces the railway station because Queen Victoria did not like the town and could not wait to leave it. The other was an ornamental fountain (no longer used as such) which stands in St Mary's Butts. Near to this fountain, in a corner of St Mary's churchyard, is to be found Harrinson's cross. It looks medieval but is actually the work of Victorian architect Slingsby Stallwood. Isaac Harrinson was a surgeon who lived on Castle Street, and who donated over £1,000 to remove a row of slum buildings that stood between the church and St Mary's Butts.

Palmer Park

The Palmer family were generous benefactors to many aspects of life in Victorian Reading. George Palmer was Mayor of Reading in 1857–8 and the town's Member of Parliament between 1878 and 1885. In 1891 he presented the town with a 49-acre park and a statue of

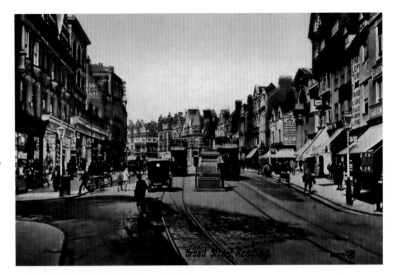

Broad Street, from near the junction with Minster Street, in 1915, with little sign yet of the conflict that was to come between traffic and pedestrians.

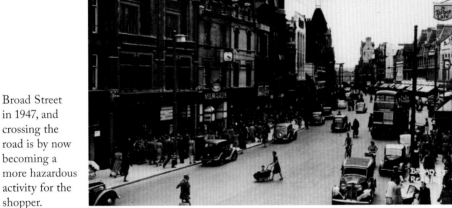

Broad Street in 1947, and crossing the road is by now becoming a more hazardous activity for the shopper.

The modern Broad Street as few have seen it – deserted! – looking west from the junction with Minster Street. The entrance to the Oracle is on the left, incorporating part of the old Debenhams store frontage.

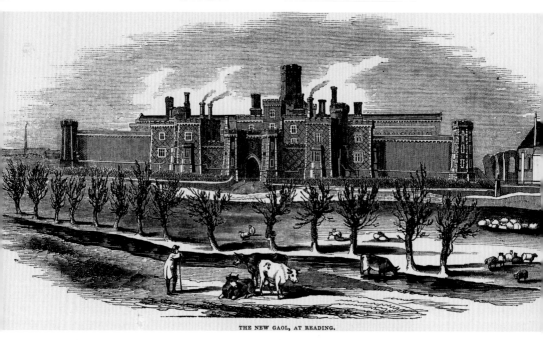

Reading Prison, as seen from the Great Western Railway in about 1844.

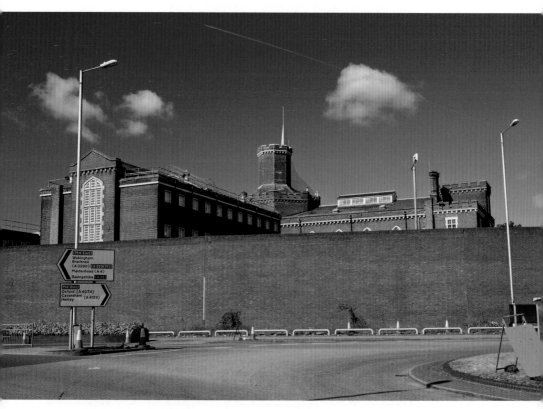

Little of George Gilbert Scott's original Victorian prison can now be seen behind the monolithic modern walls.

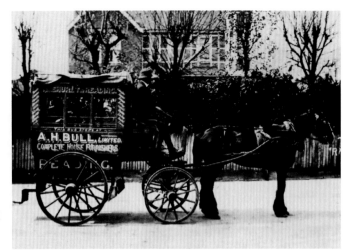

Early public transport – a horse bus that used to trade between Tilehurst and Reading, seen in 1900 at the junction of School Road, Kentwood Hill, Norcot Road and Armour Road.

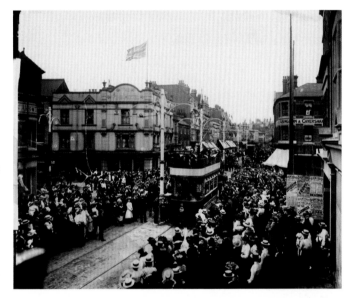

Crowds turn out for the inauguration of the electric trams in 1903. This one is just about to head off down the Oxford Road with a full compliment of civic dignitaries. The picture is taken from a broken glass plate.

Colour-coded buses wait in Friar Street in 2015.

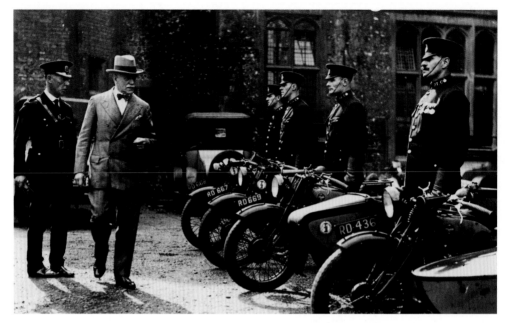

We can date this picture precisely – 10 September 1930. Sir Leonard Dunning, the Home Office's Inspector of Constabulary, inspects the Reading Police Flying Squad, consisting of four motorcycles, some equipped with sidecars.

Thames Valley Police's modern offices on the Castle Street roundabout.

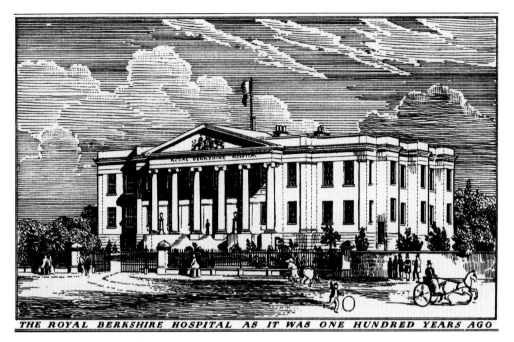

THE ROYAL BERKSHIRE HOSPITAL AS IT WAS ONE HUNDRED YEARS AGO

The Royal Berkshire Hospital as it was in 1844, but drawn a century later. A child bowls a hoop down London Road. Try that today and he would soon be glad that the hospital was near at hand.

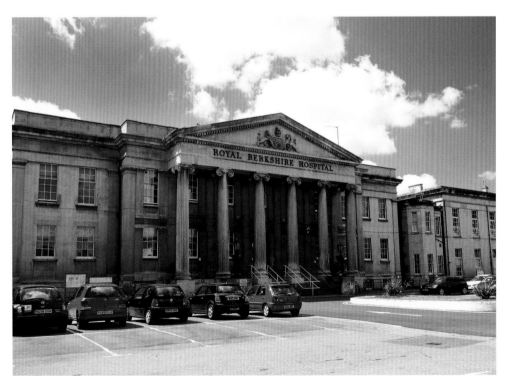

The imposing forecourt of the Royal Berkshire Hospital is today largely given over to car parking.

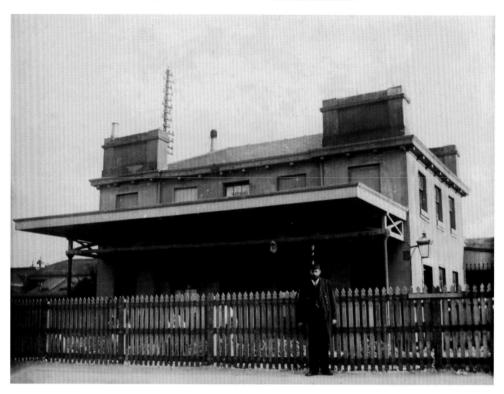

Reading's original down railway station in about 1860. Inspector Allen is the official standing in front of it.

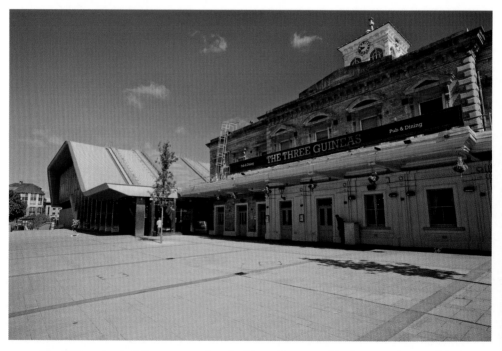

The 1868 station building, now used as the Three Guineas public house, with part of the £850 million new station rising beyond it.

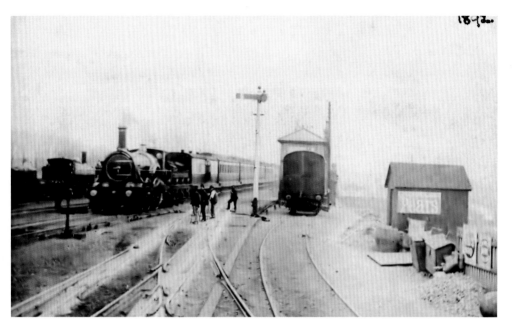

The last broad gauge train passes through Reading in 1892. The broad gauge of the locomotive can be compared with the standard gauge carriage to the right.

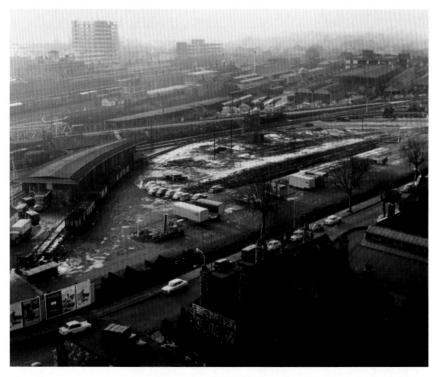

The view from the top of Reading Bridge House in about 1966. A railway goods yard occupies part of today's car park site. Western Tower is under construction in the background and the Southern Railway station (closed in September 1965) still has railway tracks where the Apex Plaza now stands.

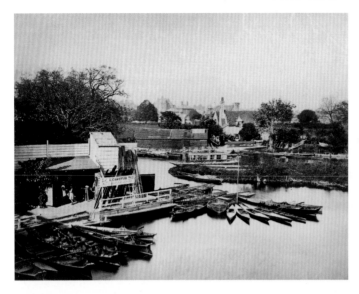

The north bank of the Thames in 1883, showing a mess of boatyards – the tip of Pipers Island can be seen in the foreground, with Cawston's boatyard on the left and Freebody's in the distance.

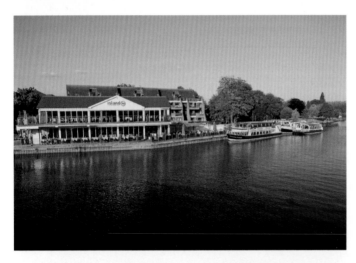

The same view as the one above. Pipers Island and the north bank of the Thames, looking eastward from Caversham Bridge in 2015.

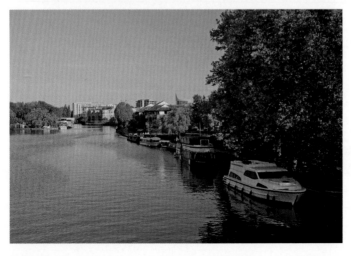

The south bank of the Thames, seen from Caversham Bridge in 2015. Many of the unsightly industrial uses have now been removed.

Market Place – the trees hide the attractive refurbishment of its southern side, but part of the hideous 1960s redevelopment scheme can be seen on the right. The Soane Monument is not enhanced by the advertisement hoardings around it.

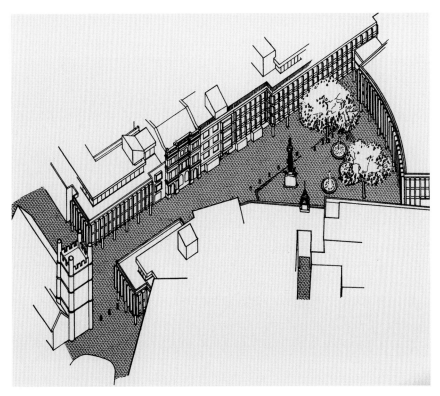

An artist's view of the fate of Market Place, should the full redevelopment scheme have been carried out.

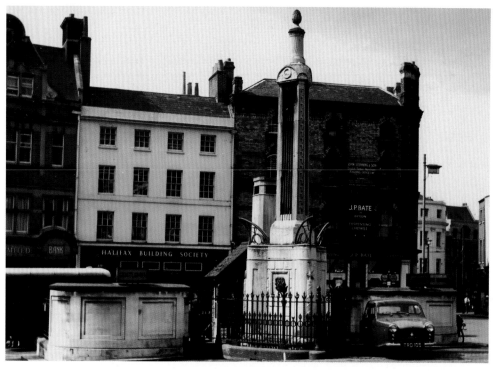

Market Place *c.* 1960, and the Soane Monument is tastefully framed by public toilets and a car parking space.

The congregation of St James' Roman Catholic church gather outside the church for their Palm Sunday procession in 1901. In the background are the engine shed and goods offices of the London & South Western Railway, across the Forbury Road. This innocent religious practice would lead to controversy in 1909

What traffic problems? Cemetery Junction, looking east down Wokingham Road in about 1937.
The trams are still running and the manually operated traffic lights are still in place.

The gateway at Cemetery Junction and Wokingham Road today, seen in a rare traffic-free
moment.

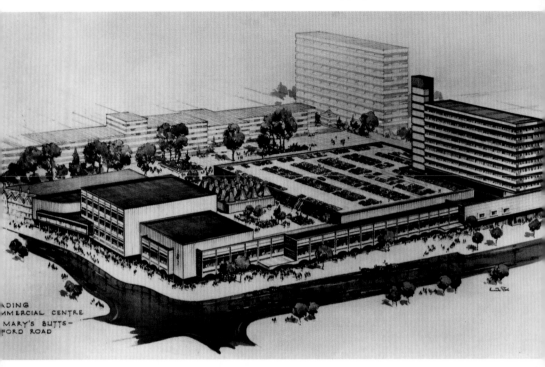

A 1970 architect's drawing of the Reading Commercial Centre (or Broad Street Mall, as we now know it). They envisage it set in a sea of fast-moving traffic, not semi-pedestrianised as it now is.

View into the Oracle shopping and leisure development from Yield Hall Place, with the Kennet and Avon Canal forming the centrepiece.

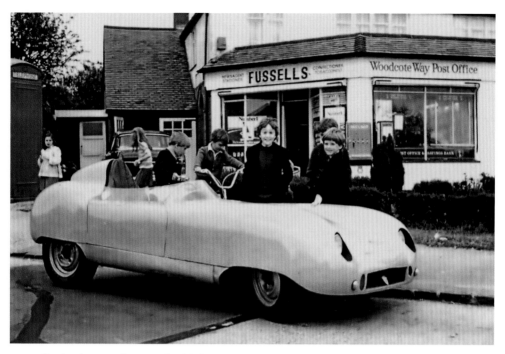

Reading's car industry – Buckler's racing prototype BB1, built in about 1959 but seen here outside the Woodcote Way Post Office in about 1970. The cars were sold from 67 Caversham Road.

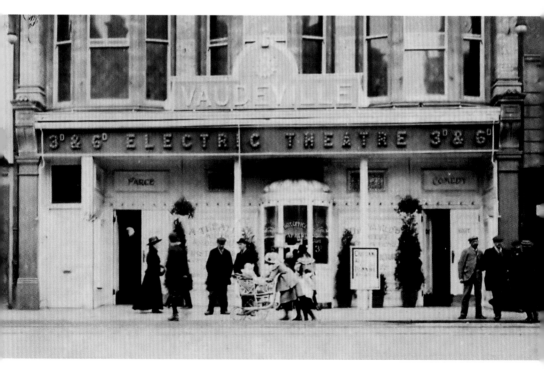

The Vaudeville Electric Theatre, seen in about 1920. It was one of Reading's most successful cinemas.

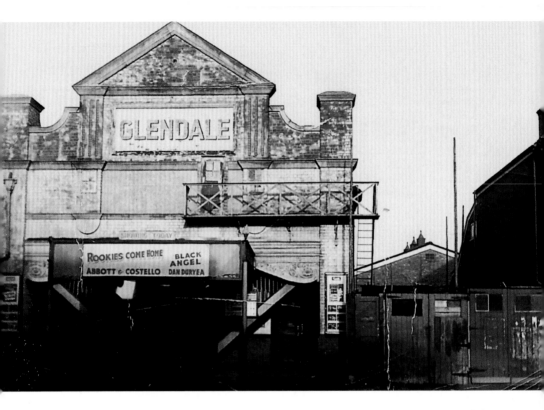

The Glendale cinema, Caversham, looking distinctly the worse for wear in about 1945. It was refurbished shortly after this picture was taken. The ticket office and the stairs to the upper floor are open to the weather.

Today the former Glendale cinema is used as a church.

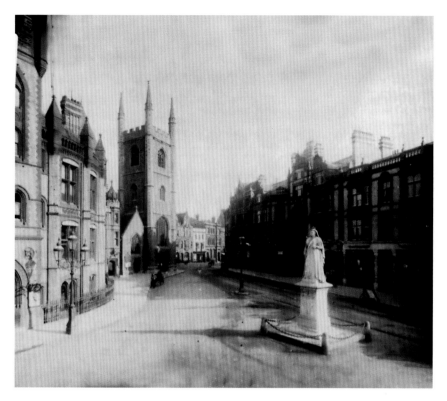

Queen Victoria in about 1893, shortly after her installation as a traffic hazard outside the Town Hall.

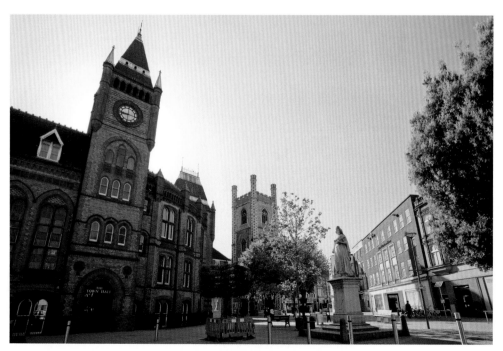

Queen Victoria in 2015, safely pedestrianised.

Reading's leafy campus at Whiteknights is reckoned to be one of the best environments of any British university.

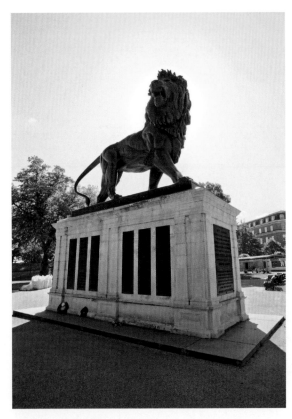

The Maiwand Lion, centrepiece of the Forbury Gardens, seen in 2015.

himself. The statue (another of George Blackall Simonds' works) shows him standing with hat and umbrella in one hand, the other grasping the lapel of his coat. It used to stand in the middle of the road at the east end of Broad Street, with trams passing to either side of it.

The location was prominent, but not ideal in every respect. Small boys on the open upper decks of the trams used to delight in trying to throw litter into his hat. It was also a hazard for motorists. In 1918, motorist Sidney Gilford tried to claim damages from the council after crashing his car into it, the grounds for his claim being that the council had not lit the statue adequately. By 1930, traffic congestion in Broad Street had become such that the statue had to be removed. It was relocated in Palmer Park, which the family had given to the town as a recreational amenity for the people of east Reading. Many of those people worked in Huntley & Palmer's factory, then the town's biggest employer. The Palmer family generally were great benefactors to the town. Their contribution to the fledgling university is discussed elsewhere, and they were also part-funders of the town's new library and acquired the King's Meadow for the council in 1869.

Marquis of Reading

The travels of the George Palmer statue are as nothing compared with that of Rufus Isaac, the first Marquis of Reading, which now stands in the gardens of Eldon Square. Isaac had a most distinguished career, first as a lawyer, then as Liberal Member of Parliament for Reading (1904–13), Lord Chief Justice (1913–20) and Viceroy of India (1921–26). The statue, commissioned during his time as Viceroy, originally stood alongside other Viceroys in the grounds of Government House, New Delhi. But an independent India understandably felt less attachment to this reminder of Empire and in 1969 it was presented to Reading. Isaac's widow paid for it to be shipped back to England (Isaac himself died in 1935), but she did not live to see it finally erected in Eldon Square.

Prospect Park and the Mansion House

The older part of the Mansion House was built in about 1760, on the site of what was originally the farmhouse to Dirle's farm. It was at one time the property of Benjamin Child, the widower of Frances Kendrick, and was extensively rebuilt for J. E. Liebenrood in about 1800. His architect, James Wright Sanderson, a pupil of James Wyatt, added wings and a portico to what had been a fairly square house, and the porte cochère was another, still later, addition. The park and house later came into the ownership of local seed merchant, entrepreneur and member of the borough council Joseph Charles Fidler, and it was with his help that it was sold to the council in 1901, '… For the benefit of weary workers who, when at rest, need some open space where communion with nature may be established.'

The park was offered to the council by Fidler for the relatively knock-down price of £13,850 for 63 acres and Fidler himself offered to put up £1,000 of the purchase price. His offer was supported enthusiastically by local environmentalists, who said:

It would constitute a true park, such as the town does not at present possess, the sylvan beauty of which should be rigidly preserved, easily accessible by an extended tram service from all parts of the town.

Minutes of the Committee to promote the acquisition of Prospect Park, 1901

Economisers on the council argued that it was a bad time for the council to be engaging in major capital expenditure (the Boer War was then in progress), that the council had competing claims on any public finance that was available – an isolation hospital, a new police station and court, the new town hall and the Thames-side promenade, and that the full cost of acquiring and maintaining the land was far greater than the simple purchase price. But the purchase went ahead and it survived another threat in 1904, this time to use the park for a municipal cemetery. As for the Mansion House itself, it was used for various park-related purposes – as a changing room for sports teams and, until the 1950s, for supplying refreshments to park users – but it gradually fell into disrepair and disuse, before being renovated for use as a restaurant.

The park and the house could serve as a monument to Alderman Fidler, as one of several initiatives he took to benefit the town. In addition to Prospect Park, he was also responsible for the rebuilding of West Street and the construction of the Market Arcade. His last improvement was the construction of Queen Victoria Street, which finally provided a direct link between the railway station and the prime shopping frontages of Broad Street. Fidler died as Queen Victoria Street was nearing completion in 1903. The building of the street involved the demolition of properties on Broad Street and Friar Street, including Laud Place, an 1813 tenement building on the site of the birthplace in 1573 of William Laud. Laud went on to become Archbishop of Canterbury before being executed for treason in 1645. But, for all his shortcomings (to put it mildly) on the national political scene in the run-up to the Civil War, Laud was a good friend to Reading over the years.

Arthur Newbery Park

For forty years Arthur Newbery ran a high-class furnishing shop at the junction of Friar Street and Queen Victoria Street. He donated this 26-acre open space to the town in 1932, citing the encroachment of housing all around it as the reason for his bequest. Newbery died in 1961, aged ninety-eight. He also sold land for part of the Whitley housing estate to the council in 1929, having bought it from the Palmer family three decades earlier. The council paid £9,000 for his 41 hectares.

John Rabson Recreation Ground

John Rabson was a long-serving Labour member of the council, twice serving as its mayor. The recreation ground was named after him shortly after his death in 1936. During the Second World War the recreation ground was used as an army camp and 'dig for victory'

allotments, and in the post-war housing shortage in 1946 homeless families squatted in the disused army camp huts. (These were due in any event to be given to the council for use as temporary housing).

Arthur Hill Memorial Baths

The swimming baths on Kings Road are Reading's oldest surviving sporting facility, opened in 1911. They were donated by members of the Hill family in memory of Arthur Hill, four times Mayor of Reading between 1883 and 1887. Businessman Arthur Hill was a great benefactor to the town. He modernised the council's finances and its sewerage system, pushed through improvements to the town's libraries and museums and bought the Victorian replica of the Bayeux Tapestry, which he then gave to the museum and which is still displayed there. He was also a benefactor to the new Reading University College until his death in 1909.

Sol Joel Playing fields

Solomon Barnato Joel was a multi-millionaire and racehorse owner. He made his money in South African diamond mining, and in brewing and railways. Since 1903 he had been the owner of a large estate at Maiden Erlegh, just outside the borough boundary. In 1927 he donated playing fields to the community – the Duke of York (later King George VI) opened them. Joel died in 1931 and the estate (but not the playing fields) was sold the following year. It went through a succession of ownerships and uses, before the estate was sold off for housing development and the house itself demolished in 1960.

McIlroy Park

William McIlroy was an Irish draper, who came to England in 1875 and opened a store in Swindon. The business grew until there were twenty-two branches across England and Wales, one of the most important of which was in Reading, and which is described in the chapter on shopping. His descendent, another William, served five terms as Mayor of Reading during the Second World War. The Reading store closed in 1955, but the park which bears the family name was designated as a Local Nature Reserve in 1992.

The Royals

A good deal of civic pride is invested in a town's football team. At the time of writing this (March 2015), Reading's football club was looking forward to an FA Cup semi-final against Arsenal at Wembley while at the same time hovering on the fringes of the relegation battle from the Championship. Depending upon the season's outcomes, a segment of the town's population could soon be overjoyed, inconsolable or simply bewildered, if Reading performed the improbable double of cup-winner and relegation victim.

This double would not be for the first time. In 1988, Reading went to Wembley to play Luton for a new trophy, the Full Members Cup (sponsored by Simod). This was an additional trophy competition for teams from the top two divisions, introduced after British clubs were banned from Europe following the Heysel stadium disaster in 1985. Reading won convincingly, 4-1, but managed to get themselves relegated from the old Second Division in the same season. Being no longer in the top two leagues, Reading were unable to defend their trophy the following season.

But the origins of the club go back well into the nineteenth century. The first rules of football were written up at Cambridge University in 1848 and its governing body, the Football Association, was formed in 1863. The first clubs to be formed and join this association in the 1860s were all based in the north of England, but in 1871 a meeting was convened in a room in Reading's Bridge Street. They resolved to establish a town football team and James Simonds of the local brewing family was elected as its first president. This makes Reading the oldest club south of the River Trent in the current Football League (though they did not actually join it until a third division of the Football League was formed in 1920). One thing that was settled from the outset was the choice of blue and white striped shirts that still feature as part of the club's strip (though the matching striped caps and blue knickerbockers of the 1870s might not be the fashion choice of the current team).

Their first match – thirteen a side – took place on the recreation ground at King's Meadow, against the local grammar school. But the club moved around a great deal in their early years, playing at Reading cricket ground (1879), Coley Park (1882, from which they were banned, due to 'rowdyism among rougher elements' of their supporters) and Caversham cricket ground (in about 1889, where access to the ground was by boat). They looked at several possible permanent sites, before settling on four acres of former gravel pit in west Reading. This was offered to them for £100 per annum by local property developer and member of the council Edwin Jesse. He insisted that no alcohol sales or betting be

allowed on the ground. The club spent £800 making the pitch and fencing the ground, and a further £500 on a grandstand, seats, dressing rooms, baths and offices. Elm Park, the club's home for the next 102 years, was born.

Their first match at the ground took place on 5 September 1896 against a scratch side, Mr A. Royston Bourke's XI. About 2,500 spectators paid 6*d* (2.5p – half price for ladies or children – total gate receipts £44) and, as if to underline the 'no alcohol' rule, the crowd were to be entertained at half time by the Reading Temperance Band. The event gave a clue as to why the site was on offer at a bargain price. A thunderstorm before the match caused the pitch to flood. Reading were leading 7-1 when the match had to be abandoned, a problem that would recur over the next thirty years. To add insult to injury, the FA then fined Reading for playing against unregistered players.

Professional football had been legalised in 1885, but Reading was still an amateur side when they joined the newly-formed Southern League in 1894. That same season, they got a taste of the gulf between amateurs and the best professional sides. They were drawn away to Preston North End in the FA Cup. Preston, known as the Invincibles, had been League champions in 1888/9 and 1889/90 and runners up for the next three years. They had previously beaten another amateur side, Hyde, 26-0 in a cup tie. They played in January in a howling gale, on a pitch which prompted one of the Reading supporters to ask, 'Who won the ploughing match here yesterday?' Reading turned out in smooth-soled footwear, in which they could scarcely stand up. Preston had studded boots, black-leaded to throw off the dirt. Reading were beaten 18-0, thought to be the biggest margin of defeat of any current Football League club. Small wonder that the club decided the following year to turn professional. (In the interest of balance, it should also be recorded that Reading's greatest margin of victory was achieved in 1946 – 10-2 against Crystal Palace).

By 1910 the club was in financial trouble, and decided to launch a public appeal for funds. It was not conspicuously successful, raising just 12/6*d* (62p). A good run in the 1911/12 FA Cup, in which they beat Aston Villa (then the glamour side of the Football League) and took Manchester United to a replay, proved more successful in resolving their financial problems. In 1920 they and the rest of the Southern League formed the new Third Division of the Football League and from 1926 Reading enjoyed four years promoted to the Second Division (younger readers, think Championship). During this period, they established a record attendance at Elm Park (33,042 for a cup tie against Brentford in February 1927) and reached the FA Cup semi-final in the same year, losing to the eventual cup-winners, Cardiff. But the biggest crowd to watch a Reading match anywhere was the aforementioned Simod Cup final at Wembley, seen by 61,470 people. As for lowest attendances, in April 1939 just 1,785 people saw Reading beat Bournemouth 1-0, in a League match which was ill-advisedly timetabled to coincide with the FA Cup final. But even this seemed jam-packed, compared with the 801 who watched Reading play Watford in a Division III cup match in October 1938.

Both World Wars caused the club considerable disruption. During the First World War, four of the team lost their lives in the armed forces and another – a German – was briefly interned. Elm Park was for a time taken over as a physical fitness training centre by the Royal Flying Corps. During the Second World War, normal League and cup activity was replaced by ad hoc competitions with scratch teams, partly made up of any professional footballers

who happened to be stationed at one of the nearby army camps and were able to get leave to play. Reading, being near the big camp at Aldershot, was rather better placed than most clubs in this respect. Their regulars included Frank Swift, the Manchester City and England goalkeeper, and the legendary Matt Busby, later of Manchester United managerial fame.

The 1982/83 season was a traumatic one for the club, which was not only relegated to the then Fourth Division but was also threatened with extinction at the hands of 'colourful' publishing magnate Robert Maxwell. He was the owner of Oxford United Football Club and announced plans for the two clubs to be merged into something called the Thames Valley Royals, with a stadium at Didcot. Maxwell claimed this was both an agreed fait accompli with the Reading management and also an economic necessity, as both clubs would otherwise go out of business within a year. It nonetheless excited opposition from players, local press and fans alike, with protest marches, pitch occupations and a challenge to the legality of the merger. The latter was led by Roger Smee, former Reading player turned property developer. Smee secured the chairmanship of Reading Football Club in July 1983 and all talk of a merger ceased. As for Maxwell's forecasts of economic doom, within three years Reading were back in the old Second Division, while Oxford (still under Maxwell's ownership) went on to win promotion to the First Division, the equivalent of today's Premier League.

If their first ground cost them £1,300 in construction costs, Reading's next move, to the 24,161-seater Madejski Stadium in August 1998, was rather more expensive – between £37 and £50 million more expensive, according to different estimates. It was built with the help of local businessman Sir John Madejski. The 1994 Taylor report into football ground safety had decreed that all grounds in the top two divisions should become all-seater. It was not a practical proposition to convert the antiquated Elm Park, and the search began for an alternative site. A former landfill site at Smallmead was obtained for £1, on condition that the A33 relief road linking it to the M4 was completed (which it was, part-funded by the football club with the help of other development along the route).

It was there in 2006 that the club secured its greatest moment of triumph, the first of its (brief) sojourns in the nation's highest league, the Premiership. This success prompted the club to apply to expand the ground to 36,900 seats. Planning permission was granted in 2007 and work was due to start on it in mid-2008, when the club got relegated and the work was put on hold. Plans were dusted off when the side was promoted again, in 2012, then shelved again, following another relegation the following year.

In addition to football facilities, the ground (which has won international awards as a stadium) has its own hotel and conference centre and since 2000 has been the home of the London Irish Rugby Union Club. It has also been a venue for pop concerts, the Rugby League World Cup and England Under-21 international football matches.

Seats of Learning

University Town

Reading today has an international reputation as a university town. It offers a wide variety of education and training and is one of the ten most research intensive universities in the United Kingdom. It came 25th out of 119 British universities in the 2016 Guardian University Guide (ahead of Bristol, Manchester, Strathclyde and Kings College, London, among others) and is ranked among the top 1 per cent of universities in the world. The Henley Business School, which has been part of the university since 2008, is also one of the largest and most prestigious of its kind in the world, and in 2012 Reading announced plans to open its first overseas campus, in Malaysia. But what were its origins?

Reading's history as a university town goes back (albeit briefly) a lot further than most people imagine. In the year 1209 a murder of a woman in Oxford, followed by the summary execution of some scholars thought to have been responsible for it, led to the dispersal of the university (that is to say, the remaining students were chased out of town by a lynch mob). Some of them went to Paris and Cambridge, but others came to Reading. The relationship between town and gown was apparently not a happy one; as one commentator put it 'the students were poor, hungry and riotous, the townsfolk sullen and grasping'. Nonetheless they remained in the town until the university was re-established at Oxford in 1214.

The current university's real roots can be traced back to the Schools of Arts and Science, which were set up in Reading in 1860 and 1870 respectively. The School of Arts was originally based in West Street and Sciences were in the site in Blagrave Street formerly occupied by Reading School in the days of Doctor Valpy. This was the site later taken to build the town's new museum and art gallery, which opened in 1883/84. Shortly before that, in 1882, the two schools were combined and housed in a building on the newly constructed Valpy Street.

At about the time the Schools of Arts and Science were being established, Oxford was in the grips of a campaign to liberalise the university. Non-conformists, women and the less wealthy started to be admitted and, in 1878, the Reverend Arthur Johnson (a Fellow of All Souls and also – incidentally – a forward in the university's FA Cup winning side of 1874) became the first person to deliver an 'Oxford Extension Lecture'. This grew into a movement, with lectures being delivered in town halls, libraries and school rooms up and down the country, as part of Oxford's missionary work to help create a better-informed democracy.

Reading's fledgling seats of further education were a natural venue for such activities and came under the wing of Christ Church, Oxford. They were instrumental in creating an extension college in Reading, opened by the Dean of Christ Church in September 1892. In that same year, the town council decided to transfer the Schools of Arts and Science to the control of the new college. Reading's proximity to Oxford and London has always been an important part of its ability to attract and retain scholars and academics of a high standard. From a more practical point of view, Reading could hire those universities' academics on a daily basis, rather than having the expense of employing their own full-timers.

It certainly could not have been the facilities of the extension college that attracted scholars and academics, since some of these were rudimentary in the extreme. In 1908, the college library comprised (according to one source) a single bookcase, and by 1913 still consisted of less than 8,000 volumes. (The modern university library has access to over a million books). In 1924, just before being granted university status, the college ran out of money to pay salaries, and had to be subsidised by its president and another wealthy benefactor. Shortage of money haunted the college in its early years:

> The finances of the college were the cause of almost ceaseless anxiety. Prophets were plentiful who foresaw that the bankruptcy of the enterprise was only a question of time. Reason seemed to be with them.
>
> Review of the College, 1913

But money was not in short enough supply to prevent them applying for a coat of arms from the College of Heralds in 1896. What they got was:

> Per fesse Gules and Sable in chief three escallops fessewise. Or and in base on a Cross engrailed Argent a rose of the first barbed and seeded proper.

Just in case any reader does not speak heraldry, this consists of a shield divided across the middle. The top half contains three shells, taken from the arms of Reading Abbey, in whose building the college originated. The bottom half contains a cross with a squiggly edge (from the arms of Christ Church, Oxford, its early benefactor). At the centre of the cross is a rose, from the arms of the County of Berkshire.

The education on offer at the college was initially by no means all of a university standard. The first student to be awarded a degree (an external one from the University of London) graduated in 1895, though the 1893 Annual Report of the college claimed to have eleven students (including five women – the college was noted for its liberality of policy towards female students) studying for degrees and other higher examinations. (The 'other higher examinations' category may have been added to swell numbers – others suggest the college at this time had just one or two would-be graduates). It was 1903 before the college had a general consent to train students for external London degrees.

A good many of the students at that time were described as 'artisans' or 'elementary school teachers', studying subjects including shorthand and typing, hygiene, wood carving and needlework. But there were some higher-level achievements; from 1899 the college had official recognition (and funding) as a trainer of teachers, and it soon had a reputation as

one of the country's leading agricultural colleges. The college even bought a 140-acre farm at Shinfield for the use of its agriculture students in 1904.

As student numbers grew, they had to provide more teaching accommodation. At first, they expanded nearby in a piecemeal manner, occupying that part of the former Abbey Hospitium that had survived the attentions of Henry VIII and subsequent centuries of neglect, and the former vicarage of St Laurence's church, bought for them by a benefactor. The college's status (and student numbers) were further enhanced when the aforementioned Department of Agriculture was opened in 1894, followed two years later by the British Dairy Institute, and in 1901 the college started receiving direct funding from the government. A more radical solution to their accommodation needs was found in 1906, when they were given a spacious six-acre site in London Road, along with a £50,000 building fund, by the local biscuit manufacturer George Palmer. Part of the site included Palmer's former home, the Acacias. The local horticultural company, Suttons, helped fund part of their relocation. The potential of the site for expansion was not quite as limitless as it might have appeared, for the Acacias was protected in perpetuity from redevelopment and the extensive gardens to the house were likewise not to be built upon.

But the principal of the college, Dr William Childs, wanted it to have full university status. From 1911 applications began to be made for the Royal Charter that was needed, and Lady Wantage and members of the Palmer family added a further £200,000 to its development fund, to underpin the bid.

The Palmers' endowment to the University College did not go down at all well with the workers at Huntley & Palmer. They were not well paid at the best of times, and had undergone a difficult year, with a lot of part-time working and layoffs. It was proving difficult to feed and clothe their families. The endowment was one of the factors behind the company's first-ever wages strike.

However, the First World War proved to be a major distraction, and if pre-war financial worries did not finish off the college, the First World War very nearly did. Within months of the outbreak of war, almost all the male students had volunteered for the armed forces. Then two of the university's halls of residence were taken over by the Royal Flying Corps, who had established a major flying school in the town, and one of the college's main teaching activities became training munitions workers. By early 1918 the RFC occupied 'every available public hall, meeting room, etc. in the Borough', and it looked for a time as if the college itself could be swallowed up by the military machine.

But it survived to renew its bid for university status after the war. By 1921 the Privy Council had more or less accepted the principle of giving it university status, but deferred a decision until the college had a slightly higher income (they fell just £8,000 short of the Privy Council's £80,000 income target, which was itself a relaxation of the £100,000 threshold they normally applied) and had a few more students (student numbers by that time had reached 1,600, though only 700 were full-time and just 320 were studying for a degree. Others were still pursuing a motley assortment of qualifications, such as gas fitting – based within the Chemistry Department – or for membership of the Institute of Certificated Grocers). Despite any remaining financial or academic shortcomings, on 17 March 1926 Reading finally became the only college to be granted university status in the United Kingdom between the two World Wars.

It was the culmination of a lifetime's ambition for William Childs (1869–1939). He had joined the college as a history lecturer in 1893 and by 1900 was vice principal. He would be the new university's first vice chancellor, and would give a total of thirty-six years' service to the university. Childs himself recalled announcing their new status to the assembled college:

> Instantly, a pack of students charged up the central aisle of the hall, pulled the heavy tables in front of me aside, and in less time than I can write the words hoisted me on their shoulders and carried me down the aisle to the door... I was carried across the green, back to the other door of the hall, where they put me down, made a ring, sang 'For he is a jolly good fellow' and called for a speech.

Even as a new university, facilities were in many cases rudimentary. Many faculties had to make do with a single professor, with perhaps a single additional lecturer, and only those who could make out a special case for needing one could have a telephone.

A further Oxford influence on Reading University were its halls of residence, which it was claimed were based on the Oxbridge college model (or, as one former vice chancellor, John Wolfenden, put it: 'like a good boarding school'). In part, this was born of necessity, since Reading was considered rather small to be a university town, and unable to provide enough off-campus residential accommodation for an academic institution of any size. But it also meant that Reading developed a reputation as a university that looked after its students, and this was certainly in line with some of the thinking of the day about higher education. The Haldane Committee was set up just before the First World War to look at university education in London. Among its conclusions, it referred to:

> The need [to provide] healthy and interesting conditions of life for the students outside the university buildings... When the modern universities were founded, little attention was paid to this aspect of their life, but experience has convinced them all of its paramount importance... the intellectual training of the students suffers if they become isolated units when they leave their classrooms.
>
> Quoted in *Past and Present*, Number 16

Past and Present magazine picked up on this theme in a pre-First World War article:

> Reading would appear to be the last place in the world in which to look for a budding university with a real character of its own and a distinctive atmosphere, and yet it is just because University College, Reading, thanks to the wisdom as well as the munificence of its founders, has from the first looked beyond the lecture room and the laboratory, that it finds itself today, though scarcely twenty-one years of age, anticipating an early promotion to full university independence ... It was recognised here, more fully than at most similar institutions in modern times that the residential system alone can afford all that is worth having in a university education beyond the acquisition of knowledge.
>
> *Past and Present*, Number 16

Reading was the first modern university to follow the example of the Oxbridge collegiate system. As early as 1913 it was celebrating the emergence of a campus identity in the town, noting that, 'None of the halls is more than ten minutes' walk from the College, or from our recreation ground. Something like a university quarter, indeed, is growing up in Reading on its south-eastern slopes.'

Over the years, the university has numbered many distinguished people among its students and teaching staff. Two of the most famous of these (both dating from its extension college period) were the war poet Wilfred Owen, who enrolled in 1912 to study Biology and Latin, and who died in action a week before the Armistice ended the First World War, and the composer Gustav Holst. Holst joined the extension college as a lecturer in composition in 1919. It was at Reading, in 1923, that he fell from the platform while conducting and suffered concussion. What at first seemed a minor injury was to plague him for years to come and curtailed most of his teaching commitments. Another even more distinguished conductor, Sir Adrian Boult, performed as a musician at the college before the First World War, and as a conductor both before and after the Second World War.

The Whiteknights Campus

As early as 1926 Vice Chancellor Childs identified the university's accommodation problems as critical to its future prospects:

> With few exceptions, the accommodation afforded by the existing buildings is exhausted ... and if the University is to continue to grow, its quarters must be enlarged. Every faculty, and nearly every department, needs more space ... the university as it is today is dangerously small; it promises to grow and it ought to grow ... Reading cannot afford to restrict its proportions to those of a college.

Their existing site at London Road was patently too small to meet their expansion needs, but the answer to their problems lay unexpectedly close to the existing campus. Whiteknights is a site with a tremendous amount of history attached to it; even the name dates back to Norman times, though there are varying views as to who the original White Knight was. One version links it to a thirteenth-century knight, John de Erleigh IV. He was a descendent of William Marshal who, as Regent to the child Henry III from 1216, for a time effectively ran England from his estate at nearby Caversham Park. The de Erleigh family owned the manor at Herlie for about two hundred years before 1365.

A more romantic version of the White Knight story identifies him as one Gilbert de Montalieu, the son of a friend of William the Conqueror, who inherited lands including the Manor of Herlie. The story goes that Gilbert fell in love with the daughter of a Saxon ruler. She was called Editha and, one day, Gilbert was mortified to see her kissing another Saxon. Without stopping to debate the matter, Gilbert killed the man. The deceased turned out to be Editha's brother, Edwy de Guildford. A distraught Editha decided to enter a nunnery and Gilbert, as a penance, embarked on a long pilgrimage to Jerusalem. Many years later, an

elderly white knight was found kneeling, dead, at the grave of Edwy de Guildford, which was said to be near the present-day Wokingham Road entrance to the Whiteknights estate. A note upon his person asked that he be buried with his victim.

Yet another interpretation of the white knights links them to a leper hospital founded somewhere in Arley (yet another alternative spelling of modern-day Earley) by Aucherius, the second Abbot of Reading Abbey. Inmates of the hospital were said to be known as white knights on account of the white cloaks and hose that they wore.

Whatever the origin of the name, by the sixteenth century the Whiteknights estate was the property of the local Catholic Englefield family. Sir Francis Englefield suffered many ups and downs in the intolerant and turbulent times in which he lived, being variously raised to high office or imprisoned or driven into exile, depending upon how his faith allied with that of the monarch of the day. By 1585 his estate was forfeit to the Crown, but was bought back by Englefield's nephew in 1606 (under a new monarch). It would remain in the family until 1783. Shortly afterwards, in 1798, it was bought by George Spencer Churchill, the Marquis of Blandford and an ancestor of Winston Churchill. Over the next twenty years he invested huge sums in elaborate landscaping of the estate, along with all the other trappings of extravagant living. By 1819, the Marquis had become the 5th Duke of Marlborough (and also bankrupt), though his financial embarrassment did not stop him moving to Oxfordshire and the splendour of Blenheim Palace.

The 1840s saw the estate survive a proposal to build a settlement of 150 villas on it. But in 1867 the Whiteknights estate was sub-divided into six leasehold plots, though overall control of the estate would remain until 1947 with the family of Sir Isaac Goldsmid, a wealthy bullion broker. Among other things, Goldsmid was also instrumental in the establishment of University College, London. Some of the plots had houses built on them by the eminent Victorian architect Alfred Waterhouse, one of which (Foxhill) became his home and another (now known as Old Whiteknights House) his father's home. The sub-leases on the plots were due to expire in 1958.

During the Second World War, part of the site was used for temporary government offices and afterwards became the Region 6 War Room, responsible in Cold War days for civil defence in south-central England and complete with its own blast-proof nuclear bunker. The bunker still remains, and is today protected as a listed structure.

The university's interest in the site dated from around the Second World War. They were looking for a site for a new hall of residence as well as somewhere to provide additional university playing fields. At a dinner in 1945 or '46, Sir Henry D'Avigdor-Goldsmid, the then freehold owner of Whiteknights, found himself seated next to E. H. Carpenter, the university's bursar and by all accounts a shrewd dealer in real estate. Goldsmid began lamenting the difficulty of maintaining estates like his in the then-current climate, and Carpenter quickly asked whether, if he should ever consider disposing of all or part of it, the university could be given first refusal. At first, the discussions that followed on from this encounter were limited to a 7.25-acre piece of the estate, to address some of the university's immediate needs. But then the debate widened and they were offered the entire 300-acre estate for an initial asking price of £150,000.

The university had to act quickly, to ward off interest from local authorities and others in the site, and another key player in the negotiation was Sir Frank Stenton, the vice chancellor.

The University Grants Committee (UGC) was called upon to fund the purchase. Not all the committee supported the project, thinking that little Reading had bitten off more than it could chew – the committee secretary referred to it as 'White Elephants' Park'. Nonetheless they agreed the funding after getting special Treasury approval, but on the basis of it being an interest-free loan, rather than a grant, so as not to discourage rich benefactors from contributing. In the event, the contributions did not materialise, and in 1955 the loan would be turned into a grant. The asking price for the land was negotiated down to £105,000 and the purchase was completed, with considerable speed, on 26 February 1947. It was subject to conditions that the parkland would be preserved, the siting of buildings was to be approved by the local authorities and public access to the park maintained. The planners rezoned the park as 'land reserved for educational purposes'. More recently, Whiteknights Park was voted top university campus environment in the country.

One slight complication with the strategic planning of the campus is that it lies roughly one-third in Reading and two-thirds in Wokingham District, the local authority boundary carving an erratic route across the site and in some cases through the middle of buildings.

The acquisition of Whiteknights led to a review of the university's growth ambitions. For many years, the desire to maintain the present character of the university – 'based on a series of halls of residence in the setting provided by a country town of moderate size' – had led them to set an ultimate target of 1,000 students. By the time of the Whiteknights purchase, that ambition had been doubled, to 2,000. By 1971, it would be able to boast 5,403 students and by 2015 had over 17,000, of 141 different nationalities.

The university did not hurry its relocation onto Whiteknights. Although the site was bought in 1947 the shortage of steel, other construction materials and labour, not to mention competition for UGC funding, meant that building did not start until 1954. The first building to be occupied was the Faculty of Letters in 1957 and it was not until 1968 that the administrative centre of the university moved to Whiteknights. Overall, the transfer took over forty years. Reading was not alone in its measured approach. As the new vice chancellor, John Wolfenden, pointed out in 1950, the University of Birmingham began its move to Edgbaston in 1910 and after forty years that move was still only about three-fifths complete.

Much of the relocation was conducted under the stewardship of John Wolfenden, vice chancellor from 1950 until he left to become chairman of the University Grants Committee in 1963. He was perhaps the best-known of the university's vice chancellors, but not necessarily for his work within the university. From 1954, he chaired the government's Departmental Committee on Homosexuality and Prostitution. The sub-text to this committee was that it was set up by the government in hopes of giving the rather repressive Home Secretary of the day, Sir David Maxwell-Fyfe, new ways of prosecuting these 'vices' but, certainly in the case of homosexuality, this was not what Maxwell-Fyfe got. Its report, published in 1957, led (eventually) to the Sexual Offences Act 1967, legalising homosexual acts between consenting adults in private.

The institution has enjoyed royal patronage over the years. The Prince of Wales (the future Edward VII) visited the college building in Valpy Street in 1898; his successor as Prince of Wales (the future Edward VIII) fitted the new university into his crowded schedule on his 1926 visit to Reading, and the Queen herself opened the Faculty of Letters, the first building on the new Whiteknights campus, in March 1957.

Town and Gown

One of the events in the student calendar that brings town and gown together (albeit perhaps less today than it used to) is rag week, in which students engage in various demented activities on the pretext of raising money for charities. The 1950s was arguably a golden age for these activities, and the townspeople would find Reading town centre taken over by students setting up camp and cooking breakfast on traffic islands, playing marbles with glass eyes in the road, anglers fishing down drains and medicine men selling bogus 'remedies' on street corners. The humour was not always in the best possible taste – at least, by modern standards. Stunts like adorning the statue of Edward VII outside Reading station with a full set of ladies' underwear and a sign saying 'woops! I'm a fairy!', or running a campaign in favour of nuclear arms, might not escape adverse comment today, as they apparently did in 1959.

Central to the rag weeks of yore was the procession of floats through the town centre, decorated in such gruesome tableaux as the torture chamber and blood-spattered medical processes. One of the features of the 1953 procession was a comedy police patrol car, 'chasing' a car-load of comedy burglars. The patrol car had a comedy smoke canister attached to its chassis, and this fell off and rolled underneath a nearby parked car, nearly causing it to catch fire.

For a long time, this humour was taken in good part by the public but, by 1968, the charm had worn off, if this *Reading Chronicle* leader was to be believed:

Clean It Up

In these days when to the more serious person the rebellious actions of students throughout the world would appear to receive an over-generous proportion of the time and space of the mass media, we make no apology for commenting on Reading Students' Rag.

A decade or so ago Rag Day was a good humoured occasion which helped cement the friendship between town and gown. In recent years the Rag has extended to a week and other educational institutions have joined in to what seems to have become little more than an excuse for unrestrained hooliganism in the name of charity...

It would appear to the man in the street that when students are not protesting about cuts in grants, or some political issue, they are quite prepared to take part in mass demonstrations of hooliganism.

The flour, eggs and tomatoes thrown in Saturday's Rag procession could have been better used in going to feed the less fortunate ... This year's Rag hit a new low in bad taste – as did its official organ 'The Rattler'... Surely it should be possible for such publications to rise above filth, The University authorities could do worse than institute some form of censorship.

Reading Chronicle, 8 March 1968

It was a pity the editorial columnist did not talk to the reporter who actually covered the procession. They quoted a traffic warden who said the offending missiles had been thrown, not by the students, but by a group of younger people who had been

following the procession. Even so, some of the activities by which the students had raised £5,000–6,000 for charity might not have won his admiration. They included some kind of strip-tease event in Broad Street, an Eastern-type slave market, in which bids of up to £2 10s (£2.50) were offered for young ladies (for services about which the newspaper was perhaps understandably silent), unofficial road blocks on the main arteries into town (which the authorities said added to Reading's perennial congestion) and drinking the Three Tuns pub dry (a feat which allegedly involved the student body consuming 2,800 pints in a night).

Rag still exists to this day, though the emphasis now seems to be more introspective, rather than one of taking over the town. Events include various sponsored activities and jailbreak, which involves travelling as far as possible from a starting point, and back to it within a given time, without the use of money.

Reading School

Reading boasts one of the most venerable educational establishments in the country, but when exactly did it begin? According to its historian, Michael Naxton, there are some grounds for suggesting it was founded in 1120, except that this would predate the founding of Reading Abbey, the most likely seat of any educational activity at that time. He suggests a more realistic date might be 1125, the year in which the abbey got its foundation charter. If so, this would make Reading the tenth oldest school in England.

Much of its early history need not concern us for the purpose of the making of modern Reading. Perhaps a more relevant time to start from might be one of the school's golden ages, under its most famous headmaster, Richard Valpy (from whom Reading's Valpy Street derives its name). He was appointed headmaster in 1781 at the relatively young age of twenty-seven, the son of a wealthy Jersey family and a graduate of Pembroke College, Oxford. He inherited a school at a very low ebb, due not least to its woefully inadequate accommodation. He asked the Corporation to provide him with a more suitable building and, when they refused, commissioned one at his own expense. He was a scholar, actor and poet, with interests in politics, agriculture, soldiering, religion and gambling. Despite being known for his strict discipline – the cartoonist George Cruikshank characterised him as the Reverend Duodecimus Wackerback and locally he was known as 'the mighty flogger' – he was apparently worshipped by his pupils.

He had some unusual teaching methods; teaching the boys to swim was one of his obsessions and he used to do so by wrapping half crowns in white paper and throwing them into the river for the boys to find. He was also famous for his dramatic productions, which he minutely supervised and which were highly regarded – one even went on to play at Covent Garden. He wrote textbooks that became the standard for teaching nationwide, introduced innovations in teaching, served on various charitable bodies and twice refused a bishopric.

The school thrived under his charge. Pupil numbers rose to 119 by 1792 and to over 200 by the time he retired in 1830. This was despite the high fees charged to pupils (50–60 guineas (£52 10s – £63) a year, plus an entrance fee of five guineas (£5 5s) and extra charges

for what might appear basic parts of the curriculum – writing, maths and classics). This was far from the idea of a free school for the poor that some thought was the original remit for the school – though there were some places for free scholars.

His son Francis succeeded him and under his command the school's decline was equally dramatic. By 1837 there were only twenty boarders and seventeen day pupils (nine of them free scholars) left; by 1866 numbers were down to two day scholars and one boarder and the school closed. Plans were set in motion (the Reading School Act 1867) to create a modern grammar school. Part of the charitable bequest by John Kendrick that had funded the original Oracle (see the shopping chapter) was redirected to that end and the Palmer family also helped pay for it. A 10-acre site at Erleigh Road was bought off the Redlands Estate and the nationally eminent (but locally resident) architect Alfred Waterhouse was engaged to design the school buildings. The Prince of Wales, the future King Edward VII, laid the foundation stone.

Arguments about the intended beneficiaries of the school continued. Was it to be a school to serve local needs, or was admission to be purely for a fee-paying elite? The school needed the boarders to ease its financial problems, but this in turn militated against any possibility of local authority subsidy. The school's 1870 prospectus proposed the uneasy compromise of 'a thorough Middle-Class education to be supplemented by a lower school for the benefit of the lower classes'.

In the event, a reluctant Corporation was left with no choice but to pick up the bill. The 1867 Act said that, if the school defaulted on its mortgages, the responsibility rested with the local authority and in 1886, they did just that. The Corporation was also responsible for another school, founded (and funded from the Kendrick charities) in 1877. They decided in 1916 to merge the overcrowded boys' part of that school with Reading School, which was then under-occupied. Kendrick had previously provided places for boys who could not afford to go to Reading School. This merger also enabled the girls' part of Kendrick to move out of their overcrowded accommodation into purpose-built premises on the corner of London Street and Sidmouth Street, in 1927.

Who Governs Reading?

An important influence in shaping modern Reading has been its local authority. But in what ways has it influenced the development of the town and how did the system of local government we are familiar with today evolve?

A good starting point is the year 1835. Prior to that, Reading, like hundreds of other towns in England and Wales, was run by an ancient medieval corporation that derived its powers from a series of royal charters. In Reading's case these went back at least to the days of Henry VIII, who first recognised the town council as a separate body to the merchant guild in 1542, and possibly as far back as the town's first charter of 1253. One of the first acts of the newly reformed Parliament after 1832 was to commission a root and branch review of local government across the country.

The Municipal Corporations Commission that they set up found that the corporations around the country had all too often become self-electing, self-perpetuating and corrupt. In Reading's case, they found that:

> They had not squandered their trust in eating and drinking; nor were they guilty of the frauds and partiality attributed to them. They did keep accounts, though they violated the express order of their charter by never publishing them. They spent money in the public interest, but the public, to whom the Corporation affairs were 'a sealed book' continued to doubt their integrity. In short, here was all 'the practical inconvenience' inseparable from the system of entrusting public responsibilities to a self-appointed clique, honeycombed by private and family compacts.
>
> Childs, 1910, page 30

No downright corruption perhaps, but hardly a ringing endorsement. The activities of the Corporation centred around managing its resources, granting licences, looking after the town's bridges (and Reading's ruinous crossing of the Thames spoke eloquently of how good they were at that) and managing (or mismanaging) local charities. They were of course totally unaccountable to any electorate and the same families tended to run them for periods of fifty years or more. As evidence of their lack of activity in the field of improvement, no by-law had been made since 1675, and the local prison, or bridewell, had for fifty years sat within the ruins of the abandoned Greyfriars church, conditions in which were a monument to their disregard of the most basic human rights.

There were no centrally imposed duties on them to improve the environment or to perform any of the hundreds of activities associated with modern local government. Any attempt at improvement depended on a local initiative to seek the Act of Parliament needed to undertake it. These did not need to be council initiatives. In Reading's case, private enterprise companies had obtained their own private Acts of Parliament to supply the town with water and gas. Then there were the Poor Law Guardians, who administered a version of social services for the poor and needy whose legislation dated back to the time of Queen Elizabeth I (laws which were themselves shortly to be reformed).

There were also the Paving Commissioners, first established by an Act of 1785 to carry out environmental improvements. Their main authority came from the Reading Improvement Act of 1826 – 'An Act for the Better Paving, Lighting, Cleansing, Watching and Otherwise Improving the Borough of Reading'. The sweeping powers implied by this so-called All Perfection Act's title were not matched by the Commissioners' delivery and the Reading of 1835 was 'a notably insanitary and disease-ridden borough'. Part of this inactivity stemmed from the marked reluctance of many of the town's citizens to pay the rates needed to fund the improvements. Nor was there any obligation upon Parliament to ensure that the Acts they passed were being carried out.

The Municipal Corporations Act of 1835 set out to radically reform this fragmented and partially moribund local government structure. It was to be replaced by a simpler, directly-elected municipal borough council, one that a radical government hoped would be a nail in the coffin of traditional conservatism. The first election in Reading certainly pointed in that direction, with 'reform' candidates winning fifteen of the eighteen seats. Only six out of twenty-two members of the old Corporation stood for re-election and four of these were defeated. The moribund nature of the old structure was highlighted by the limited duties they handed on to the new borough; these consisted of managing corporate property, maintaining bridges and trusteeship of the Reading Free Grammar School. The only new duty they had was to establish a police force. Prior to this, such policing as went on in the town was carried out by a few night-watchmen, appointed by the Paving Commissioners. The new police service was the new authority's main initial preoccupation but they were even uneasy about funding that. Having set the level of manning at thirty men, it was steadily reduced to eighteen over the next year as a cost saving, and some of the salaries downgraded. By 1853, it was said that 'the police force of Reading are receiving the lowest wages of any in the Kingdom'.

The establishment of the new council did not mean an end to a confusing and fragmented structure of local government. All it did was to create conditions under which a multi-purpose authority capable of addressing the various needs of the town could eventually emerge. Between 1835 and 1870 new powers were given to other bodies (some of them relatively long-established, like the Paving Commissioners and the gas and water companies, and others relative newcomers, like the Local Board of Health, initially created in 1831/2 to tackle a cholera outbreak). Many of these bodies had overlapping memberships, giving rise to issues of conflicts of interest, and of individual local worthies having undue influence over the affairs of the town.

Local Government and Public Health

Another barrier to progress was an attitude that prevailed in some quarters that it was not the job of the authorities to promote public health or prosecute those who created health hazards. This found extreme expression in 1859 in the views of an Alderman Brown, who declared that 'the prevention of fever was impious and that to say that a good drainage system would prevent disease was saying more than mortal man ought to do'.

Reading was growing rapidly in the 1830s and this growth forced other concerns onto the municipal agenda. In 1839 the council resurrected the issue (which had been a concern for decades past) of 'the disgraceful state of the public streets and highways of the Borough from accumulated mud and dirt and that when the streets are scraped the heaps formed thereby are allowed to remain without being removed'. However, rather than doing anything about it, they simply drew it to the attention of the Paving Commissioners (who existed in parallel to the borough council until 1850).

But this was only part of a more general concern about the health of the town, for someone living in Reading at the start of Queen Victoria's reign had a life expectancy that was five years shorter than his next door neighbours in Wokingham or Easthamstead. Part of the problem was thought to be the setting of the town, surrounded by low-lying marshy ground between two rivers that encouraged epidemics of fever. But by the 1840s a clear recognition was also beginning to emerge of the links between poor sanitation and ill-health, and one thing that was not in short supply in Victorian Reading was poor sanitation. The town was visited in 1847 by Dr Southwood Smith of the Royal Commission on the Health of Towns. He was scathing about what he found, calling Reading 'nothing but an extended cesspool'. Almost 2,000 of its 4,155 houses had no water supply, and 390 of them drew their water from the River Kennet. However, the River Kennet also served as a sewer for a large part of the town, with privies, slaughterhouses and pigsties draining into it. The town's drinking wells were surrounded (and polluted) by some 2,700 cesspools, some so deep they were almost impossible to clean out, and every street seemed to have its own sanitation nightmare. In Silver Street, sewage discharged into a ditch with no outlet; London Street had a black open gutter that was very offensive in hot weather, and the *Reading Mercury* reported in August 1849 that no one could pass down a by-street without being offended by some stagnant pool of putridity, the insufferable stench of a slaughterhouse or the foul air of a half-choked drain' (Quoted in Childs (1910), page 37).

Small wonder that the death-rate in Reading in 1849 was thirty per thousand, almost twice the national average. But even in death there was no escape from public health problems. The town's parish graveyards were full to overflowing and there was a horrifying contemporary account of gravediggers hacking their way through decomposing corpses to make room for further occupants.

The council was sufficiently aware of these problems to commission a report from a Mr John Billing (a councillor who was also a surveyor) on the sanitary condition of the town. One point to note about Billing's survey was that he was not a full-time salaried officer of the corporation. No such position existed until John Marshall was appointed as Surveyor to the Board of Health in 1856. Billing was a contractor who did a lot of business with the corporation. He would have expected to gain some lucrative contracts from the proposed

improvements and there was some suggestion that his analysis of the costs and benefits of his scheme was not entirely disinterested.

His conclusions nonetheless led the council to propose an extension to their powers in December 1846, to enable them to improve drainage and water supply. This would prove to be controversial, both to those who opposed spending on anything involving the rates on principle, and to vested interests like the water company, who would have been taken over by the council. There was even opposition within the council itself. A longstanding councillor and former mayor, Alderman Thomas Rickford, resigned because he would not 'be a party to the distressing taxation which [would] be entailed upon... the ratepayers by the measures which a part of the council are now taking'.

A meeting to discuss the proposal was held at the Town Hall on 22 December 1846. It was packed with opponents of the scheme. In the face of the evidence they could hardly deny the need for improved sanitation, but its opponents sought instead to argue that it was premature, since the government was likely soon to introduce general legislation, in response to the report of the Health of Towns Commission. A motion opposing the measure was carried by a large majority, and the *Berkshire Chronicle* condemned the meeting on 26 December 1846 as 'a melancholy exhibition of private interests and special pleading combining for the obstruction of the public good'. But this was not just about penny-pinching; it also reflected a view, prevalent at the time, that an Englishman's private property was sacrosanct, and that this extended to an Englishman's drains (or lack of them). Reading's local Improvement Bill was doomed to failure.

Sure enough, general legislation in 1848 meant that the council could be designated by government as the Local Board of Health, but the local bill's controversial passage meant that the council was by then deeply divided on the subject of sanitary improvements. Worse still, implementing a national, rather than a local, scheme also meant that they would not be masters in their own house, but subject to the overview of a national General Board of Health. During 1849, lobbying by the town's pro-improvement interests led to a further government survey of the borough's public health needs.

This recommended that a Local Board of Health be created in Reading, giving new powers to the council (whether they wanted them or not). These powers would include the remaining powers of the Paving Commissioners, the ability to acquire the local gas companies and to give control over water supplies. Other potential areas of action for the council were the provision of new cemeteries, improved paving and street cleaning, the creation of new uncongested streets and dealing with the proliferation of slaughterhouses.

But what was lacking was any way for central government to make the corporation do anything with its new powers – the idea of the centre requiring local authorities to act in promoting the general welfare had not yet taken root. Nonetheless, in August 1850 a new local authority body was created in Reading with the power to levy a rate. For most practical purposes, the new Local Board of Health and the council appeared to be one and the same. The majority on the council, who were opposed to change or expenditure, set about using every delaying tactic at their disposal to stop these powers being used. The council managed to postpone major capital spending on drainage and sewerage until 1870, though some progress wade in the meantime through the regulation of individual nuisances. Most of the council's business was conducted in committee, safely out of the public gaze to which

full council meetings were subject. Not until the Local Government Act 1972 were local authorities required to open all their meetings to the press and public, unless matters of a sensitive or personal nature were being discussed.

Some progress was however made in three fields of regulation and licensing. The first concerned the inspection and licensing of common lodging houses. This was underpinned by a strong dose of Victorian paternalism, the statutes being 'directed against a very chief source of physical pestilence as well as moral depravity among the labouring classes. Conditions in Silver Street were singled out for concern for there the evils were aggravated by numerous houses for prostitutes, thieves, tramps and Irish' (Alexander, page 41). A second area of regulation concerned the proliferation of private slaughterhouses. These were insanitary in themselves and gave rise to offensive trades involving animal by-products. This began with the inspection and regulation of existing slaughterhouses and led by 1860 to the opening of council abattoirs that enabled them to close the private ones. The third concerned the removal of refuse and control of the timing and manner of cleansing and emptying of water-closets, privies and cesspools. In the days before local authorities had many paid staff, elected members would often be given the job of inspecting the town for nuisances and carrying out site visits.

Other areas of intervention included the licensing of hackney cabs and cab ranks, the regulation of pub opening hours and the closing of the overcrowded parish cemeteries in 1851 (giving a monopoly on burials to the Reading Cemetery Company). On the leisure front, land at Forbury Hill was bought as a recreational asset in 1854 and, three years later, an ornamental approach from the Forbury Pleasure Gardens to the abbey ruins was agreed (though the £1,200 cost had to be met by public subscription, including £100 from members' own pockets). Middle Row, one of the town's most notorious slums, was bought and demolished by unemployed men employed for the purpose through the Mayor's Public Relief Fund. The site of the Oracle, the seventeenth-century work hall built to alleviate a previous generation's unemployment, was bought by the council in 1852 after it was learned that the owners, the governors of Christ's Hospital, planned to 'grant the site on building leases which would lead to the erection of a large number of dwelling houses of an inferior class and thereby preclude the hope of effecting any improvement in that part of the Borough' (Alexander, page 45).

Attitudes to intervention were changing. By 1865, the corporation was not only responding to the most serious of environmental nuisances that could not be disregarded, but were sending out the Surveyor to look for 'any removable causes of disease' that the Local Board of Health had powers to tackle. By 1863 they were preparing by-laws to ensure 'observance of proper regulations on the erection of new buildings throughout the Borough'. Thus, before it had yet got to grips with investing in sewerage works, the council was making the first moves towards becoming a planning authority.

Fire Brigade

As we saw, firefighting was made a responsibility of the Superintendent of Police in 1844, and three of his men were trained in the use of the town's fire engines. But by August 1862

it was agreed that policemen were not the right people to be operating them; in the event of a major fire, they were likely to be fully occupied with policing activities. It was decided that five dedicated permanent staff would be appointed, and paid a retainer for keeping the equipment in good order and attending fires and other emergencies. The new fire service would continue to be responsible to the Superintendent of Police. They were to be supported by the men of the Berkshire Volunteer Rifles, who would be under the command of their own officers. The situation was further complicated by the existence of a number of private fire services, who would from time to time offer the council their assistance.

Water and Sewage

The council had powers to acquire the local water and gas companies but chose, until 1868, when the major drainage scheme was imminent, to limit itself to controlling the price charged for water. The drainage scheme was forced on the council by the scathing criticism of the Commons Select Committee on the Thames Navigation Bill, which was told in 1856 that 'schemes of drainage have been submitted to the Local Board of Reading and to their disgrace … they have been treated with the greatest contempt' (Alexander, page 55).

For fifteen years, evidence of the need for the town to have a comprehensive drainage and sewerage system had been accumulating, and every excuse had been used for doing nothing about it. A scheme put forward by Borough Surveyor John Marshall in 1858 had been rejected because of supposed doubts about its technical feasibility, and the more extreme economisers on the council had even tried to keep running the discredited argument that there was no proven link between dirt and disease. Councillor Boorne spoke for this group, saying that, 'Sanitary science is yet in its infancy, and [the Board] ought to take warnings in the experience of others and not allow experiments to be tried upon them at their cost.' (Alexander, page 58).

Repeated outbreaks of cholera, including one in Reading in 1854, were eloquent testimony against the arguments of the economisers, though some of them even tried to get references to the links between the town's drainage and cholera deleted from committee reports. But the real agenda was an objection to the cost involved. The council's hand was forced in 1866 by two developments. First, a private company announced its plan to apply for parliamentary approval to build a sewage works near Reading and, second, the Thames Navigation Bill threatened to make it illegal to discharge sewage into the Thames and its tributaries. The council began to be won over to an idea for dealing with Reading's sewage first proposed in 1846, which was to apply it to the land to be broken down, rather than polluting rivers. A scheme for acquiring land outside the borough for a sewage farm, as well as acquiring the town's waterworks, began to emerge in 1867. The purchase of Manor Farm in Lower Whitley would have a major impact on the quality of life of people in Reading but would prove to be expensive and controversial. The money collected from the rates rose by 250 per cent between 1868 and 1875 and by 1879 the general district rate stood at 5s 4d (26 pence) in the pound, almost half of which (12.5 pence) went to service the debts on the sewerage scheme. The Reading Corporation Act 1881 gave the council many new powers, including one to issue Corporation stock, which it used to refinance its debts and reduce the rates.

The council's first purpose-built town hall was erected as long ago as 1785/6. It cost £1,800 and was designed by one of the councillors, Alderman Charles Poulton, who was a cabinetmaker rather than an architect. It survives today as the Victoria Hall, the part of the town hall complex that is not visible from Friar Street. The 1860s and 1870s saw radical change in British local government. Local authorities were moving away from the model of corporations served by a small number of (mostly part-time) staff to having a much larger, mostly full-time establishment. The local authorities were not legally obliged to have any staff at all, until the Public Health Act 1872 made them appoint a Medical Officer of Health. The first holder of this post, the formidable Dr Shea, made a number of important changes to the way the council was run, including getting them involved in housing through its housing enforcement powers under the Artisans' and Labourers' Dwelling Act 1868.

More generally, the Second Reform Act was passed in 1867, and was followed by a number of pieces of social legislation, which the local authorities had to put into practice. Universal, publicly funded education came in with the Education Act 1870 and there were new local authority responsibilities in the fields of public health and housing. More responsibilities meant more staff and more staff created a need for additional accommodation.

Proposals for new municipal buildings came forward in 1871, though there was a disagreement about whether they should build something straight away, or rent premises as an interim measure. The architect Alfred Waterhouse was eventually engaged to design purpose-built accommodation. The foundation stone of the new council offices was laid in October 1874 and the first meeting of the council in its new council chamber was held in June 1876.

Almost immediately, demands for additional civic space began to make themselves felt. In 1877 the council was left a museum collection in the will of a Burghfield resident, Mr Horatio Bland, and in June of that year the council resolved to provide the town with a public library. Mr Bland's museum collection was itself bizarre and eclectic enough, including as it did a decorated cider jar from Ecuador, bricks from the walls of Babylon, the head and hands of a mummy, an opium pipe and the skeleton of a boa constrictor. But the people of Reading took the idea of public subscription to heart and the council was deluged with a moose's head, a stuffed crocodile and other curiosities. (The owner of the crocodile did not donate so much as lend his exhibit to the council, saying 'I gave a kind of promise that I would not give it away but it is … very unlikely that I should again require it for my own purposes.')

At the same 1877 meeting that the need for more council office space was raised, a group of local worthies proposed the building of a new public hall, a free library, reading room and museum and accommodation for the Schools of Science and the Arts. The last of these would qualify for a grant and the rest would be paid for by public subscription. On the strict understanding that it would not be an additional burden on the rates, the council approved the proposal and agreed to buy the land for it. An architectural competition was held to award the contract. Alfred Waterhouse entered, but his scheme was judged to be too expensive, and the adjudicator of the competition, Thomas Lainson, awarded the contract to himself. In the event, public subscription raised only about half the £44,000 that was the lowest tender for the building, and the council was pressured into putting a further £10,000 into the project. The buildings were finally opened in May 1882, after the council made

it clear that any costs of the opening ceremony would not come from the rates. The final phase of the town hall complex, the library extension and art gallery, was also paid for by public subscription and opened in 1892, giving Reading a town hall that was designed by four different architects over a period of more than a hundred years.

Scarcely had the cement dried on the last phase of the old town hall than a need was identified in 1901 for more council accommodation. Also in the truest Reading tradition, the council spent the next three-quarters of a century thinking about it. Any number of sites for it were discussed – the Forbury Gardens, London Road, Reading prison, Hills Meadow and Prospect Park. But it was not until 1978 that the Queen and the Duke of Edinburgh arrived in Reading to open to open the first phase of an ambitious civic complex, including the Civic Offices, the Hexagon entertainment centre and the magistrates' courts. It is built on a former slum housing area, part of which was cleared to make way for what is now the Broad Street Mall and the Inner Distribution Road. The Civic Centre plan, originally conceived in 1959, was designed to have a further phase, a cultural centre, bridging the access road from Castle Street into the Broad Street Mall car park. The temporary fencing still stands as a reminder of where it would have gone, and is wearing rather better than the Civic Offices themselves, which were being replaced as this was being written.

There are two further examples of where the council preferred to use private funding, rather than looking to public resources. In 1877 the council approved the principle of providing the town with a tramway system, in response to a proposal from a private company to build one. One key decision was whether to build the tramway themselves and lease it to the operator, or to allow the private company to do it all. They sought advice from other towns with experience in the matter and, despite being strongly advised by them to build it themselves, the council supported the private company's application to build it. As we see elsewhere in the book, the council bought out the tramway in 1901. Similarly, when private companies applied in 1882 for licenses to supply electricity to the borough, the council had the option of applying for a license to do so itself. They rejected it, leaving the field open for the Reading Electricity Supply Company. Again, this eventually found its way into council ownership, this time in 1933.

Education was to become one of the largest of the council's responsibilities. Following the 1870 Act a School Board was set up in Reading. It was elected separately to the council and set its own budget, though the council was responsible for collecting it as part of the rates. Quite separately, the council was directly involved in education, through its trusteeship of the Reading Free Grammar School. The council became the local education authority in 1903.

The council found its independence threatened by the Local Government Bill 1888. Under this, counties were to be brought under a similar form of democratic control to that given to boroughs under the Municipal Corporations Act 1835. In Reading's case, it would have meant much of the council's independence passing to the new Berkshire County Council, with no guarantee that rates collected in Reading would be spent there. Initially the only exclusions were to be the ten largest boroughs, with populations of more than 150,000 (Reading was then about a third of that size). Furious lobbying by Reading and other similarly affected boroughs as the Bill went through Parliament got the threshold reduced to 50,000 but, even then, a certain amount of creative demography was needed to

raise Reading's 'official' population above the threshold. Thereafter the natural increase in the population and extension of the borough boundaries kept Reading's independence and control over all areas of local government policy safe, at least until the passing of the Local Government Act 1972.

In brief, the 1972 Act meant an end to political independence for Reading. It created a two-tier system of local government across the country (three, if you count parishes). A number of Reading's powers went across to Berkshire County Council, including libraries, consumer protection, education, strategic planning, social services, waste disposal, public transport and transport planning. This took effect from 1 April 1974. This division of responsibilities remained until 1 April 1998, when the provisions of the Local Government Act 1992 took effect, and created six all-purpose unitary authorities, abolishing Berkshire County Council.

The two-tier system was not scrapped everywhere. Berkshire County Council were sometimes said to have been 'the turkeys that voted for Christmas' because of their support for their own abolition. Two reasons have been suggested for this. The first was that the Conservative Member of Parliament for Wokingham, John Redwood, was one of the driving forces for its abolition. A Labour/Liberal Democrat coalition had taken control of the county council in 1983 and it was suggested that he did not want them to be a rival to Wokingham's Conservative administration.

The second suggested reason was that Berkshire were a victim of their own success – they had managed to contract out so many of their services that they had rendered themselves superfluous.

In addition to the powers it lost to Berkshire in 1974, Reading had also surrendered responsibility for the police, hospitals, fire service and water supply, in previous reorganisations which set up:

- The Thames Valley Police Force (an amalgamation of five forces under the Police Act 1964 (with effect from 1968);
- The Regional Hospital Board (created by the National Health Service Act 1946, itself later replaced by the Regional Health Authority in 1974);
- The Berkshire and Reading Fire Authority (created by Local Government Reorganisation in 1974); and
- The Thames Valley Water Board (1959) (later (1974) the Thames Water Authority and then a privatised Thames Water).

Acknowledgements

I have been enormously aided in my task by the many excellent published sources of information about different aspects of the town's history. I would encourage anyone whose interest is taken by a particular aspect of the town's story to look at these in more detail. Many are now out of print, but can still be found in the local studies section of Reading Central Library, where I did much of the research for this book. I must also thank Anne Smith, Katie Amos and their colleagues in the library for their unfailing helpfulness with my researches and for the use of some of their extensive library of historic photographs to illustrate the book. Equally helpful were the staff at the Berkshire County Records Office. The modern photographs of Reading were taken by my son, Michael, and Margaret Simons provided much useful information about local authority housing. Last but not least, the internet seems to have a gift for throwing light on some of the most obscure corners of the town's history. I have not listed most of my internet sources in the bibliography, but you should be able to find them by putting the appropriate words into your search engine.

Bibliography

Alexander, Alan, *Borough Government and Politics: Reading 1835–1985* (George Allen & Unwin, 1985)

Beecroft, Joseph J., *A Handy Guide to Reading* (J. J. Beecroft, 1882)

Berkshire Chronicle

Berkshire County Council Remembered (BCC, 1998)

Berkshire County Council, *Reading Highway Strategy: The Third Thames Bridge* (BCC, 1984)

Berry, Warren, *The Kennet and Avon Navigation* (Phillimore, 2009)

Burstall, Patricia, *The Golden Age of the Thames* (David & Charles, 1981)

Burton, K. G., 'A reception town in war and peace' (*Planning Outlook*, Volume III Number 3)

Census records 1901–1991

Childs, William M., *The Town of Reading During the Early Part of the Nineteenth Century* (1910, 1967 Reading Public Libraries)

Childs, William M., 'The Future of the Town of Reading' (transcript of lectures, given in 1922)

Childs, William M., *Making a University* (Dent, 1933)

Christiansen, Rex, *A Regional History of the Railways of Great Britain Volume 13: Thames and Severn* (David & Charles, 1981)

Clapson, Mark, *Working Class Suburb: Social change on an English Council Estate 1930–2010* (University of Manchester Press, 2012)

Clark, Gillian, *Down by the River* (Two Rivers Press, 2009)

County Borough of Reading, *The Thames in Flood* (1947)

County Borough of Reading, Development Plan written analysis (February 1953)

Culpin, Ewart, *Housing of the Working Classes* (Reading Borough Council 1918)

Deacon, Nick, 'The Huntley and Palmer Railway' in *Railway Bylines* (December 2013 and January 2014)

Deacon, Nick, 'The Coley Branch of the Great Western Railway' in *Railway Bylines* (February–March 2014)

Department of the Environment, *Comprehensive Traffic Management in Reading* (Traffic Advisory Unit, 1972)

Downs, David, *Biscuits and Royals: A History of Reading FC 1871–1986* (Fericon Press, 1986)

Dunnett, H. McG., *Gateway to the West* (Picture Press Vol. 1, No 5, 1966)

Gregory, Roy, *The Minister's line: Or, the M4 comes to Berkshire, parts 1 and 2* (Public Administration, 1967)

Hall, Dave (editor), *An Unofficial Guide to Reading University and Reading Town* (Reading University Students' Union, 1991)

Hall, D. A., *Reading Trolley Buses* (Trolleybooks, 1991)

Hattersley, Roy, *Borrowed Time* (Abacus, 2009)

Holt, J. C., *The University of Reading: the First Fifty Years* (Reading University Press, 1977)

Humphreys, A. L., *Caversham Bridge 1231–1926* (The Holybrook Press, 1926)

Hylton, Stuart, *Reading Places, Reading People* (Berkshire Books, 1992)

Hylton, Stuart, *Reading at War* (Sutton/History Press 1996/2011)

Hylton, Stuart, *Reading: the 1950s* (Sutton/History Press, 1997/2013)

Hylton, Stuart, *A Reading Century* (Sutton, 1999)

Hylton, Stuart, *Reading Past and Present* (Sutton, 2000: reissued by History Press as *Reading Then and Now*, 2011)

Hylton, Stuart, *A History of Reading* (Phillimore, 2007)

Hylton, Stuart, *The Little Book of Berkshire* (History Press, 2014)

Independent Transport Commission, Report to Reading Borough Council (July 2008)

Jordan, Edgar, *Reading Tramways* (Middleton Press, 1996)

Jordan, H. E., *The Tramways of Reading* (The Light Railway Transport League, 1957)

Kneebone, Roger, *The Development of Social Services in Reading – A Brief History* (Reading County Borough, 1972)

Maggs, Colin C., *GWR Principal Stations* (Ian Allan, 1987)

Ministry of Transport press release about the M4, 9 August 1965

Morris, Colin, *Reading Transport Glory Days* (Ian Allan, 2005)

Mouchel & Partners Ltd, Reading Corporation Act 1913 – Construction of bridges (1913)

Naxton, Michael, *The History of Reading School* (Reading School, 1986)

Past and Present, *Number 16: the Rise of a Residential University*

Petyt, Malcolm (editor), *The Growth of Reading* (Sutton, 1993)

Phillips, Daphne, *Reading Theatres, Cinemas and Other Entertainments* (Reading Libraries, 1978)

Phillips, Daphne, *The Story of Reading* (Countryside Books, 1980, 1990)

Phillips, Daphne, *How the Great Western came to Berkshire* (Reading Libraries, undated)

Phillips, Geoffrey, *Thames Crossings* (David & Charles, 1981)

Punter, John V., *Office Development in the Borough of Reading 1954–1984* (University of Reading, 1985)

Railton, Margaret, *Early Medical Services: Berkshire and South Oxfordshire from 1740* (Polmood, 1994)

Railton, Margaret and Marshall Barr, *The Royal Berkshire Hospital 1839–1989* (Royal Berkshire Hospital, 1989)

Railton, Margaret and Marshall Barr, *Battle Workhouse and Hospital 1867–2005* (Berkshire Medical Heritage Centre, 2005)

Reading Borough Council, Committee and Council minutes (various dates)

Reading Borough Council, Hosier Street/Broad Street Mall planning and development brief (RBC and Donaldsons, 1990)

Reading Borough Council, Private sector house condition survey (RBC, 2013)

Reading Chronicle

Reading County Borough Council, Reading Inner Distribution Road (RBC, 1969)

Reading Evening Post

Reading Handbook, (Arthur Anderson and the Corporation of Reading, 1906)

Reading Mercury

Reading Public Libraries, Reading's Statues, *Monuments and Memorials* (1972)

Reading University, *Making a University* (exhibition catalogue,1968)

Robert Matthew, Johnson-Marshall & Partners, *The Market Place Reading Proposed Redevelopment* (Reading Borough Council, 1965)

Salter's Guide to the Thames (Alden & Co., 1912)

Scott, Peter, *A History of the Thames Side Promenade Miniature Railway* (Minor Railway Histories No. 4, 2005)

Smith, Ann, *100 Years of Shops in Reading* (Reading Libraries, 2014)

Southerton, Peter, *The Story of a Prison* (Osprey, 1975)

Sowan, Adam, *A Mark of Affection: The Soane Obelisk in Reading* (Two Rivers Press, 2007)

Stokes, Anthony, *Pit of Shame – The Real Ballad of Reading Gaol* (Waterside Press, 2007)

Stone, Graham L., *Buses of Reading and Newbury* (Reading Bus Preservation Group)

Thames Valley Police, *History of the Thames Valley Police* (TVP, 2004)

University College of Reading, First Annual Report (1893)

University College of Reading, General Prospectus (1907)

University College of Reading, *A University for Reading: Is it Worthwhile?* (University College leaflet, October 1921)

University College of Reading, 21st Anniversary Event: Michaelmas Day, 1913

Vaughan, Adrian, *A Pictorial Record of Great Western Architecture* (Oxford Publishing Company, 1977)

Wise, Michael, *The South Wales Motorway* (undated)

Wright, Patrick, *The River: The Thames in Our Time* (BBC, 1999)

Wykes, Alan, *The Queen's Peace: A History of the Reading Borough Police 1836–1968* (Reading Corporation, 1968)

www.buszone.co.uk

www.headington.org.uk

www.reading.ac.uk

Index